Character Modeling with Maya and ZBrush

Character Modeling with Maya and ZBrush

Professional Polygonal Modeling Techniques

Jason Patnode

ELSEVIER

AMSTERDAM • BOSTON • HEIDELBERG • LONDON • NEW YORK • OXFORD
PARIS • SAN DIEGO • SAN FRANCISCO • SINGAPORE • SYDNEY • TOKYO
Focal Press is an imprint of Elsevier

Focal Press is an imprint of Elsevier
Linacre House, Jordan Hill, Oxford OX2 8DP, UK
30 Corporate Drive, Suite 400, Burlington, MA 01803, USA

First edition 2008

British Library Cataloguing in Publication Data
A catalogue record for this book is available from the British Library

Library of Congress Catalog Number: 2007941699

ISBN: 978-0-240-52034-6

Typeset by Charon Tec Ltd (A Macmillan Company), Chennai, India
www.charontec.com

For information on all Focal Press publications
visit our website at www.focalpress.com

Printed and bound in Canada

08 09 10 11 11 10 9 8 7 6 5 4 3 2 1

CONTENTS

Contents

ACKNOWLEDGMENTS

I would like to send special thanks to Georgia Kennedy for helping to keep this book on course.

Thanks to Bridget Dash and Aida Cazares for proofreading.

And special thanks to my mom, Nandell for helping out as often as she could.

Last, I want to send thanks to Alice. She encouraged and helped me on many a night as I drank my sixth cup of coffee trying to finish one thing or another.

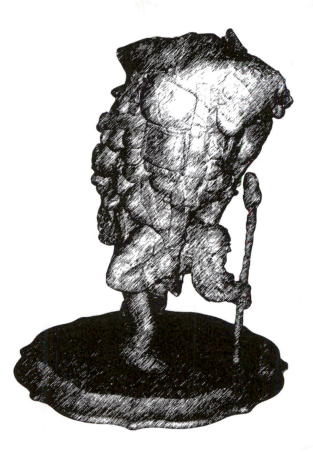

Pipeline and Modeling Guidelines

The pipeline is the path that assets travel to make it into movie or game. It is important to have a solid, working pipeline in place before beginning production. Who is the first person to touch a model once the concept art is done? Where does a character go after it has been modeled? What happens if a model needs to go back for revisions? These are all question that should be answered before any art is created.

Yes, it does add some extra work before you can get to the fun part of creation, but it will save countless hours during actual production. While this book will be focusing on modeling, be aware that a pipeline encompasses all aspects of a production. At any given time, you should be able to locate art assets. Thus it is very important to become familiar with how production pipelines work.

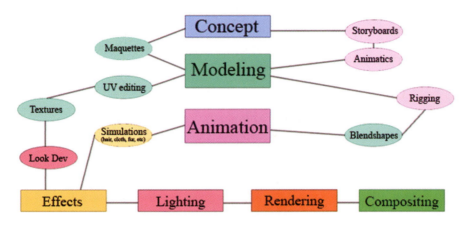

FIGURE 1-1 A typical production pipeline.

Concept art is the 2D designs created during pre-production. These will consist of orthographic views, reference views, and character sheets. A character sheet typically portrays the character in a variety of poses.

From concept, the pipeline usually branches out for storyboards on the animation side and maquettes on the modeling side.

Storyboards are somewhat related to animation. They are the story sequences as realized visually. The artist will compose the camera and place the characters on paper or 4 × 6 cards. If something doesn't look right at this stage, say a camera is too tight on a character or a character's pose is awkward, simply have the storyboard artist draw the frame again. It's much cheaper to work out the scene staging during the storyboarding phase than it would be during production.

After the storyboards are approved, they are given to the layout department to be made into animatics. Think of an animatic as a moving storyboard. During layout, the timing and spacing of the characters will be animated as well as the camera animation. The characters are generally low polygon placeholders. Simple quick renderings or playblasts are fine. The goal is to fine tune the timing and spacing for the characters and to get the camera animation in place. Working with simple placeholder objects allows for quick reviews and redos at this stage. This amounts to a huge cost-savings benefit.

The other branch from concept art is the maquette phase. A maquette is usually a clay model built for reference purposes. The more complex the character the more likely there will be a maquette made. By allowing 3D modelers to handle a tiny statue that can be viewed from any angle, maquettes generally help for the creation of more lifelike characters. Some game companies, and almost every movie house, will have a maquette artist create a model. The 3D modeler may create the maquettes or at some larger companies there might be fulltime maquette artists on staff.

Modeling is the creation of the object or environment mesh in 3D. As with all of the other stages, the type of work may be split into smaller subgroups. For example, one person may model props, another may model Hero (a.k.a. main) characters, and still another might work on just the environments. Whatever needs to be modeled, though, it is done during this stage.

FIGURE 1-2 Maquette.

The focus of this book, of course, is character modeling, but it is important to see how modeling fits into the pipeline. Typically multiple people will work on the same model in different capacities and that work is often done concurrently.

After modeling, an object can be textured and rigged concurrently.

During the texturing phase, a model needs to have the UV texture coordinate laid out. UVs are used to conform and hold the textures to an object. Maya creates UVs automatically, but these will almost always need to be changed. At many game companies the modeler lays out the UVs, while at a larger film company, there might be a dedicated person working on the UVs. Proper UVs are vital for a model to look correct once textured, but be forewarned, UV editing can be a very time-consuming process.

Once the UVs are complete, the textures can be created. The UVs can then be brought into an image editing program like Adobe Photoshop to be used as a template when creating the textures.

Rigging is the process of preparing a model for animation. There are many steps within the rigging phase. First a skeleton comprised of joints and bones needs to be created. A skeleton in 3D functions the same as a skeleton in the real world; it acts as the framework for the body. In 3D the body being the mesh is created by the modeler. The mesh needs to be bound and weighted to the joints so that the mesh will move with the skeleton.

After the rigging is complete, any blendshapes needed are created. Blendshapes (also known as morph targets) can be used for facial animation or for correcting problematic mesh deformations. To help keep the art consistent, blendshapes are usually created by the same person that modeled the character.

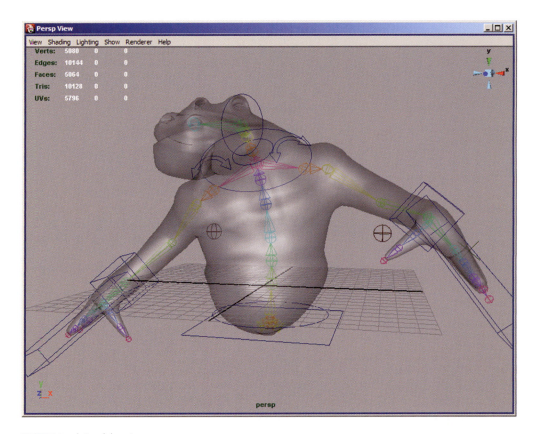

FIGURE 1-3 A rigged character.

Look development can begin at this time. Creating shading networks and designing lighting for the characters are all part of developing the look of a character.

The next step is to animate the character. Once animation is complete, fur, hair, and cloth simulations can be performed. From there, the assets move to the effects artists.

Once the animation is complete, final lighting is applied.

Finally, the character is exported into the game engine or sent to the render farm for final rendering. For film and video game cutscenes, there is an added step after rendering. All of the elements need to be composited together.

This is an example of a very simple pipeline. On large productions, each of these jobs could be further broken down into separate tasks. However, even on large productions, the goal is to make the process of getting assets into the game or movie as pain-free as possible. Often times, a model will need to go through the pipeline multiple times (if something needs to be changed, for instance) and having a smooth process to facilitate this is vital.

Now that we can see how important it is to work within a pipeline, how can that be transferred over to Maya? Maya has very simple, yet complete project tools to help set up and manage your own pipeline. In Maya these are called projects.

To set up a new project go to:

1. File>Project>New.
2. In the Project Setting window, type a name for the project and set a path.
3. Next click Use Defaults. It's advised to always select Use Defaults as this will allow Maya to organize all of the assets for the project.
4. Click Accept.

You now have a new project and are ready to work.

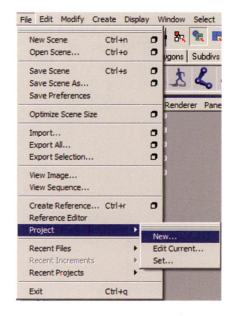

FIGURE 1-4 New project.

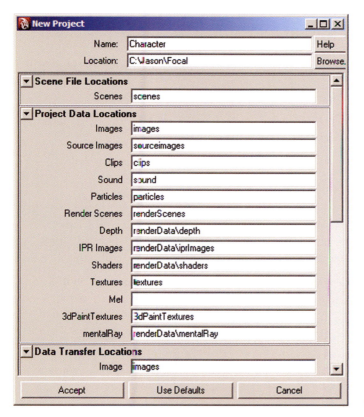

FIGURE 1-5 Project settings.

For a long while, polygons were relegated mainly to video game work. For that use they excelled. The higher number of polygons needed to achieve photorealism proved to be prohibitive for film work. Thus NURBS were used extensively at many film houses.

FIGURE 1-6 Polygon sphere on left. NURBS sphere on right.

Notice that the polygonal sphere has blocky edges. In years past, the amount of extra polygons needed to render polygon objects with smooth edges similar to those of a NURBS object would have taken too many polygons to be feasible and useable on high-resolution film projects. The render times would have been too high. The nature of NURBS surfaces allowed for very organic characters that would fit within the rendering budgets. With NURBS, though, came the extra difficulty needed in working with the surfaces. Surface patches could lose their stitching during rigging and animation. Surfaces also had to be properly parametized for texturing, and surface trims had to be dealt with if holes were needed in the model. Polygons, on the other hand, had none of these drawbacks. Their one disadvantage was the incredibly high number of polygons needed for organic characters. Polygons could be made of a single mesh. UVs could be edited independently of the model. And polygons could contain holes in the mesh as desired. Not only that, but polygons were usually much easier for new artists to learn how to use for modeling.

That has all changed now. Within the last few years, more powerful computers allow for the incredibly high amount of polygons needed for photorealistic film projects. This was a huge turning point for polygonal modelers. Now they could apply their work on film projects as well as video games.

That being said, keep in mind that there are still plenty of times where other modeling approaches will be useful. While NURBS have fallen out of favor for character modeling at most companies, they are still very useful for hard surface modeling. Vehicles are a perfect example of the type of hard surface model that many artists create using NURBS. The panel type construction of most vehicles lends itself very well to object creation using NURBS curves and surfaces. Also, because the models are hard surfaces and won't deform, there is no danger of gaps appearing where the different surfaces meet. If you need a vase, simply create a curve outline and revolve it. Eyeballs are another good use of NURBS; the surfaces are ready to accept textures, no UV editing required.

FIGURE 1-7 A simple vase.

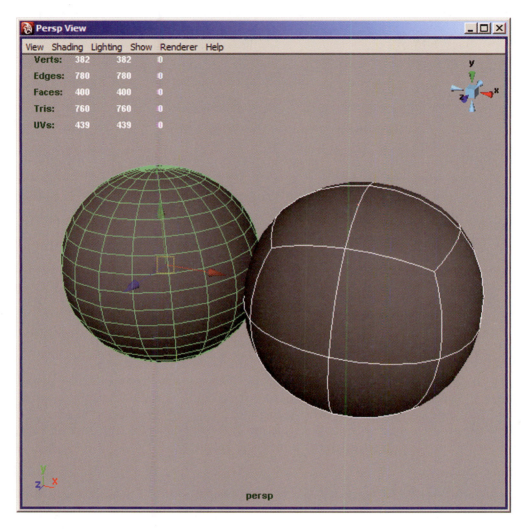

FIGURE 1-8 Polygon sphere on left and subdivision sphere on right.

Maya also comes with Subdivision Surfaces. If a production pipeline includes displacement maps, then most likely subD surfaces will be included in the mix. SubD surfaces generally produce better results than polygons when using displacement maps. When working with displacement maps, most artists will generally create the model with polygons because of the ease of working with them and then convert the model to subD surfaces prior to rendering. Not to worry, we'll cover subD surfaces in depth later in the book.

Maya

Overview of Maya

Maya is at the forefront of 3D graphics. The newest version of Maya has a host of new features and improvements to help the modeler achieve amazing results.

Before we move into modeling let's go over some guideline we want to stick with to ensure clean models. These are concepts to follow when dealing with all models, be it a low polygon monster or a photorealistic human.

- *Use quad polygons*: A quad is a four sided polygon. Quad polygons are generally easier for everyone to work with. Quads subdivide in a predictable manner. It is easier for a character rigger to paint weights on quads. It is also easier for the texture artist to paint images with minimal stretching. If you need to terminate an edge loop, hide the triangle in a part of the mesh that is in an inconspicuous place that won't deform. Any triangle used needs to be kept to an absolute minimum. Polygons with more than four sides (*n*-gons) cannot be used.

- *Uniformly spaced topology*: By uniformly spacing the polygons you will be making everyone's job easier. Uniformly spaced models will subdivide in a predictable manner. Uniform topology has less texture stretching then unevenly spaced mesh so it is easier for the texture artists to create images. It's also easier for the character rigger to set up the model because the weights are much easier to distribute evenly across the model.
- *Model your edge loops according to the muscles*: An edge loop is a path of connected polygons. By having the edge loops follow the muscles, the character will deform much better when animated. Proper edge loops also allow you to add extra detail only in sections of the model where needed.

While this book is intended for users with experience using Maya, it should be noted that in this chapter I cover information that is important in setting up a proper workflow. Some of this may be old news for the more seasoned users. If it is, feel free to jump ahead to the information on the new tools available in Maya later in this chapter.

The Window menu is where you set the Maya scene preferences. It's very important that before you begin working on your model you have all of your preferences set correctly.

1. Go to Window>Settings/Preferences>Preferences to bring up the Preferences window.
2. Click on Settings and set the World Coordinate System to Up Axis Y. Leave the other Settings options at their default. Maya uses centimeters for its internal measurements so working in centimeters makes sense. Most people write scripts based on the default settings of Maya. It usually won't be an issue, but better to be safe. If you need to convert to inches, simply divide the number of centimeters by 2.5 to get the total in inches. Most production houses use Y up world coordinates so you'll be making things much easier for yourself by setting your axis correctly to begin with.

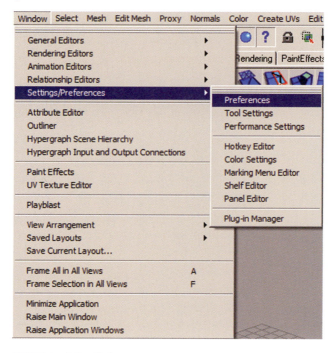

FIGURE 2-1 Settings/Preferences.

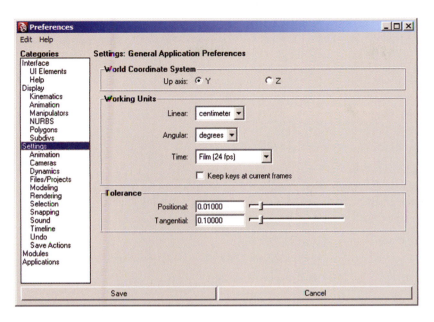

FIGURE 2-2 The default Preferences window.

3. Click on Cameras. I always uncheck Fit View and Fit View All under the Animated Camera Transitions section. Some people like this feature. Personally, I don't care for animated transitions. When I am cruising along modeling, the last I want to do is wait for the animated camera to finish its thing.

FIGURE 2-3 Camera preferences.

4. Click on Selection. In the Polygon Selection section, select Whole Face. The default polygon face selection is Center, which is fine most of the time. But occasionally on very small faces, the center selection box is very difficult to click. By changing to whole face selection this won't be a problem.

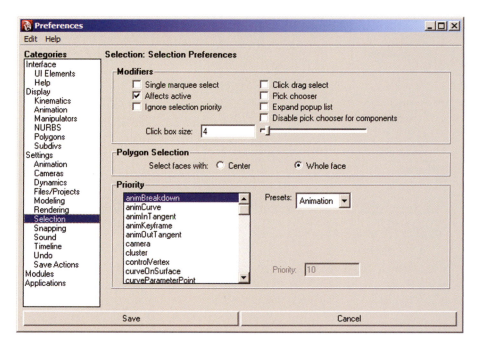

FIGURE 2-4 Selection preferences.

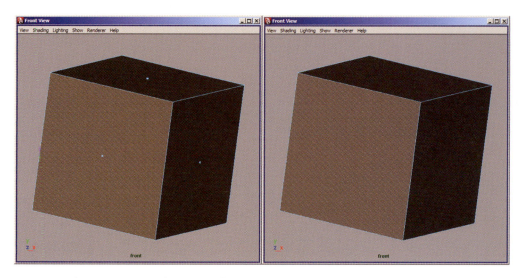

FIGURE 2-5 Polygon center selection (left) versus whole face selection.

Next uncheck Interactive Creation under the Create>
Polygon Primitives window. Interactive Creation allows
you to create a model anywhere you desire by clicking on
the screen and dragging with your left mouse button. For
creating a character, though, you need to have the model
centered on the YZ axis. You also need to make sure Keep
Faces Together is checked. This option keeps adjacent
polygons that are extruded at same time welded together.
To enable click Edit Mesh>Keep Faces Together.

If Keep Faces Together is off it will insert a new face
between adjacent polygons during each extrude
operation. Generally this is undesirable with character
creation.

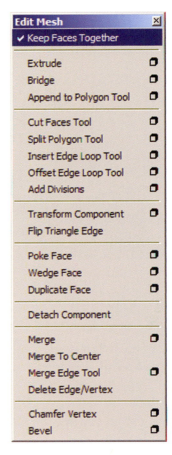

FIGURE 2-6 Keep Faces Together.

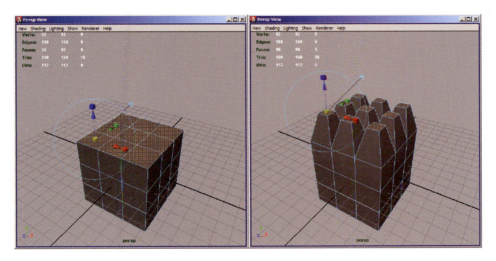

FIGURE 2-7 A cube with Keep Faces Together turned off.

FIGURE 2-8 The same cube with Keep Faces Together turned on.

Now that all of the preferences are set, let's look at the polygon modeling tools of choice and the new tools available in Maya.

You'll note that Maya has a revamped interface. Chief for us is that all of the polygon tools have been moved to a new Polygons menu set. The Polygons menu is set up with more logic now. All of the tools are now very easy to find. This should help speed up productivity.

FIGURE 2-9 Polygon menu set.

The Toolbox has a new permanent addition: the Paint Selection Tool (Edit>Paint Selection). This tool allows you to pick components by painting your selection. This can save a huge time over manual section using the marquee tools.

When used in conjunction with Quick Select Sets, you only have to select complex component groups once.

1. Right mouse click on an object and select the desired component (vertex, face, or edge) type.
2. Click the Paint Selection icon in the toolbox.
3. Paint the desired selection. This can be vertices for manipulation, faces for texturing, etc. The paint selection tool will only paint the visible side of the mesh.

FIGURE 2-10 *The Toolbox.*

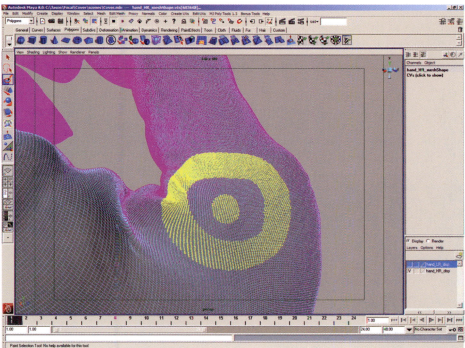

FIGURE 2-11 *Complex selection.*

4. With the components still selected, click Create>Sets>Quick Select Set. Keep in mind that quick select sets work with more than just components. They work with most nodes in Maya. This can really help organize your scenes.

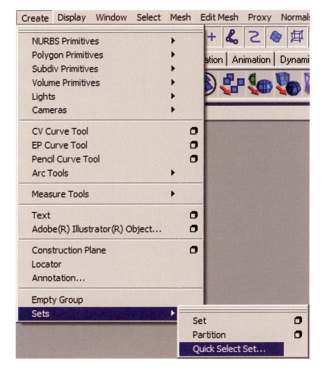

FIGURE 2-12 Creating a quick select set.

5. At the prompt type in a name for the quick select set.

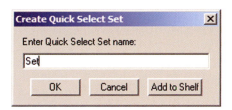

FIGURE 2-13 The quick select prompt.

6. Anytime you need to select the set, go to Edit>Quick Select Sets and select the desired set.

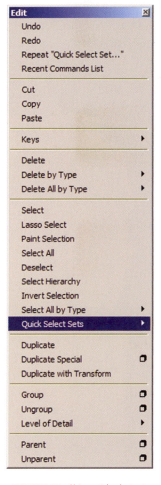

FIGURE 2-14 Using quick select sets.

Still in the toolbox is the updated Soft Modification Tool. The soft mod tool is an incredibly powerful tool for modeling. The soft mod tool now displays a color image of the falloff amount. No more guesswork. The brighter colors have a stronger deformation than the darker areas.

FIGURE 2-15 Soft modification tool.

Click on the tool manipulator to switch to edit mode. Select and adjust the red manipulator to adjust the falloff amount. You can even move the modification position by translating the manipulator.

All of the component extrude operations now function under one command. Gone are extrude face, extrude edge, and extrude vertex from earlier versions of Maya. Now simply click Edit Mesh> Extrude to extrude the selected component type.

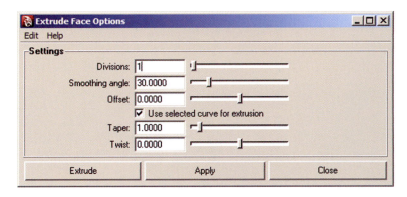

FIGURE 2-16 Extrude options.

Most of the time, you'll extrude using the default settings. But don't forget about the options available in the extrude options. Taper and twist are very useful in creating things like horns.

1. Click Create>Polygon Primitives>Cube to create a default cube.
2. In the front view click Create>EP Curve Tool to create an edit point curve that begins at the center of the face and follows the shape of a horn.

FIGURE 2-17 Adding a curve to extrude along.

3. Select the face and shift select the curve. By shift selecting the curve, you're telling Maya that the next extrusion will follow the curve.

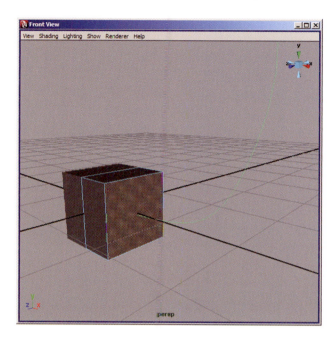

FIGURE 2-18 Face and curve selected for extrude operation.

4. Click Edit Mesh>Extrude. Usually I like to keep tool settings at the default and will change them later in the Channel Box or Attribute Editor. You can interactively change the settings this way, which makes it much easier to get the desired results.

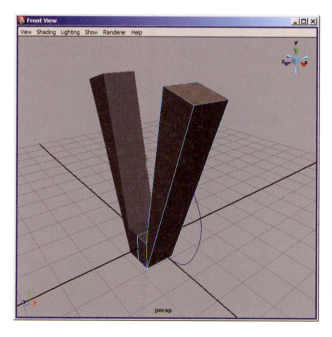

FIGURE 2-19 Default extrusion along a curve. Notice how the face extrudes to the end of the curve.

5. Open the Channel Box to view the extrude operation. If you accidentally deselect the object, you can select the object and click the extrude node in the INPUTS section of the Channel Box.

6. Add some division levels to subdivide the horn. To change a channel's value, select it in the Channel Box with the left mouse button, then press the middle mouse button and scrub left and right in the modeling windows to interactively adjust the number.

FIGURE 2-20 Extrude options viewed in the Channel Box.

FIGURE 2-21 Scrubbing channels to interactively change the object.

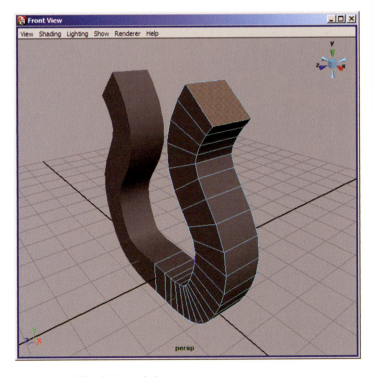

FIGURE 2-22 Adding divisions to the horn.

7. Adjust the Twist and Taper values until you get a nice spiraling horn. Here I set the Twist value to −180 and the Taper to 0.

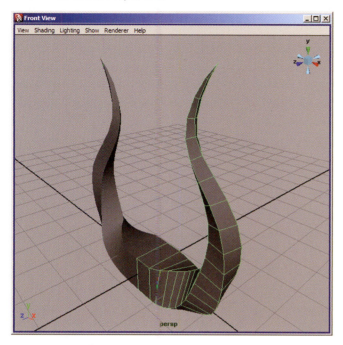

FIGURE 2-23 Adding Twist and Taper to the horns.

8. History is still intact on the horn so you can still make adjustments to the shape by right clicking on the curve and moving the edit points around.

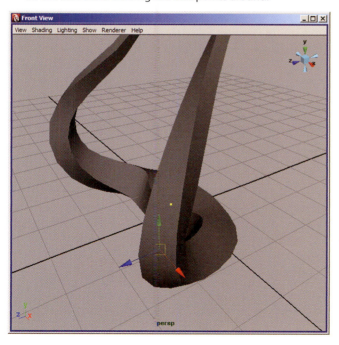

FIGURE 2-24 Manipulating the curve after creation.

9. If desired, you can smooth the horns by selecting the object and clicking Mesh>Smooth.

FIGURE 2-25 *Final smoothed horns.*

The edge loop tools have also been strengthened with the addition of the Offset Edge Loop Tool and Slide Edge Loop tools. The Offset Edge Loop Tool creates two new edges evenly spaced between the selected edge and the adjacent edge on either side. The Slide Edge Loop Tool allows you to adjust the position of edge loops by sliding them across the mesh. Proper edge loop modeling is vital for clean topology. Edge loops make it easier to layout the UVs. They also make it easier for the character TD to rig a model for proper deformation during animation.

While polygons have become the format of choice for organic modeling, don't overlook the value of subdivision and NURBS tools. Most pipelines are built around polygons these days, but there are still some instances where the other modeling formats are still useful.

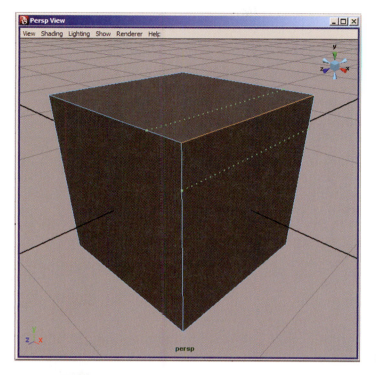

FIGURE 2-26 Offset edge loops.

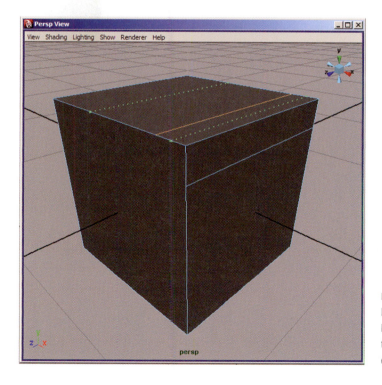

FIGURE 2-27 Offset edge loops between different sized polygons. Notice how the tool evenly spaces the new edges between the adjacent edges on either side.

Subdivision surfaces handle displacement maps better than polygons. Because of that, most artists, when using displacement maps, will convert polygons to subdivision surfaces at render time. We'll be covering this process later in the book.

NURBS can also be used in a polygonal modeling pipeline. For instance, I almost always stick with a simple NURBS sphere when creating an eyeball. Because NURBS have imbedded texture coordinates there is little editing that needs to be done when applying the pupil textures. By converting a NURBS object to polygons using the proper settings, an artist familiar with NURBS modeling can work with the tools they know and still deliver the required polygonal characters.

1. Create a NURBS sphere Create>NURBS Primitives>Sphere. Make sure Interactive Placement is unchecked. The NURBS sphere will act as the eye.
2. Rotate the sphere 90 degrees on the X axis. This will point the pole of the sphere forward on the Z axis. This can then be used as the pupil of the eyeball.

FIGURE 2-28 Placing the eyeball.

3. Click on Create>NURBS Primitives>Circle.
4. Name the circle eyeCurve1 and rotate it 90 degrees on the X axis and place it in front of the sphere.

FIGURE 2-29 Adding the first curve.

5. In the front viewport, right click on the curve to go into component mode and adjust the control vertices into the desired shape of the eye.

FIGURE 2-30 Changing curve shape.

6. In the side and perspective views, adjust the control vertices of the curve so they conform to the shape of the eye. This will be the inside of the eyelid.

FIGURE 2-31 Adjusting the shape of the curve.

7. Duplicate the curve and scale it down slightly. Name the new curve eyeCurve2. To properly build the surface, all curves need to have the same number of control vertices. By duplicating the original curve, keeping the same CV (control vertex) count is very easy.

8. Move eyeCurve2 forward to help form the section of the eyelid where the lashes sit.

FIGURE 2-32 Adjusting the second curve.

9. Duplicate eyeCurve2 and name it eyeCurve3. Move the new curve forward a small amount, and scale it slightly up. By starting with these three curves, depth is given to the eyelids.

FIGURE 2-33 The third curve of the lid.

10. Duplicate eyeCurve3, name it eyeCurve4 and scale it up to start forming the surface around the eye. Use the CVs to start rounding out this curve.

FIGURE 2-34 The third curve of the lid.

27

11. Duplicate eyeCurve4 and name it eyeCurve5. Scale this curve up and continue shaping it to add to the shape around the eye.

12. Duplicate eyeCurve5 and name it eyeCurve6. Scale this up and continue shaping the curve. Your curves should be placed similar to Figure 2-35.

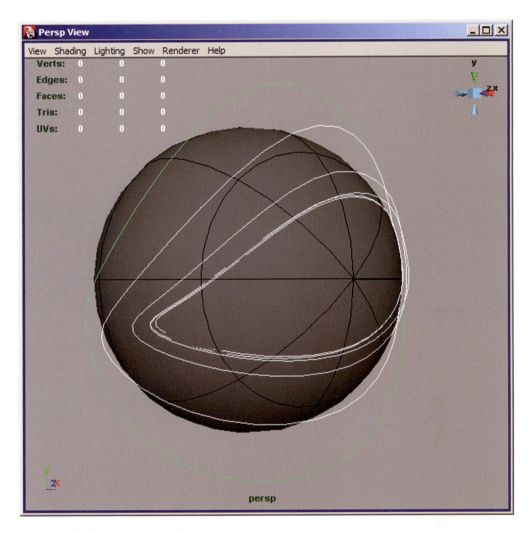

FIGURE 2-35 Final curve placement around the eye.

13. Starting with eyeCurve1, select all of the curves in order. The curves need to be selected in the right order or the surface will not come out correct.

14. With the curves still highlighted, click Surfaces>Loft>□. Set the options according to Figure 2-36 and press Loft. Chord length parameterization creates better curvature on new surfaces. Auto reverse will help prevent twisting of the new surface that can arise if any of the

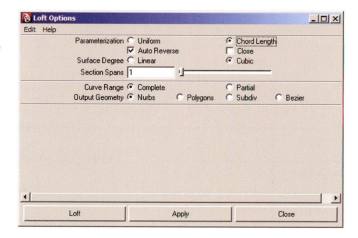

FIGURE 2-36 Loft options.

curves are running in different directions. Cubic surface degree results in a smooth surface, whereas linear gives a faceted appearance. The section spans change the number of sections in each span of the surface. Keeping this set to 1 allows you to work with smaller amounts of detail. Always start small and work in the extra detail later.

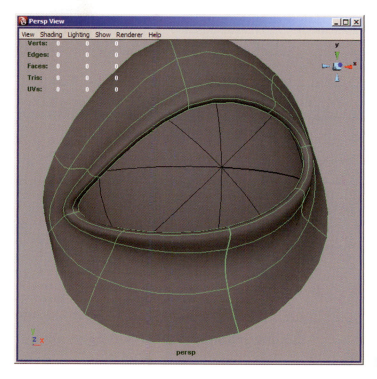

FIGURE 2-37 The resulting surface.

15. Now to convert the surface to polygons. Click on Modify>Convert>NURBS to Polygons>□. Set the options according to Figure 2-38 and press Tessellate. If you have multiple patches, you can check Attach multiple output meshes. Our object is only one surface so it can be left unchecked. Change the Type to Quads and the Tessellation method to General. This will allow us to better control the resulting polygonal mesh. Under Initial Tessellation Controls set both the U and V type to Per span # of iso params and the Number U to 2 and Number V to 1. This will allow us to control exactly how many polygons will be added to each span in the U and V directions of the surface. In this case each span will have two polygons created in the U direction and one in the V. Leave the other options at the default.

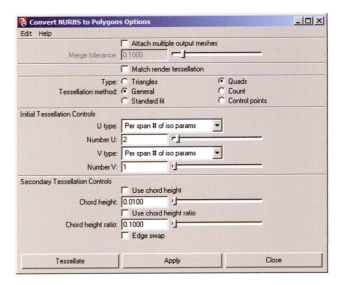

FIGURE 2-38 NURBS to polygons options.

FIGURE 2-39 Surface converted to polygons with good clean quad topology.

Another very powerful modeling aid is the use of animation deformers. By applying deformers to a mesh, the object can quickly be changed in ways that would be too difficult or take too long using traditional methods.

1. Create a polygon cylinder with a height of 6 and a subdivision height of 20.
2. Select the cylinder and click on Deform>Create Nonlinear>Bend. This will add a deformer to the mesh.

FIGURE 2-40 Nonlinear deformers.

FIGURE 2-41 Bend deformer.

3. If the deformer is oriented in the wrong direction, you can select it in the outliner and rotate to the correction position.

FIGURE 2-42 Locating the deformer in the outliner.

4. Adjust the bend deformer options in the channel box. Curvature will bend the cylinder in a way that would take forever using other methods. Low bound and high bound adjusts where the bend effect starts and stops affecting the mesh from the bottom and top, respectively.

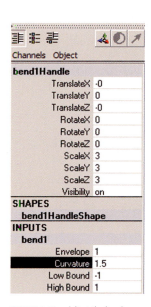

FIGURE 2-43 Adjust the bend options. Here the curvature is set to 1.5.

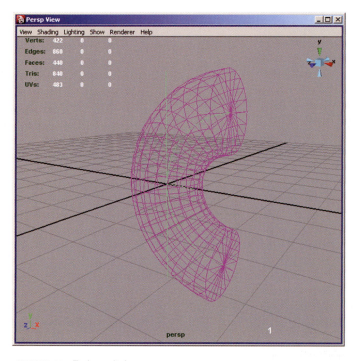

FIGURE 2-44 The bent cylinder.

Experiment with the other nonlinear deformers. Test the different channels for each type. As soon as the changes are acceptable, you need to select the mesh and delete its history by clicking Edit>Delete by Type>History. Deleting the history will remove the deformer while keeping the mesh in its bent state.

The other type of deformer useful for modeling is the lattice. Creating a lattice places a low-res cage that surrounds the selected object. You can then manipulate a high-res object using the lower number of points in the lattice.

1. Create a sphere with the subdivisions along the axis and height to 80.
2. With the sphere selected, click Deform>Create Lattice. This will place a low-res cage around the sphere.

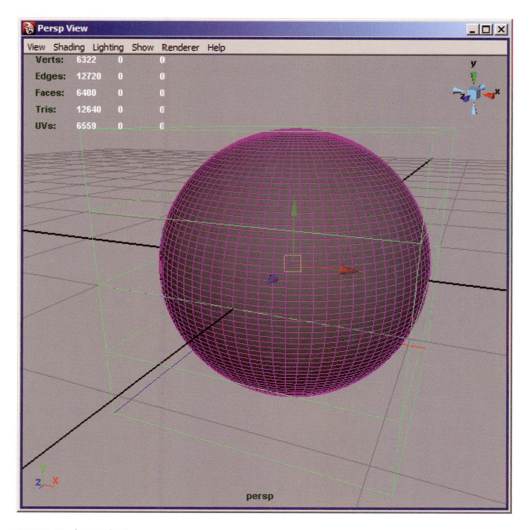

FIGURE 2-45 *Creating a lattice.*

3. Right mouse click on the lattice and select Lattice Point.
4. Select and move the lattice points until you get the desired shape. Notice how moving one lattice point adjusts a large number of vertices on the main object.

FIGURE 2-46 Adjusting the lattice.

5. If you need more lattice points, click the lattice and adjust the S, T, and U divisions to the desired amount of the lattice shape node in the channel box. Remember anytime you see S, T, and U it is equivalent to X, Y, and Z.

6. If you've already changed the lattice, you will need to click Deform>Edit Lattice>Remove Lattice Tweaks before you can add extra divisions.

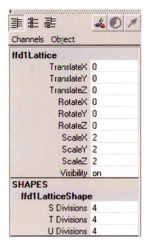

FIGURE 2-47 *Adding extra divisions to the lattice.*

FIGURE 2-48 *The higher resolution lattice.*

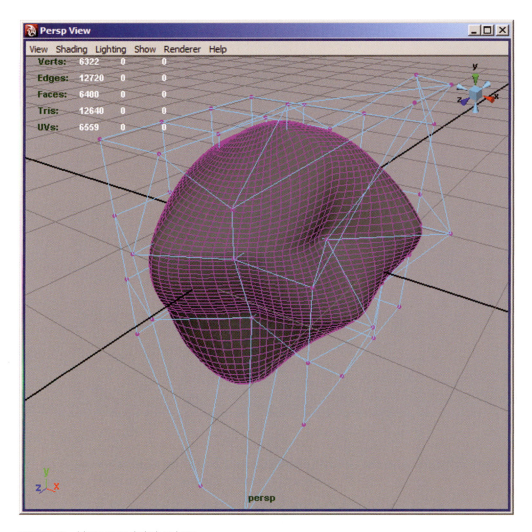

FIGURE 2-49 *Adjustments to the high-res lattice.*

7. After you're finished using the lattice you will need to select the mesh and delete its history.

Before you begin modeling, you'll want to have concept sketches and a minimum of front and side orthographic views of the character you plan on building. The concept sketches are for visual reference during model construction. The orthographic views, though, will be used directly in Maya to help you create your model. First, you will need to scan your orthographic drawings. Next, you will need to bring the scanned images into Maya for use as a template to build your model.

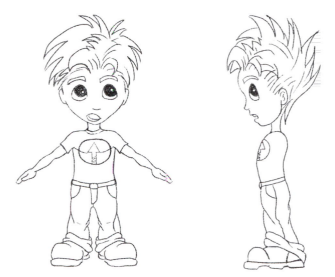

FIGURE 2-50 Front and side sketches of a character ready for construction.

1. Create a new scene by clicking on File>New Scene.
2. In the front viewport select View>Image Plane>Import Image.

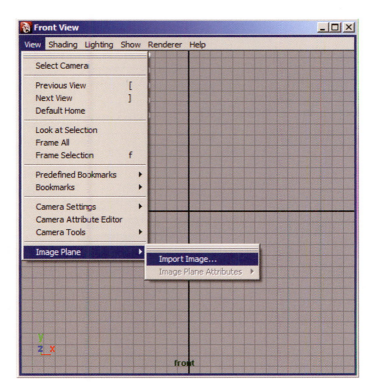

FIGURE 2-51 Loading an Image Plane.

3. At the prompt, select the front view of the character to load it as a template image.
4. In the side viewport select View>Image Plane>Import Image.
5. At the prompt, load the side view sketch of your character.

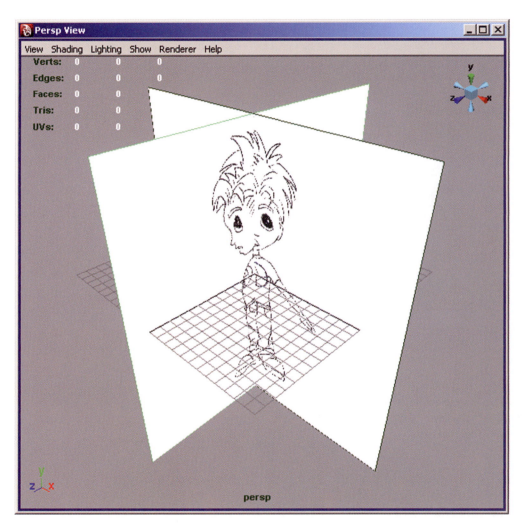

FIGURE 2-52 Template geometry.

6. Go to Display>UI Elements>Channel Box/Layer Editor to bring up the Channel Box or click the show Channel Box/Layer Editor button on the Status Line.

7. Press the Show the Channel Box and Layer Editor button near the top of the Channel Box/Layer Editor window.

8. Click on the Display radial.

9. Select Layers>Create Layer in the Layer Editor. Name the layer templateDisplay.

FIGURE 2-53 Show Channel Box and Layer Editor.

FIGURE 2-54 Creating the display layer.

10. Select the newly created layer.

11. Drag select the two planes in the Perspective view.

12. In the Layer Editor, select Layers>Add Selected Objects to Current Layer.

13. Select the front image plane in the perspective viewport. By default the image planes are created at the center of the world. This makes it very difficult to model. Fortunately this is fairly easy to correct.

14. Select the imagePlane input node in the INPUTS section of the Channel Box.

15. Adjust the CenterZ channel so the image plane won't interfere with your modeling. Remember, that in most cases, you should model with your character facing forward into the +Z axis so that would mean adjusting the CenterZ into negative values.

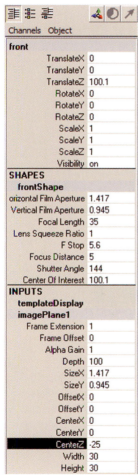

FIGURE 2-55 Offsetting the image planes.

39

16. Select the side image plane in the perspective viewport.

17. Select the imagePlane input node in the INPUTS section of the Channel Box.

18. Adjust the CenterX channel so the image plane won't interfere with your modeling. This time the CenterX channel should be adjusted into the −X values.

19. Click the middle box of your Layer until it displays an R. Now the image planes can't be accidentally selected if you're working in the perspective view. If you need to open the layer for editing at a later time, simply click the middle box of the layer until it is empty.

20. Now you can go back to your scene and begin modeling. If you need to hide the template objects for any reason, click V in the first box of your layer until it is empty. This will turn off the layer visibility and hide any objects within it.

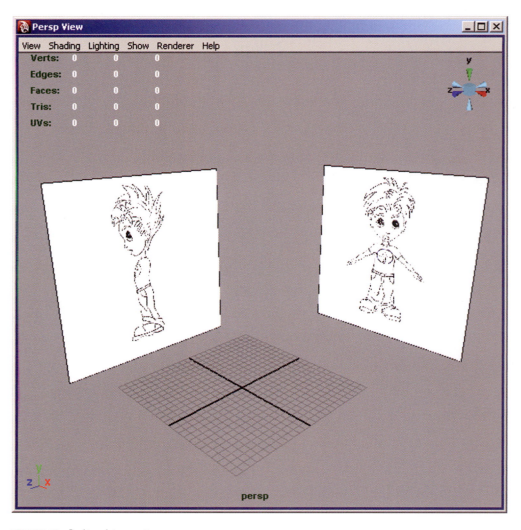

FIGURE 2-56 Final template geometry.

It's time to begin modeling the character. The first stage is called blocking. Blocking means creating a basic frame for your character. I can't stress enough how essential it is to start simple and add detail later. If you try to start with a dense mesh, editing the character later will become very difficult. Something very important to remember is that when you add vertical edge loops, they will travel through multiple sections of the character. The tutorials are presented in a step-by-step fashion so that is hard to take that into account. As you become more familiar with modeling you will probably want to shift around and do some basic shaping in all of the affected areas anytime new vertical edge loops are created.

1. Open your template.
2. Make sure Edit Mesh>Keep Faces Together is checked. This option will keep extra polygons from being created in between adjacent polygons during extrude operations.
3. Click Create>Polygon Primitives>Interactive Placement to uncheck and turn off this feature. Remember, all modeling should be done on the +X axis with the character facing forward into +Z. Interactive placement creates objects wherever you click in the viewport, not in the center of the world like we need.
4. Click Create>Polygon Primitives>Cube □. Set the Width divisions to 2 and click Create. Always start with a simple object and add detail as needed. I can't stress this enough. If you add detail too quickly the mesh will become very hard to edit later. That makes a cube, which is one of the simplest of polygon meshes, the perfect primitive to begin modeling with.

FIGURE 2-57 Cube settings.

5. Select the polygon faces in the −X axis and delete them.

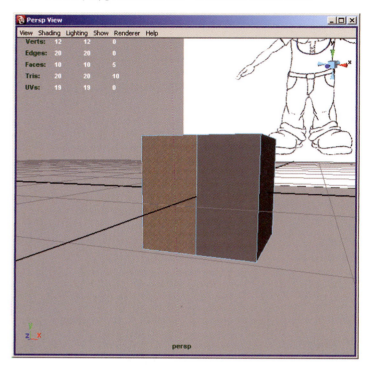

FIGURE 2-58 Faces to delete.

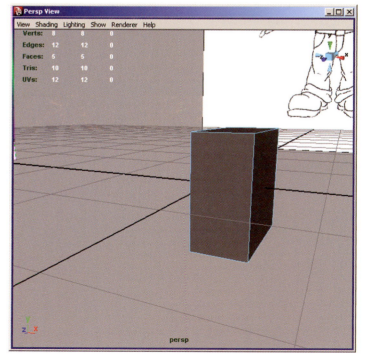

FIGURE 2-59 Deleted faces.

6. Select the remaining half cube.
7. Click Edit>Duplicate Special □.
 Set the Geometry type to
 Instance. Change the X scale
 to −1. Press apply. Making a
 negative instance of the half cube
 creates a mirror of the object that
 will update with any changes
 made to the original half. By
 doing this, you work on half the
 object, but in the end get a full
 model. Half the work to get a
 complete model; always a good
 idea.

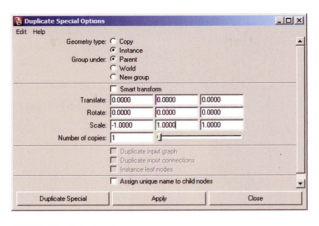

FIGURE 2-60 Duplicate options.

Note: Anytime you see columns
in Maya, the first one represents X, the middle one is Y, and the last one is Z.

8. Using only component mode, position and scale the half cube so that it fits the character's
 chest area. By using component mode to adjust the model, the instanced half will update along
 with the changes to the original half. The center vertices can move on the Y and Z axes, but it's
 vital not to move them in the X direction. Doing this would cause holes to appear in the model.

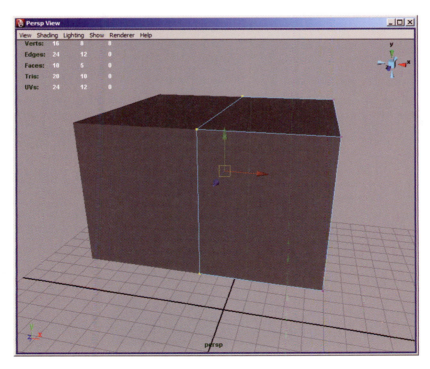

FIGURE 2-61 Don't move these vertices on the X axis.

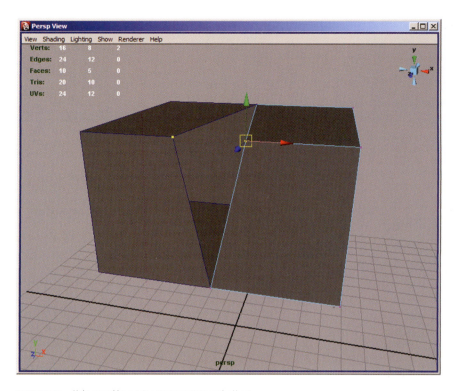

FIGURE 2-62 Hole caused by moving center vertices on the X axis.

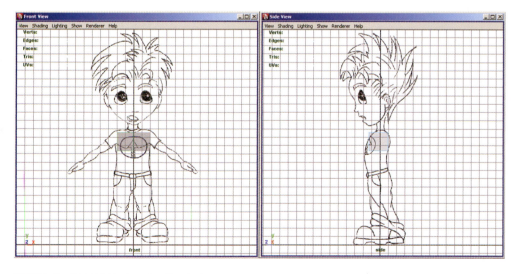

FIGURE 2-63 Front and side views of positioned cube.

9. Select the bottom face.

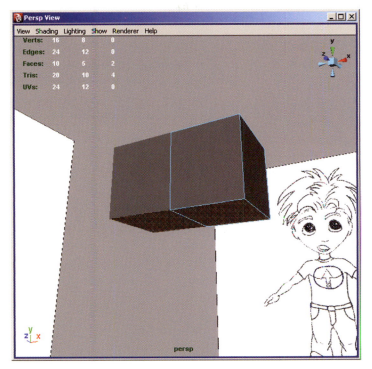

FIGURE 2-64 Bottom face to be extruded.

10. Click Edit Mesh>Extrude and the tool manipulator will appear. The extrude tool has two modes: local space and world space. The default, local space will extrude in the direction the polygon is currently facing. World space will extrude in the XYZ direction of the main world coordinates.

FIGURE 2-65 The extrude tool.

11. Click the blue manipulator to switch the extrusion to world space.
12. Extrude this face down to the center of the belly. It's important to add detail in small amounts to keep the mesh easier to work with. The extrude modeling method that we use is really good for that.

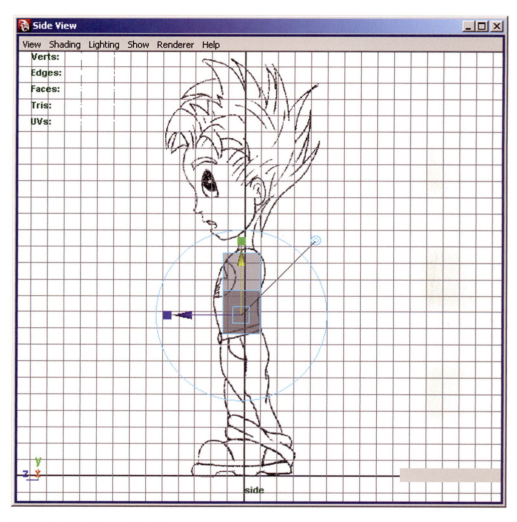

FIGURE 2-66 Extrude to center of the belly.

13. You will notice that anytime you extrude along the center YZ axes, a polygon is added. This needs to be deleted. Anytime a face is created in an area that lies hidden within the boundary of the mesh, it should be deleted or it can cause problems with the geometry later.

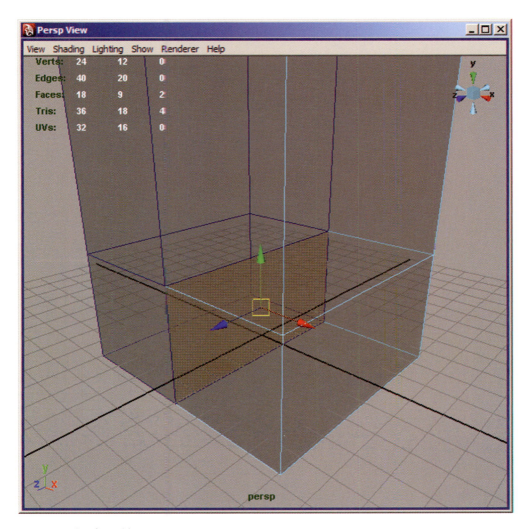

FIGURE 2-67 Extra face to delete.

14. Again select the bottom face and extrude to the bottom of the crotch.

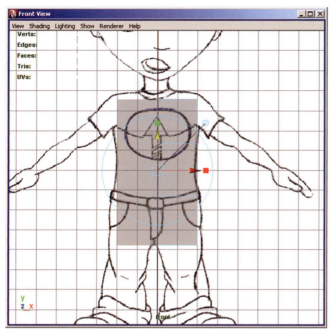

FIGURE 2-68 Extrude to the bottom of the crotch.

15. Select the new face that is created in the center on the YZ axes and delete it.

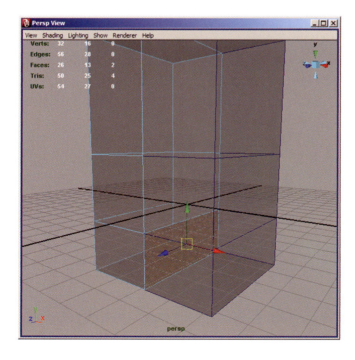

FIGURE 2-69 Delete this face too.

16. Begin shaping the torso by pushing and pulling the vertices and edges into place. It's very important to start shaping the mesh while it is still of low resolution.

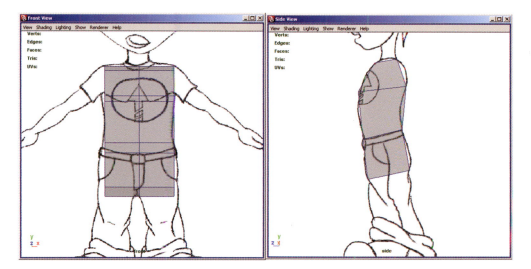

FIGURE 2-70 The torso taking shape.

17. Select the bottom outer edge and move it in to form the crotch. This is very important in allowing us to get proper edge loops in the legs.

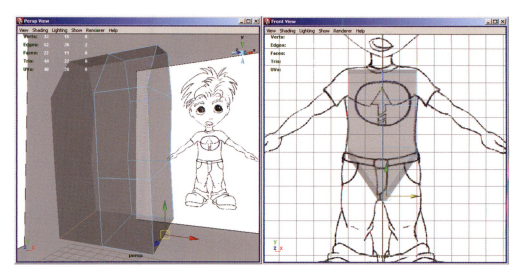

FIGURE 2-71 Move this edge to form the crotch.

18. Select the face that forms the hip.

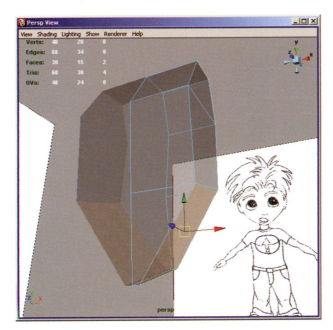

FIGURE 2-72 The newly created hips.

19. Extrude this face down in world space to form the beginning of the thigh. This is a crucial step in getting the edge loops to flow properly through the legs. Note the inner thigh is formed in this step.

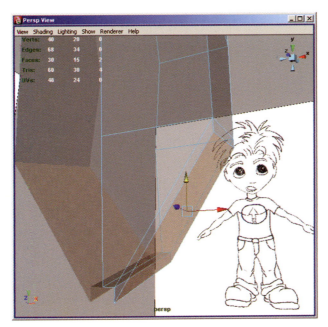

FIGURE 2-73 Blocking out the thigh.

50

20. Now the outer thigh needs to be set. To do this, adjust the outer vertices of the newly created polygon so it matches the thigh of your template.

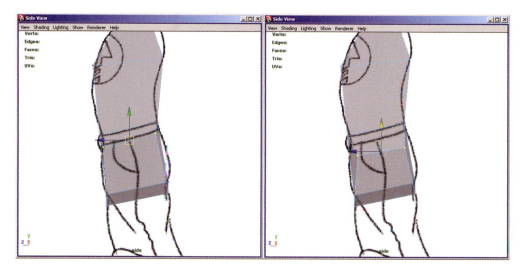

FIGURE 2-74 Continuing to block out the thigh.

21. Next select the outer vertices of the thigh and pull them down in the front view. This is another step in forming the legs that will have proper edge loops.

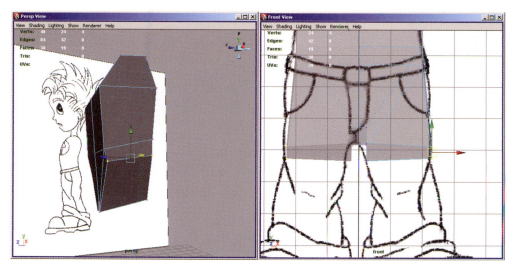

FIGURE 2-75 Pulling down the vertices of the thigh.

22. Select the bottom face of the thigh and extrude to the top of the knee.

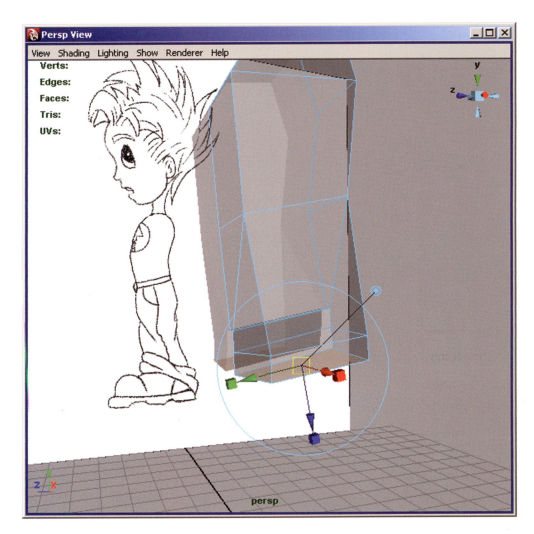

FIGURE 2-76 Extrude bottom of the leg faces to top of the knee.

23. Extrude the new face to the bottom of the knee. It's very important to add extra edges around the joints so they will have enough polygons to deform correctly.

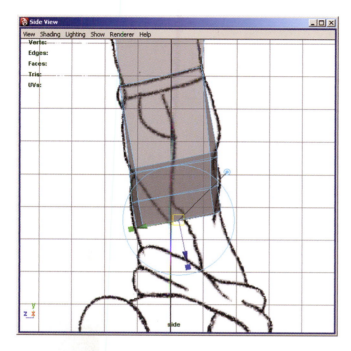

FIGURE 2-77 Extrude the new face to bottom of the knee.

24. Extrude this new face to the ankle.

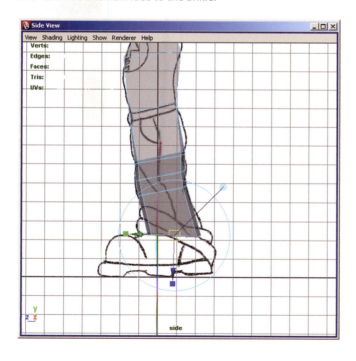

FIGURE 2-78 Extrude to the ankle.

25. Next you need to start forming the foot. Extrude the ankle to the bottom of the foot. Check the front and side viewports to make sure that the new foot is aligned correctly.

FIGURE 2-79 Blocking out the foot.

26. Now you need to move the back of the heel out. Simply select the rear bottom edge of the foot and slide it over. The heel is a bit on the outside when compared to the rest of the foot. This is one of those little steps that can add a ton of realism to your character.

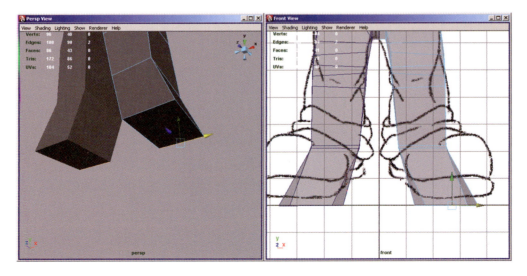

FIGURE 2-80 The heel.

27. Select the front face below the ankle and extrude forward to the ball of the foot. Make sure it matches the foot from the reference image.

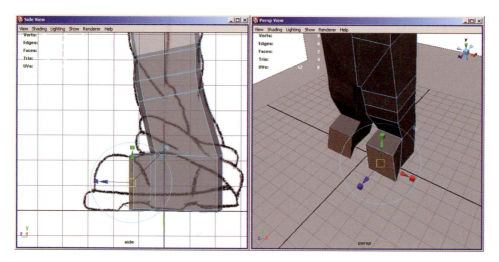

FIGURE 2-81 The mid-section of the foot.

28. Extrude the front face of the ball forward to create the toe.

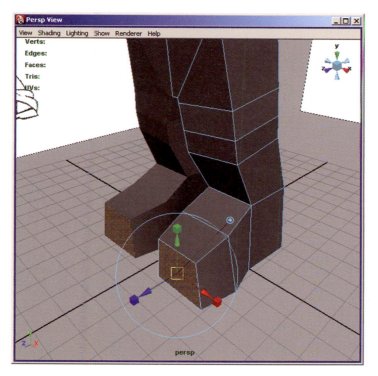

FIGURE 2-82 Creating the toe.

29. Use Edit Mesh>Insert Edge Loop Tool to create a new edge loop in the middle of the chest. Any time you add detail, you need to make sure to keep shaping the form of the character. Remember if you wait to start shaping the form, you will have a much harder time. At this stage, we've moved on to other sections of the body. It's a good idea to work out the basic form for the entire character in the first pass. That way, when you begin adding more edge loops, they will travel correctly through the body.

FIGURE 2-83 Splitting the chest.

30. Next we need to start pulling out the arms. Select face on the side of the torso created from the newly added edge loop.

31. Extrude this face out and up to form the shoulder. Check the side and front views to help correctly shape the shoulder.

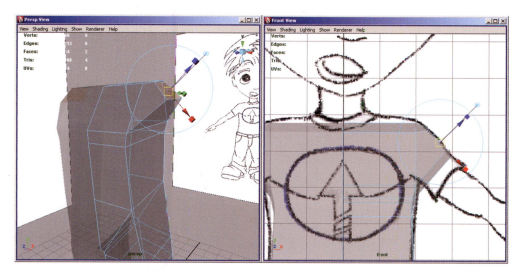

FIGURE 2-84 The shoulders.

32. Next select the bottom face of the newly extruded shoulder and extrude down to the elbow to create the upper arm. The reason for extruding the bottom face of the shoulder is that it gives us nice edge loops from the chest, around the shoulders, and into the back.

FIGURE 2-85 The upper arm.

33. Use Edit Mesh>Insert Edge Loop Tool to add an edge loop across the top of the chest and through the shoulders. We want to add the loop now so you can use component mode to manipulate the vertices and edges to round off the shoulders.

FIGURE 2-86 Rounding the shoulder.

34. Extrude the bottom face again to create the elbow. As you extrude the arm make sure to check all of the views to ensure it matches your reference images.

FIGURE 2-87 The elbow.

35. Make another extrude to the top of the wrist to create the forearm.

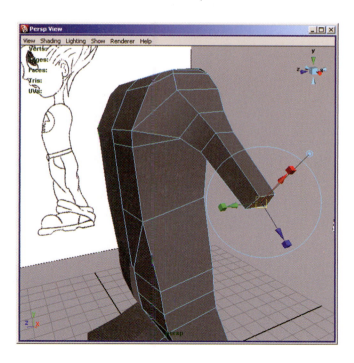

FIGURE 2-88 Creating the forearm.

36. Rotate the bottom face of the arm 90 degrees to add the twist of the forearm created by the ulna and radius bones.

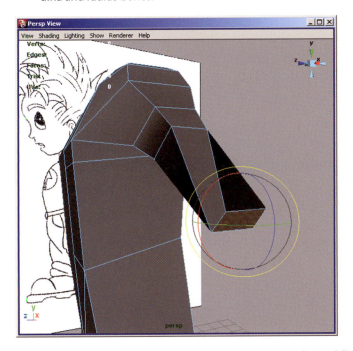

FIGURE 2-89 Creating the forearm twist.

37. Next using the Insert Edge Loop Tool, add a loop in the middle of the forearm.

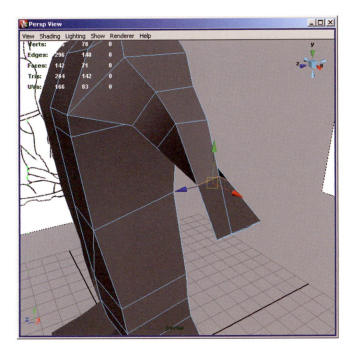

FIGURE 2-90 Adding a loop to the forearm.

38. Select the polygon at the end of the arm and extrude it out to mid-palm for the beginning of the hand. Tilting the face up can help in shaping the rest of the hand.

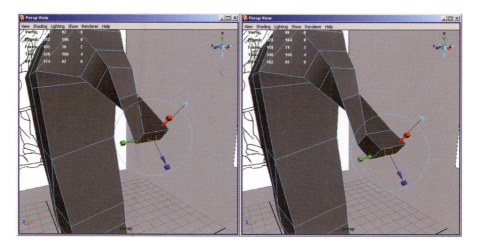

FIGURE 2-91 Starting the hand.

39. Use the Insert Edge Loop Tool to a vertical edge loop through the new face. The new edge loop will travel around the length of the arm.

FIGURE 2-92 Adding a vertical edge loop through the arm.

40. Add a second horizontal edge loop to the face. This edge loop will travel through the arm and down the side of the body. In this case that is good because it gives us some more detail to help round out the body.

FIGURE 2-93 Adding a horizontal edge loop through the arm.

41. Remember to keep rounding out the form as you add detail.
42. Select and extrude the two faces on the thumb side to continue forming the hand. This is the metacarpal bone of the thumb and it forms the base.

FIGURE 2-94 Extrude the side of the hand and create the base of the thumb.

43. Select and extrude the two faces on the pinky side to continue forming the hand. This actually becomes the hypothenar muscles (the fleshy pad) on the pinky side of the hand.

FIGURE 2-95 Extrude to form the fleshy pad on the side of the hand.

44. Using component mode, adjust the newly added polygons to the proper shape of the hand. As always you want to continue shaping the polygons as added.

FIGURE 2-96 Shaping the newly added polygons.

45. Select the faces at the end of the hand and extrude them to the middle of the palm.

Continue shaping as you work. The hand has an indentation in the palm, so you should adjust the new faces to account for this. Don't add any extra detail though.

FIGURE 2-97 Extrude to the middle of the palm.

46. Select the end faces of the hand and extrude out to form the rest of the palm.

FIGURE 2-98 Extrude to the end of the palm. Notice that the edges on the side have been pulled out to help round out the hand.

47. Using component mode, pull the vertices that form the base of the pinky finger back. If you look at your hand, you'll see that the base of the pinky is lower than the other fingers.

FIGURE 2-99 Pulling the base of the pinky finger back.

48. Click on Edit Mesh>Split Polygon Tool and create two new rows of edges that starts at the top of the hand, loops around the inside edge of the index finger, and extends to mid-palm. We need to add this split because the fingers have a natural gap in between them. This is one of the easier ways to create fingers.

FIGURE 2-100 Creating the finger separation.

49. This will leave you with two triangles that you'll want to clean up. To do this, simply select the edge in between the two triangles and delete it.

FIGURE 2-101 Changing the triangles to quads.

FIGURE 2-102 The split on the palm of the hand.

50. Create the finger separation for the remaining fingers.

FIGURE 2-103 Finishing the spacing of the fingers.

51. Now we can start extruding the fingers. The base of the finger forms the first, and largest, knuckle. Select the faces at the base of the index finger and extrude them out to the second knuckle. The finger tapers as it nears the tip so be sure to resize the faces down as extrude.

FIGURE 2-104 Extruding the first part of the index finger.

52. With the faces still selected, extrude out to the third knuckle.

FIGURE 2-105 Extruding the second part of the index finger.

53. Extrude the faces again out to the tip of the finger. At this point, don't worry about extruding the rest of the fingers. Once you've added extra detail, you'll actually duplicate the existing finger, thus saving yourself extra work.

FIGURE 2-106 Extruding the tip of the index finger.

54. Using component mode, round out the form of the hand and index finger.

FIGURE 2-107 Rounding out the hand and finger.

55. Now it's time to extrude the thumb. Select the faces that make up the base of the thumb. The outer face will form the first knuckle. The inside face extends onto the palm and forms the bulging muscles of the thumb. Extrude the faces down to the second knuckle and straighten the vertices.

FIGURE 2-108 Extruding the first part of the thumb.

56. With the faces still selected, extrude the faces again down to the tip of the thumb.

FIGURE 2-109 Creating the tip of the thumb.

57. Pull down the indicated vertices and edge to help form the shape of the thumb. The vertices pulled down on the outside help define the first knuckle. The edge pulled down on the inside forms the large muscle at the base of the thumb that extends onto the palm. You also want to round out the shape of the thumb.

FIGURE 2-110 Shaping the thumb.

58. The final part needed to block out your character is the head. Select and extrude the faces at the top of the torso and shape them as indicated in Figure 6-68. These polygons form the trapezius muscle.

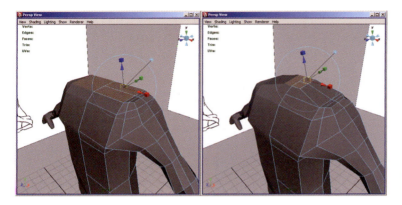

FIGURE 2-111 Extruding the trapezius.

59. Now select the faces of the top of the trapezius and extrude them up twice to form the neck and the start of the head.

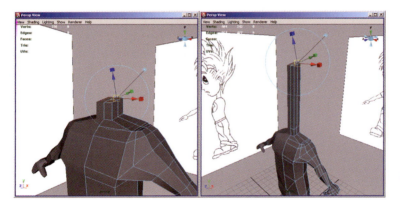

FIGURE 2-112 Extruding the neck and start of the head.

60. Select the faces on the front of the head and extrude them forward to create the face. Remember to adjust the vertices to round out the face.

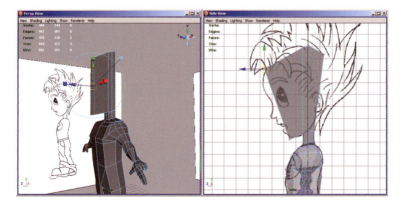

FIGURE 2-113 Creating the face.

61. Insert an edge loop through the eye and round out the polygons to finish blocking the head.

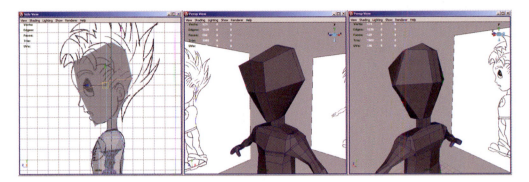

FIGURE 2-114 Blocking out the rest of the head.

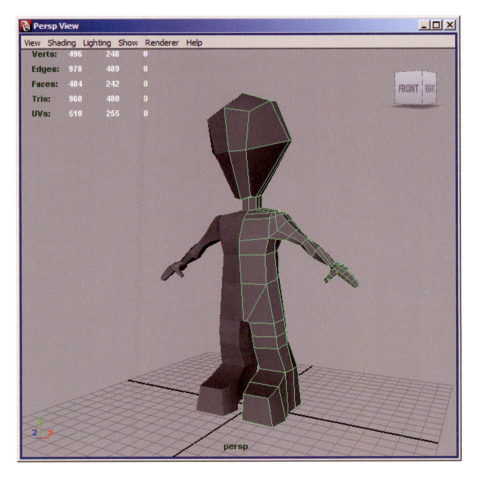

FIGURE 2-115 Final blocking of character.

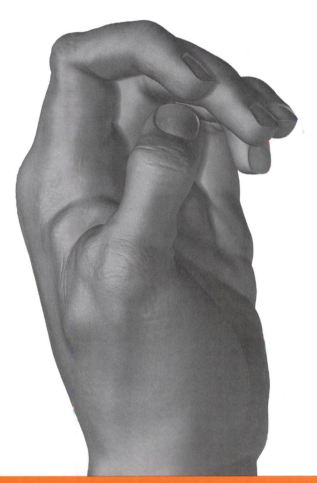

Introduction to ZBrush Modeling

So what exactly is ZBrush? ZBrush is Pixologic, Inc.'s 3D modeling and paint package. ZBrush uses brush-based sculpting to allow the artist to quickly add detail to models. Highly detailed models with millions of polygons can quickly be created. ZBrush uses technology known as Pixols. Pixols are pixels that retain the depth and orientation information after they are created. That means you can change the lighting and it will affect the shading of the Pixols.

Many artists coming over from other packages might find the single camera view a bit hard to get used to. But, after spending a bit of time navigating the interface, you'll find that it really lends itself to modeling and texture creation.

FIGURE 3-1 Pixologic website.

Pixologic also has one of the best online communities for artists called Pixolator. On this site, artists will post work for critique or even a how to.

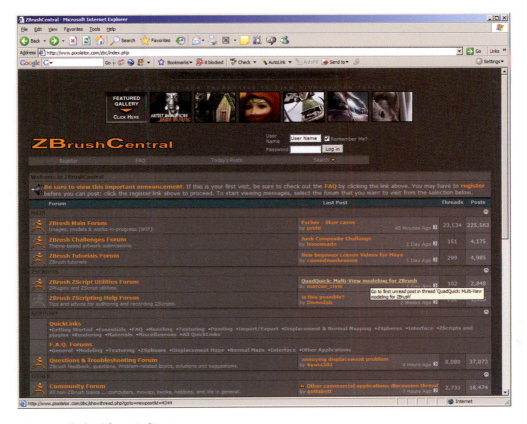

FIGURE 3-2 Pixologic's forum site, Pixolator.

Why is ZBrush in a character modeling book? Well, simply put, amazingly detailed characters can be created so easily in ZBrush that many artists and companies have incorporated the program into their modeling pipelines. Companies like Industrial Light & Magic, Luma Pictures, and Id Software have all started using ZBrush for movie and game projects like Pirate of the Caribbean 2: Dead Man's Chest, Underworld 2, and Doom 3.

As an artist, you have a tool at your disposal in ZBrush that allows you to create levels of detail in your characters that, until the program came out, was virtually unattainable. And because models are created in an intuitive way using brushes, most artists can quickly create incredibly detailed characters.

The first thing you will notice upon opening ZBrush is that it has a single viewport. This can take bit of getting used to if you're coming from a standard 3D package with four views like Maya.

FIGURE 3-3 ZBrush interface.

Just like in Maya, hotkeys will also help speed up your work in ZBrush. The default hotkeys are:

- t = enter/exits edit mode.
- q = draw mode.
- w = move.
- e = rotate.
- r = scale.
- g = open the projection master.
- Ctrl+z = undo.
- Ctrl+shift+z = redo.
- LMB = click the left mouse button in a blank area of the viewport and drag to rotate model.
- Alt+LMB = click and drag model in the viewport.

- Ctrl+LMB = click in the viewport and drag onto a mesh to marquee select a mask on the object. Click and draw directly on the mesh to paint a custom mask. By clicking on a blank section of the viewport it will inverse the masks. By dragging on a blank section of the viewport it will clear the masks.
- Alt+LMB = inverse paints the transform settings of the current tool. For instance, if you are currently inflating your model, this hotkey combo will instead deflate.
- Shift+LMB = switches the transform settings of the current tool to smooth.
- Ctrl+shift+LMB = drag marquee on mesh to hide polygons outside of the selection. Drag on a blank section of the viewport to invert the polygons that are hidden. Press the hotkey and click (no dragging) in a blank section of the canvas to unhide everything.

Along the top, you'll see the memory usage for your current scene. Keep close tabs on this as you work. If you begin dividing your model too much the memory usage can become too high for your computer.

FIGURE 3-4 Memory usage.

Below the memory usage are the menus. This is where you create new scenes, change the lighting, adjust tool settings, etc. I'll go into more detail on the different menus that you will commonly use for modeling a bit later in this chapter after covering the main interface.

FIGURE 3-5 Menus.

Below the menus are the tool options. Here you can enter the Projection Master to add fine detail to your model. You can also enter edit mode for your models and change your brush preferences as you work.

FIGURE 3-6 Tool options.

Below the tool options is the viewport window. All of your painting and modeling takes place in this window. One of the things to keep in mind is that in the current version of ZBrush you can't actually move the camera. You can spin and scale the mesh and zoom in on the canvas but the camera does not actually rotate. This can take a bit of getting used to.

FIGURE 3-7 Work window.

To the left of the viewport is the toolbox that allows you to change your brushes, alphas, stroke settings, materials, textures, and colors. By clicking on one of the icons, it will bring up the different settings available to choose from.

FIGURE 3-9 Brush tools.

FIGURE 3-8 The toolbox.

To the right of the viewport are the options to adjust the viewport. Zoom, scale, pan, etc. are all found here.

Now let's go into some of the more commonly used menus. The Alpha menu is where you change your brush profile. By changing the brush alpha to a shape you've created, you can paint detail in any way needed. Skin pores, wrinkles, and scales are types of things that can be created with different types of alphas.

FIGURE 3-10 Viewport control options.

FIGURE 3-11 Alpha menu.

The Color menu allows you to change the color of the current paint brush. This uses a color picker similar to what you'd find in most other paint programs. Simply click a color on the picker box and begin drawing.

The Document menu is for creating new scenes and changing the resolution. Note that import from the Document menu is for loading background images. Importing 3D objects is done from a different menu.

Tutorial: Saving Custom Materials

Loading materials is very different with ZBrush then it is within Maya. There is, however, an easy way to reapply your textures and materials. Normally you work with 3D tools. After you spend time creating a custom material, save the document. This will store all of the material information. When you restart ZBrush, simply load the document before the ZTool and your custom materials will load as well.

The Draw menu is used to change the paint brush options. These options can also be changed using the tool options lines.

The Edit menu is for undo and redo. Each work area uses a different set of undos. For example, the work you do in edit mode has a different undo buffer than the work you do in the Projection Master.

The Layer menu allows you to work in layers similar to those with Adobe Photoshop. Because ZBrush stores Pixol information, different objects behave differently when using layers. 3D objects will interact with all layers, while brush strokes will only affect the current layer.

With the Light menu, you can change the direction of the lights or even add more lights to the scene. By default there are two lights active (designated by the orange boxes). To add more lights, click on a lightbulb to activate, then drag the orange box on the sphere to change the position of the light.

The Material menu is for creating new materials and editing existing ones.

FIGURE 3-12 Light menu. **FIGURE 3-13** Material menu.

Tutorial: Using ZSpheres

ZSpheres can be thought of as a preview tool. Using ZSpheres you can quickly pose a model then apply the mesh on top.

FIGURE 3-14 ZSphere.

1. To use ZSpheres switch to the ZSphere brush and place one in the canvas window.
2. Press "t" to make it active.
3. Click and drag on the existing ZSphere in the spot where you need to place the next one. The size of the new ZSphere is defined by how long you click and drag. If needed, you can turn on the symmetry in the Transform palette to create mirrored ZSpheres.

FIGURE 3-15 Placing more Zspheres.

4. After you've created the ZSphere framework, you can see what the skinned version will look like by clicking Preview under Transform>Adaptive Skin. The higher the density slider, the more polygons will be included in the model.

5. If the adaptive skin is on, press Preview again to go back to ZSphere mode.

6. Rotate, move, and scale the ZSpheres to finish shaping the object. Periodically, you should switch to adaptive mode to see what the ZSpheres will look like skinned.

7. Once the ZSpheres are set and you are pleased with the preview, press Tool>Adaptive Skin> Make Adaptive Skin. This will create a new ZTool called Skin_ ZSphere#.

8. Click on the new ZTool to switch over. You can now divide the mesh as needed and begin adding details.

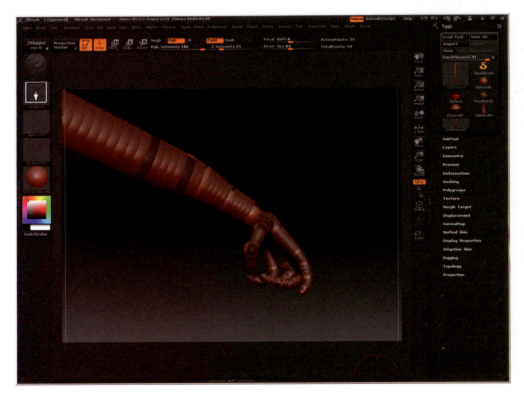

FIGURE 3-16 ZSphere hand.

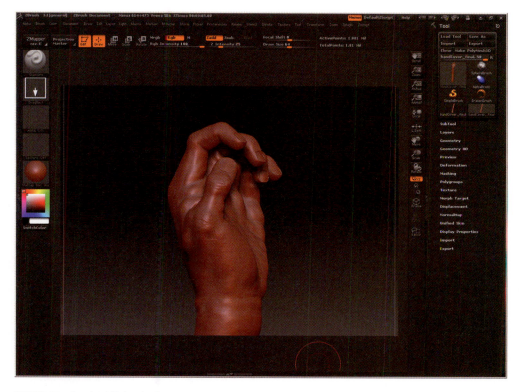

FIGURE 3-17 Completed ZSphere hand.

Tutorial: Exporting a Model from Maya

Exporting from Maya to ZBrush is a fairly simple matter. Any model created in Maya for use in ZBrush needs to be exported as an .obj file. The .obj file format is a model format that is actually used by every 3D program.

1. Open your model in Maya.
2. Select the mesh and click File>Export Selection. Don't forget that ZBrush's automatic UV creation method doesn't work very well with Maya. That being said, you should create your UVs in Maya before exporting. UV creation is covered in Chapter 9. Also extra care should be given so that the UVs do not overlap.
3. Open ZBrush, click Tool>Import and navigate to the .obj model. This will import the file as the current tool.
4. Click drag in the work area to place the model in the scene.
5. Immediately press the "t" shortcut key to enter edit mode. This is important. If you try to do anything else, the model will be dropped to the canvas and will no longer be a 3D object.

Tutorial: Exporting a Model from ZBrush to Maya

If you need to bring a model from ZBrush back into Maya for further editing or rendering, it is done as an .obj.

1. In ZBrush select Tool>Export.
2. Open Maya and select File>Import □. Set Create Multiple objects to False. This is very important. If the vertex order of the object changes in any way, the models will not work correctly when moving between the two programs.

Tutorial: Rebuilding Bad Topology

ZBrush has some great retopology tools. If you are working with a mesh that doesn't have well laid out edge loops, you can use the retopology tools in ZBrush to quickly rebuild the mesh.

1. Import your mesh and place it on the canvas. Remember to enter edit mode.

FIGURE 3-18 Model with bad topology.

2. Click Tools>Clone to make a copy of your mesh. I find having this extra copy to make working with topology a bit easier.

3. Click on the ZSphere button in the Tools menu. The mesh will switch to a ZSphere. Don't worry; your mesh is still there, you just need to switch over to a ZSphere in order to work with the retopology tools.

FIGURE 3-19 Preparing for retopology.

4. Click Tools>Rigging>Select Mesh. Select your original mesh in the popup. The ZSphere will now be drawn on top of your mesh.
5. Next click on Tools>Topology>Select Topo and pick the cloned mesh in the popup.
6. Click on Tools>Topology>Edit Topology to switch into editing mode. A wire frame of your topology will wrap around the mesh. By erasing and recreating these lines you can rebuild the entire topology of your character.

FIGURE 3-20 Ready to rebuild the topology.

7. Press Transform>Activate Symmetry and turn on the X symmetry.
8. Press shift and LMB click while dragging across the faulty sections of the mesh to erase the current topology.
9. Press shift and LMB click and release on the mesh to designate where you want to begin creating the new topology. This can take a bit to get the hang of. Try not to drag when designating new build positions, as this will erase the topology.
10. Continue using the shift and LMB controls to rebuild the character with proper edge loop topology.
11. Press "a" to preview the new mesh.

FIGURE 3-21 Rebuilding the topology.

FIGURE 3-22 Mesh in progress.

FIGURE 3-23 Mesh in progress.

FIGURE 3-24 Final rebuilt mesh.

Tutorial: Using HD Geometry

HD geometry allows you to work on models with higher polygon counts than your computer can normally handle.

1. Load your model into ZBrush
2. Divide the mesh as many times as your computer can work with.
3. Click Tool>Geometry HD>DivideHD. Divide a few times to begin subdivide into HD geometry.

FIGURE 3-25 Original mesh.

FIGURE 3-26 Diving the mesh into HD geometry. Note the higher polygon count.

4. Make sure Click Tool>Geometry>RadialRGN is checked. This will display the safe radial region that you can work within.
5. Click Tool>Geometry>SculptHD.
6. Hover the mouse cursor over a section of the model and press "a." This will enable the radial region that you can sculpt in HD.

FIGURE 3-27 HD radial sculpting region.

7. Sculpt the model using all of the normal tools.

8. When you need to work on a different section, press "a" to exit HD, hover the mouse of the new section, and press "a" again.

9. Rendering HD geometry press the "a" hotkey when the mouse is not hovering over the model.

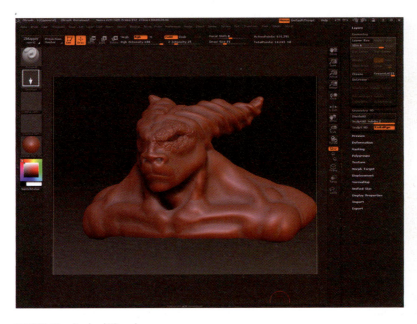

FIGURE 3-28 Rendered HD mesh.

Tutorial: Using Smart Resym

If you lose symmetry on your model you can use Smart Resym to automatically regain it. In the HD example, when modeling around one eye, the other half was hidden from view and thus did not get changed.

1. Ctrl+LMB drag around the updated half of the model.

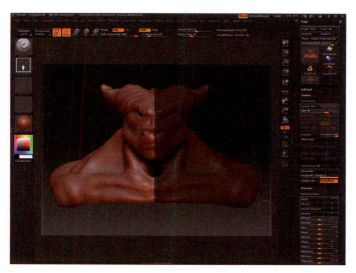

FIGURE 3-29 Masking part of the mesh for Smart ReSym.

2. Click Tool>Deformation>Smart ReSym. Make sure it is set to resym across the X axis. Smart ReSym can take awhile depending on the complexity of the mesh.

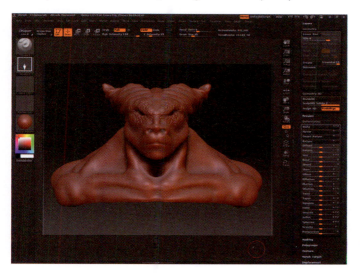

FIGURE 3-30 The updated symmetrical model.

As you can see ZBrush is an incredibly deep program. I recommend that as you are working with it, always check out the great forum site http://www.pixolator.com. Here you can find tons of tutorials and critiques.

Concept Art

Concept art is a vital part of any production. Concept art allows an artist to design the look and feel of movie, game, or character prior to moving into the expensive production stage.

After the story is approved, an artist is brought in to start delivering concepts. Concept art is the first visual created for a production. The artist can quickly and easily produce many different designs. Each design can go before the art director for approval and if changes are needed, it's a very simple matter. It's much easier and more cost effective to rework some concept art than it would be to have to redo an entire model. Color, lighting, even the overall mood of a scene can be worked out by an artists with just some pen and paper.

FIGURE 4-1 Tools of the concept artist: pencils, paper, grayscale pens, blue pencils, etc.

Even on smaller productions it's very important to create concept art prior to moving into production. Work out the look of your character before moving into production when changes would be expensive and time consuming to perform.

Tutorial: Cleaning up concept art

When sketching your concept art using paper and pencil, it's a good idea to use a non-photo blue pencil (available at any art store) to rough out your character. Later you can finalize the outline using a hard pencil or ink.

First scan your image at high enough resolution. Line art is typically scanned at 300 dpi for concept work. Use a higher if you need to send it off for print.

If you've scanned the image as black and white, you're all finished. The non-photo blue should not register during the scanning process.

However, if you need to remove the blue in Adobe Photoshop scan the image in color and load it into the program.

FIGURE 4-2 Character concept.

1. In Adobe Photoshop open the Channels window.
2. Deselect all channels except for blue. This will turn all of the blue pencil work invisible leaving the gray outlines intact.

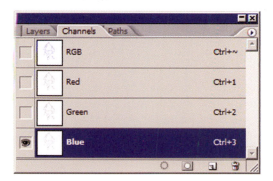

FIGURE 4-3 Working with just the blue channel.

3. Click Select>All.
4. Click Edit>Copy.
5. Change to the Green channel.
6. Click Edit>Paste. This will paste the clean pencil work into the green channel.
7. Repeat for the Red and RGB channels.

FIGURE 4-4 Final image with blue removed.

Adobe Photoshop is, of course, one of the more popular programs available for the concept artist. I also enjoy using a program called ArtRage by Ambient Designs, Ltd. Both programs have important roles in the concept artist's toolbox, Photoshop for its unparalleled image editing tools and ArtRage for its intuitive pencil brushes.

FIGURE 4-5 Adobe Photoshop.

FIGURE 4-6 ArtRage by Ambient Designs, Ltd.

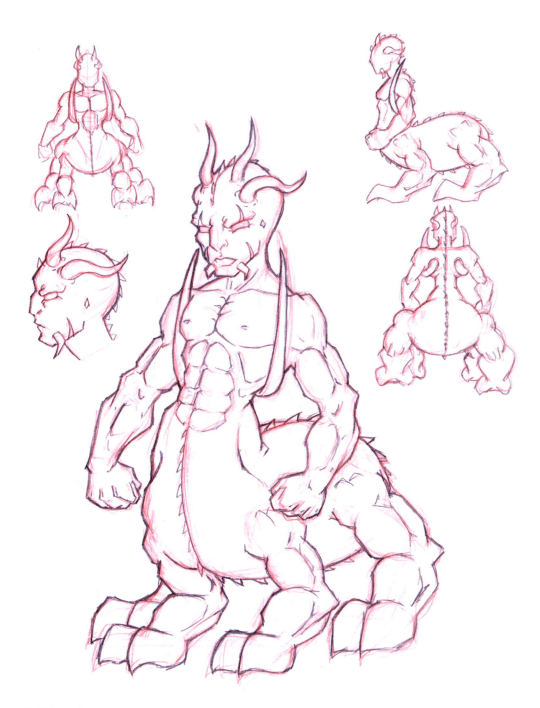

FIGURE 4-7 Concept art.

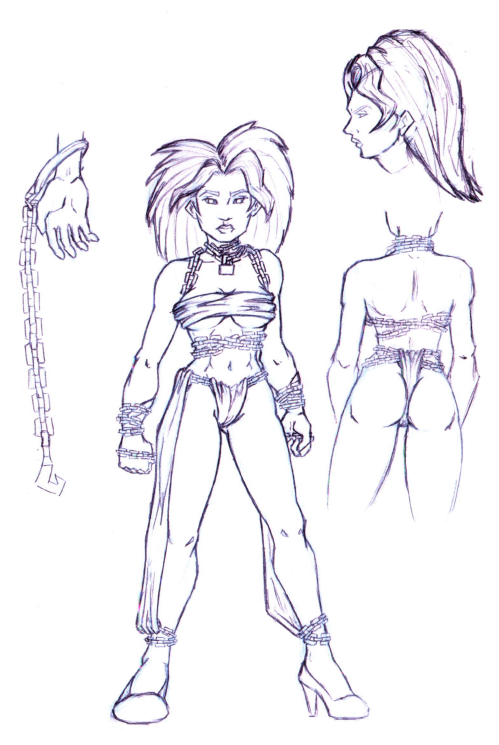

FIGURE 4-8 Concept art.

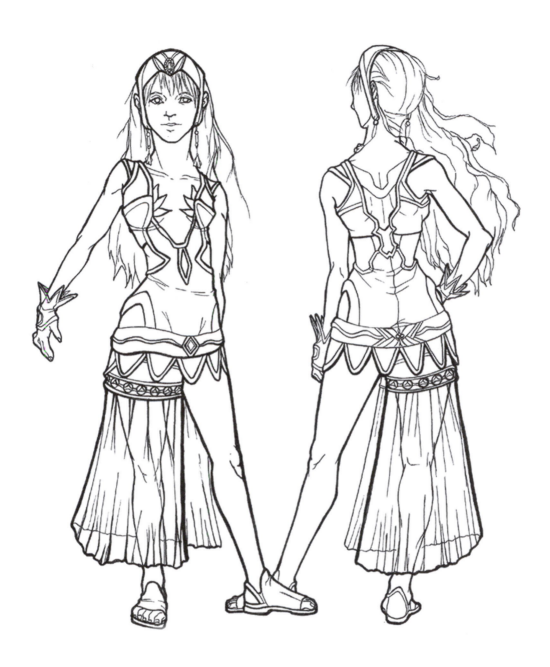

FIGURE 4-9

FIGURE 4-10

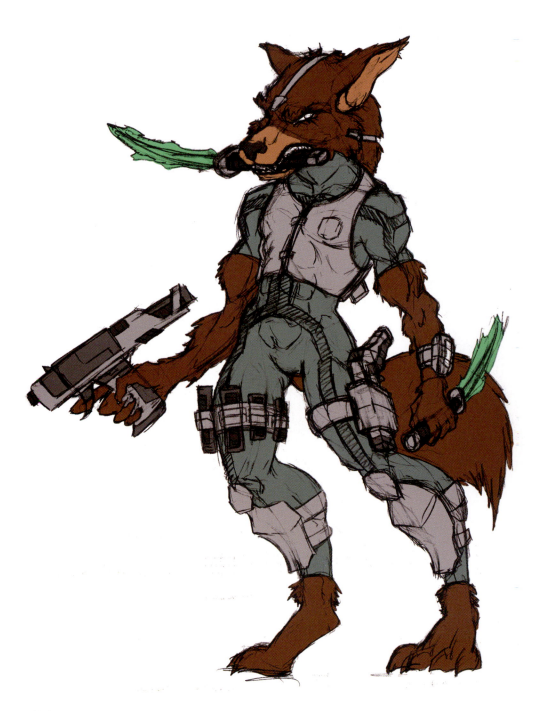

FIGURE 4-11

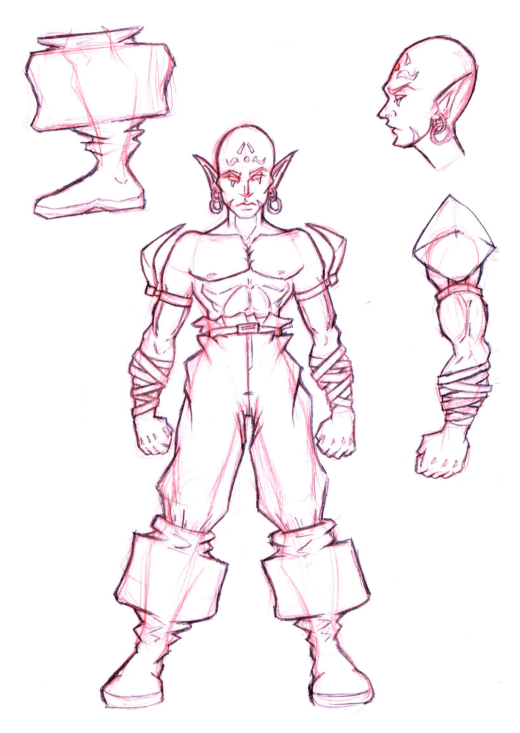

FIGURE 4-12

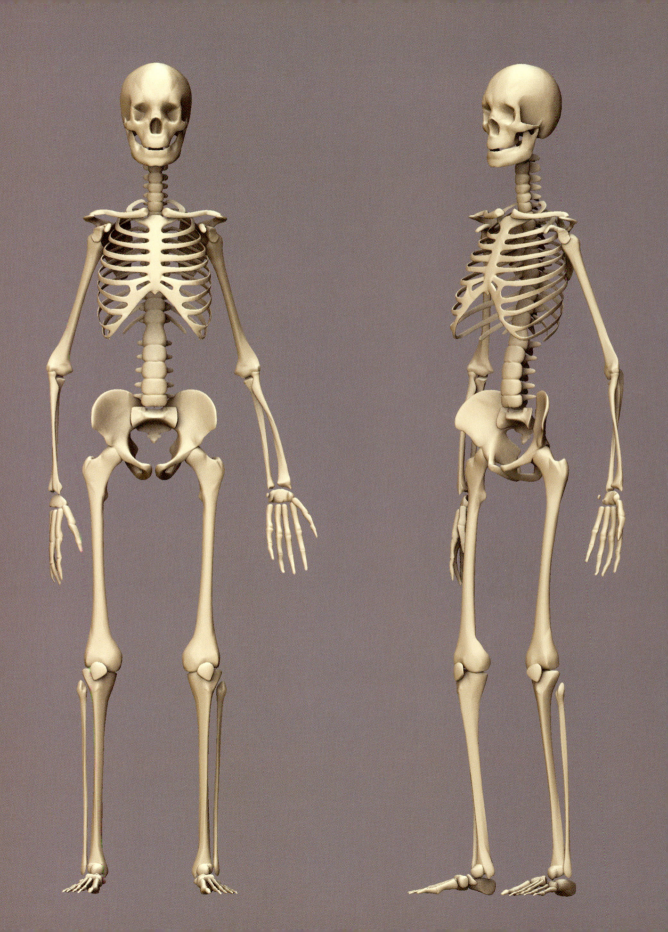

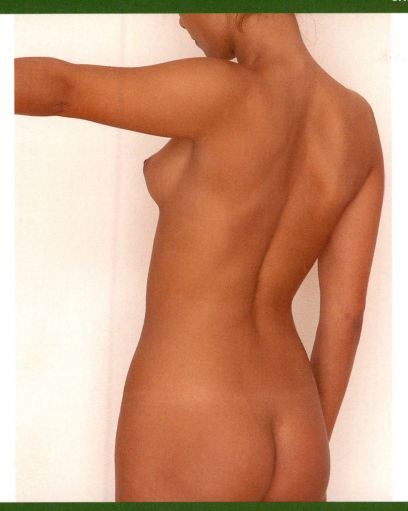

Anatomy

A basic understanding of anatomy is vital in creating believable characters. You don't have to go to medical school for 4 years, but be prepared to study some basic anatomy. Luckily there are tons of resources available.

First, pick up some books on the subject. While this chapter offers information on anatomy, it shouldn't take the place of books solely devoted to the subject.

My favorite anatomy books are:

- *Artistic Anatomy*, by Paul Richter, Watson-Guptill Publications.

FIGURE 5-1 Artistic Anatomy.

- *An Atlas of Animal Anatomy for Artists*, by Frances A. Davis, Dover Publications.

FIGURE 5-3 An Atlas of Animal Anatomy for Artists.

- *Cyclopedia Anatomicae*, by Gyorgy Feher, Black Dog & Leventhal Publishers, Inc.

FIGURE 5-2 Cyclopedia Anatomicae.

- *Dynamic Anatomy*, by Burne Hogarth, Watson-Guptill Publications.

FIGURE 5-4 Dynamic Anatomy.

In addition to the books, I also recommend the Quickstudy Academic Charts by BarCharts, Inc. These are great laminated charts that easily fit into a laptop case or folder. I always carry the charts for skeletal, muscular, and surface anatomy.

FIGURE 5-5 Quickstudy Anatomy by BarCharts, Inc.

One of the best ways to study anatomy is to attend life drawing sessions. I can't recommend enough to attend a weekly class to exercise your sketching. As you practice, you'll more easily be able to picture the human form in a variety of poses. Of course the availability of classes differs depending on your location. Search the internet to see what is available. Also, check local community colleges. They often times have inexpensive art classes.

If you are unable to attend an art class, there are some websites available that provide very nice anatomy studies. My favorite of the anatomy websites is http://www.3d.sk/. There are thousands of photos available ranging from modeling poses, to clothed humans, to action poses. Truly an invaluable resource if you are unable to attend life drawing classes.

FIGURE 5-6 Anatomy website.

The skeleton is the framework of a human. As such, it should be the first thing you learn when you begin studying anatomy. Many artists make the mistake of skipping past studying the skeleton and their art suffers. If the skeleton isn't learned, the resulting art can lack proper form; it tends to be a bit blobby.

What the artist should learn is where the main bony masses lie. These masses are prominent structures like the elbows, knees, pelvis, etc. Of course, it's important to learn where bones like the vertebrae, femur, pelvis, and ulna are located. But even more important is studying how these bones affect the overlying muscles.

After learning the major bone structures, you'll be able to detail those sections properly in your art and your characters will have more life.

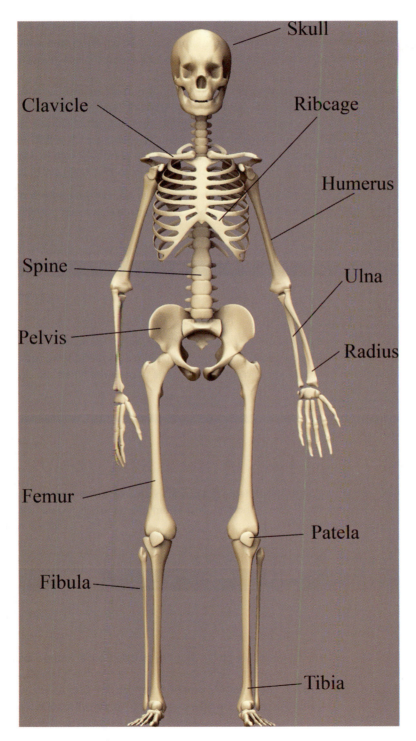

Skull

Clavicle

Ribcage

Humerus

Spine

Ulna

Pelvis

Radius

Femur

Patela

Fibula

Tibia

FIGURE 5-7 Skeleton front.

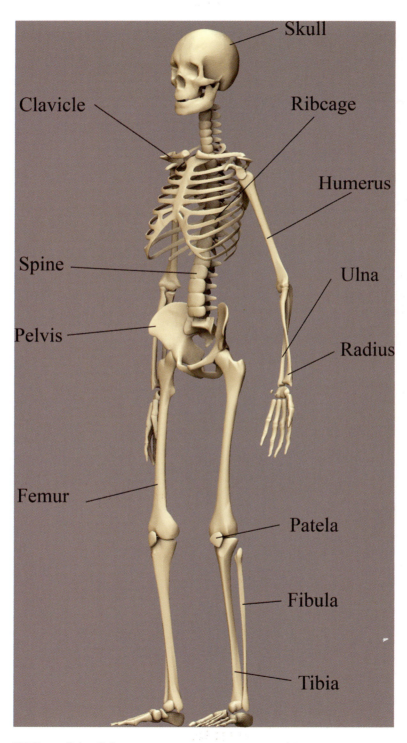

FIGURE 5-8 Skeleton ¾ view.

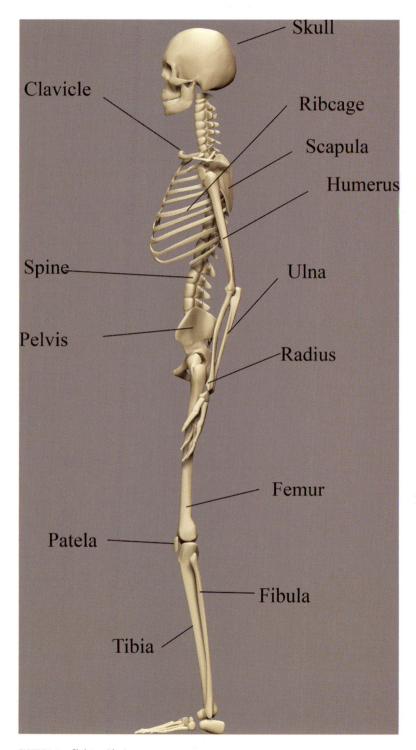

FIGURE 5-9 Skeleton side view.

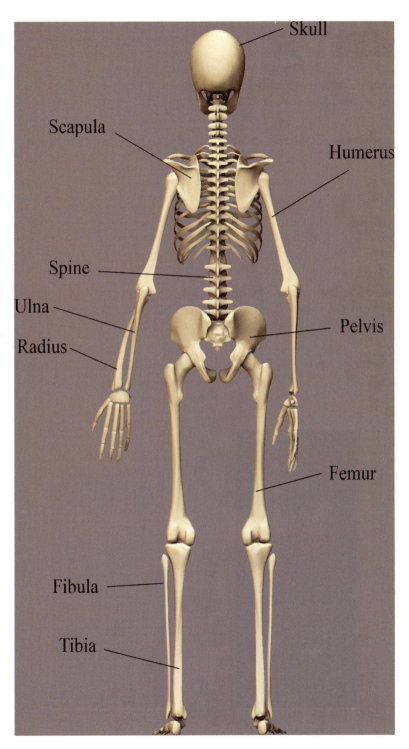

FIGURE 5-10 Skeleton back view.

Characters are often designed by how many of the character's head high they stand. The ideal male is generally thought to be eight heads high. A meek character may be six-and-a-half heads high, with the average male being around seven heads high. Of course, eight heads high is a generalization, but it does give you a good starting point when designing a new character.

Males typically have less body fat than females. The male pelvis is much narrower than that of a female. Males also have much wider shoulders. All of these should be taken into account in any original designs.

Notice how the different body types compare to the ideal male. Keep an eye on where the different bony masses lie.

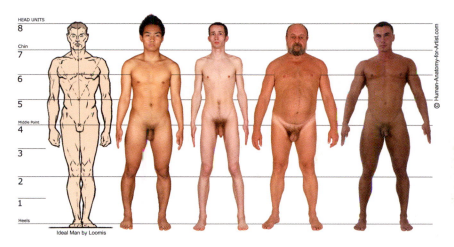

FIGURE 5-11 Male body comparisons (front view).

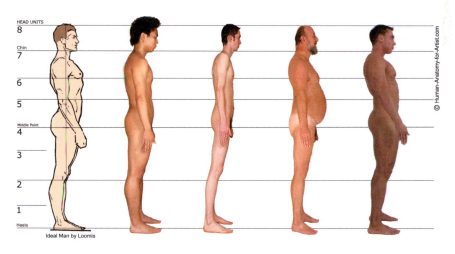

FIGURE 5-12 Male body comparisons (side view).

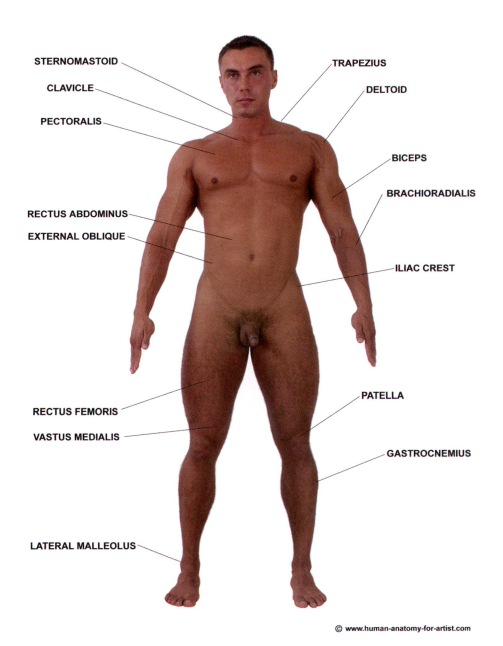

STERNOMASTOID

CLAVICLE

PECTORALIS

TRAPEZIUS

DELTOID

BICEPS

BRACHIORADIALIS

RECTUS ABDOMINUS

EXTERNAL OBLIQUE

ILIAC CREST

RECTUS FEMORIS

VASTUS MEDIALIS

PATELLA

GASTROCNEMIUS

LATERAL MALLEOLUS

© www.human-anatomy-for-artist.com

FIGURE 5-13 Male front view.

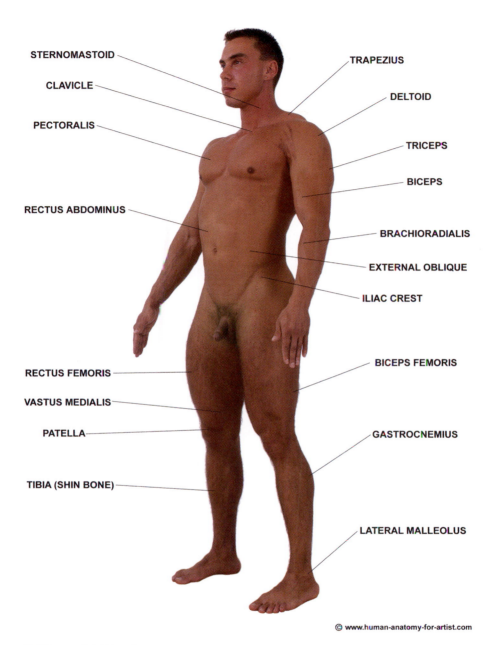

STERNOMASTOID

CLAVICLE

PECTORALIS

RECTUS ABDOMINUS

RECTUS FEMORIS

VASTUS MEDIALIS

PATELLA

TIBIA (SHIN BONE)

TRAPEZIUS

DELTOID

TRICEPS

BICEPS

BRACHIORADIALIS

EXTERNAL OBLIQUE

ILIAC CREST

BICEPS FEMORIS

GASTROCNEMIUS

LATERAL MALLEOLUS

© www.human-anatomy-for-artist.com

FIGURE 5-14 Male ¾ front view.

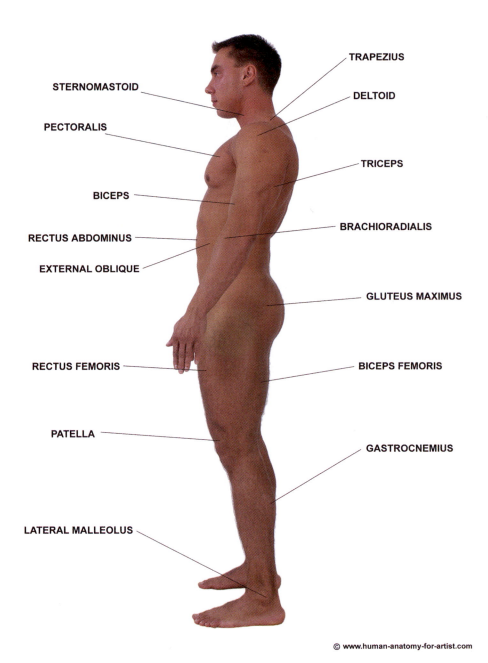

STERNOMASTOID

PECTORALIS

BICEPS

RECTUS ABDOMINUS

EXTERNAL OBLIQUE

RECTUS FEMORIS

PATELLA

LATERAL MALLEOLUS

TRAPEZIUS

DELTOID

TRICEPS

BRACHIORADIALIS

GLUTEUS MAXIMUS

BICEPS FEMORIS

GASTROCNEMIUS

© www.human-anatomy-for-artist.com

FIGURE 5-15 Male side view.

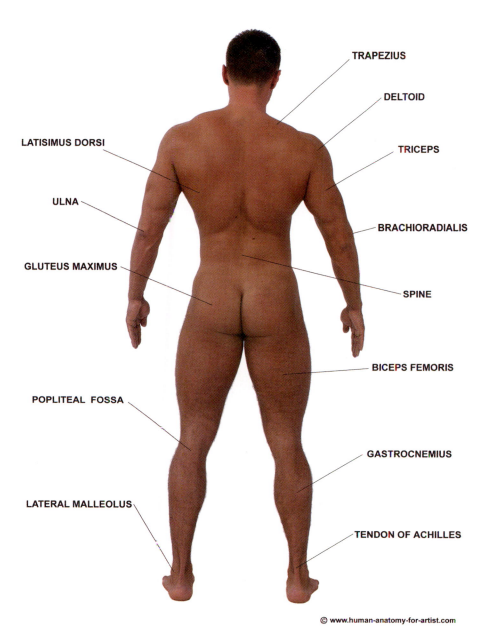

TRAPEZIUS

DELTOID

LATISIMUS DORSI

TRICEPS

ULNA

BRACHIORADIALIS

GLUTEUS MAXIMUS

SPINE

BICEPS FEMORIS

POPLITEAL FOSSA

GASTROCNEMIUS

LATERAL MALLEOLUS

TENDON OF ACHILLES

© www.human-anatomy-for-artist.com

FIGURE 5-16 Male back view.

The first thing to note about the skeletal anatomy of women is that the pelvis is wider and shallower than a man's. This is a good example of the bony structure I mentioned earlier. This is something the artist really needs to emphasize or the character will not look right. Women also have narrower rib cages and smaller, less angular jaw lines. The arms and legs in a female are also thinner and shorter than those in a male.

As with a male, the ideal female is usually depicted as being eight heads high. With the average woman being between seven and seven-and-a-half heads high.

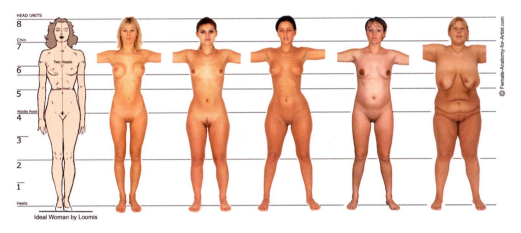

FIGURE 5-17 Female body comparisons (front view).

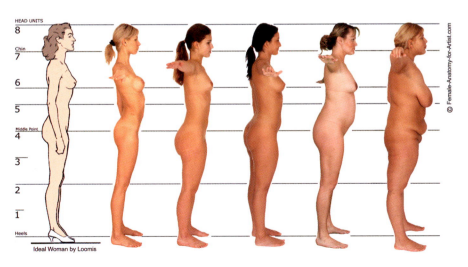

FIGURE 5-18 Female body comparisons (side view).

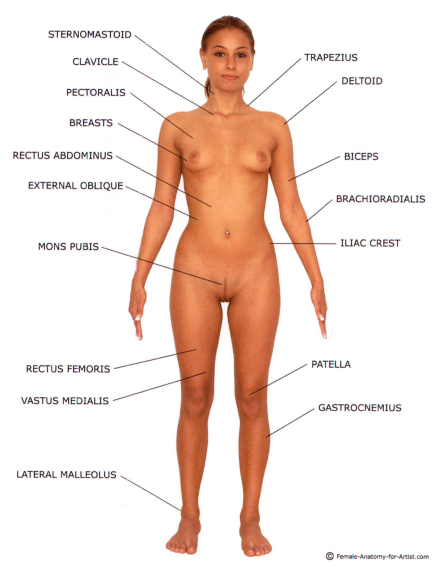

STERNOMASTOID

CLAVICLE

PECTORALIS

BREASTS

RECTUS ABDOMINUS

EXTERNAL OBLIQUE

MONS PUBIS

TRAPEZIUS

DELTOID

BICEPS

BRACHIORADIALIS

ILIAC CREST

RECTUS FEMORIS

VASTUS MEDIALIS

PATELLA

GASTROCNEMIUS

LATERAL MALLEOLUS

FIGURE 5-19 Female front view.

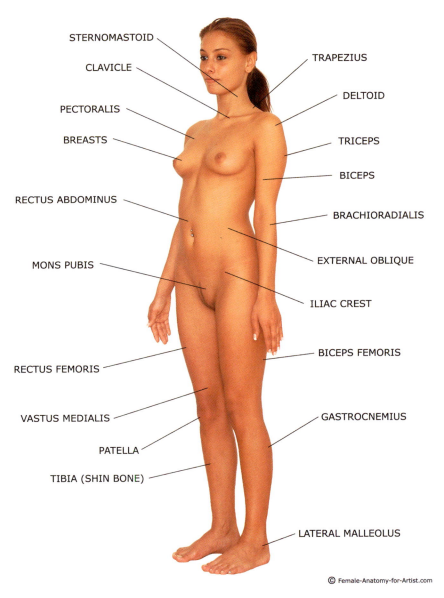

STERNOMASTOID

CLAVICLE

PECTORALIS

BREASTS

RECTUS ABDOMINUS

MONS PUBIS

RECTUS FEMORIS

VASTUS MEDIALIS

PATELLA

TIBIA (SHIN BONE)

TRAPEZIUS

DELTOID

TRICEPS

BICEPS

BRACHIORADIALIS

EXTERNAL OBLIQUE

ILIAC CREST

BICEPS FEMORIS

GASTROCNEMIUS

LATERAL MALLEOLUS

© Female-Anatomy-for-Artist.com

FIGURE 5-20 Female ¾ front view.

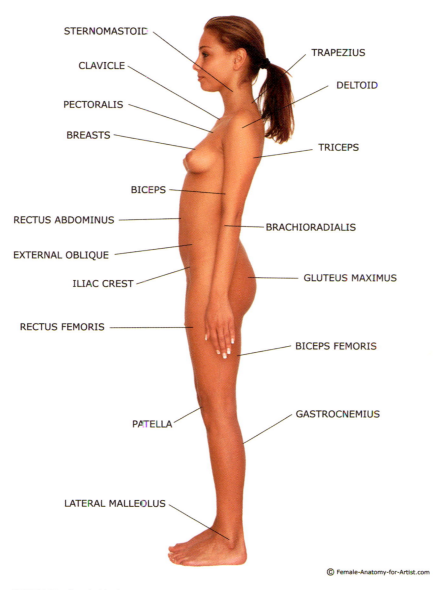

STERNOMASTOID

CLAVICLE

PECTORALIS

BREASTS

BICEPS

RECTUS ABDOMINUS

EXTERNAL OBLIQUE

ILIAC CREST

RECTUS FEMORIS

PATELLA

LATERAL MALLEOLUS

TRAPEZIUS

DELTOID

TRICEPS

BRACHIORADIALIS

GLUTEUS MAXIMUS

BICEPS FEMORIS

GASTROCNEMIUS

© Female-Anatomy-for-Artist.com

FIGURE 5-21 Female side view.

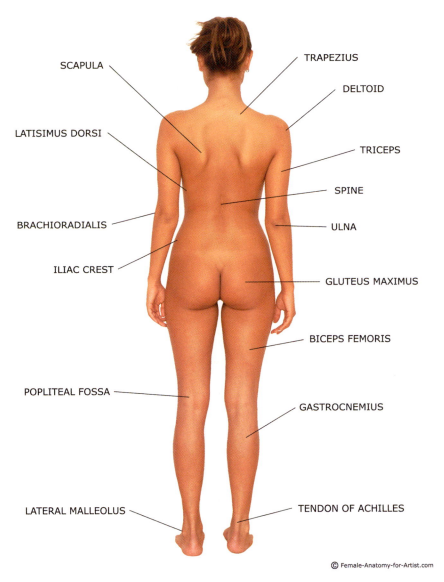

SCAPULA

TRAPEZIUS

DELTOID

LATISIMUS DORSI

TRICEPS

SPINE

BRACHIORADIALIS

ULNA

ILIAC CREST

GLUTEUS MAXIMUS

BICEPS FEMORIS

POPLITEAL FOSSA

GASTROCNEMIUS

LATERAL MALLEOLUS

TENDON OF ACHILLES

FIGURE 5-22 Female back view.

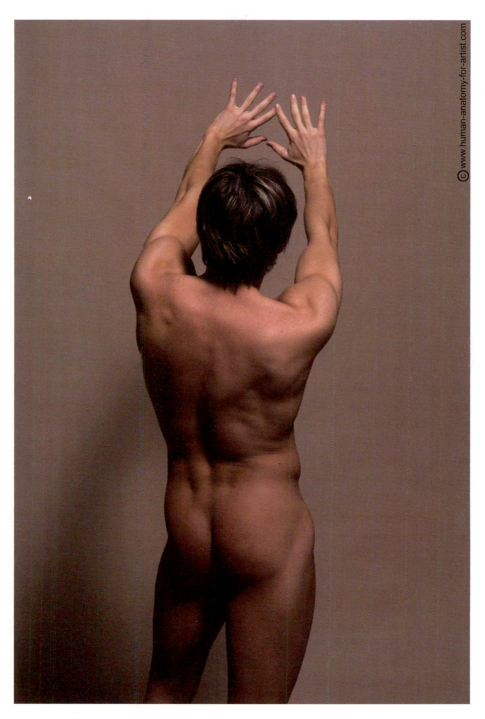

FIGURE 5-23 Male back.

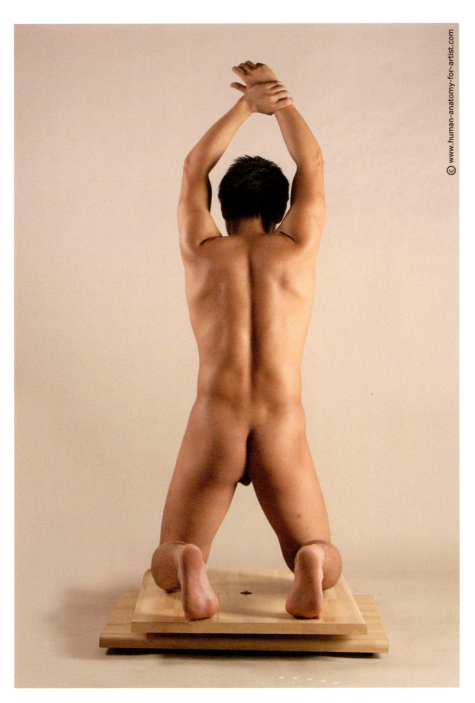

© www.human-anatomy-for-artist.com

FIGURE 5-24 Male kneeling back view.

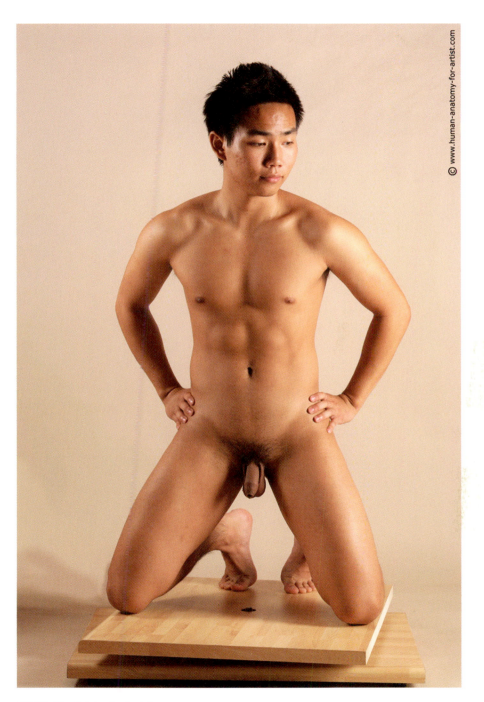

FIGURE 5-25 Male kneeling front view.

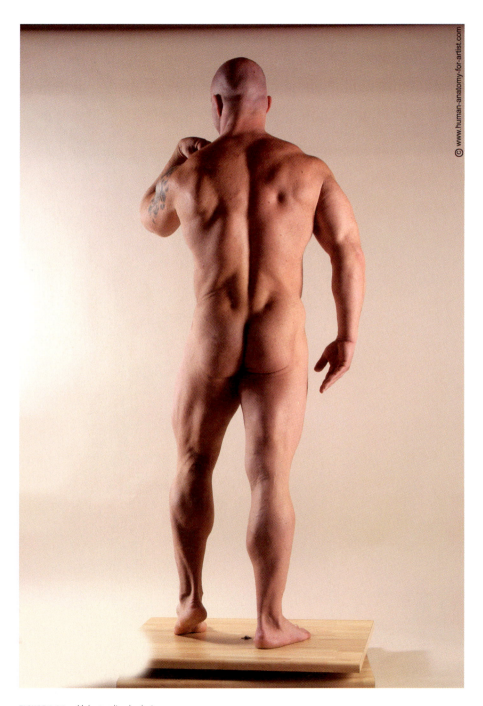

FIGURE 5-26 Male standing back view.

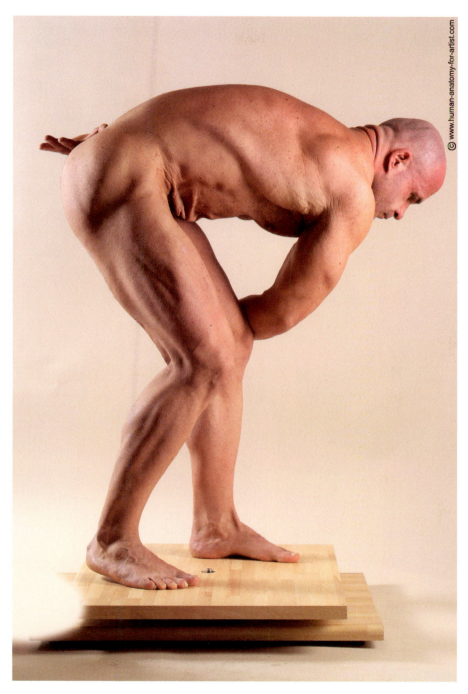

FIGURE 5-27 Male standing front view.

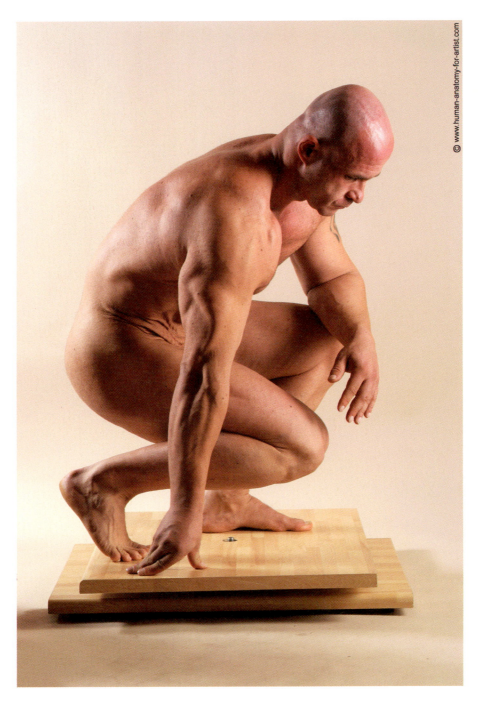

© www.human-anatomy-for-artist.com

FIGURE 5-28 Male kneeling.

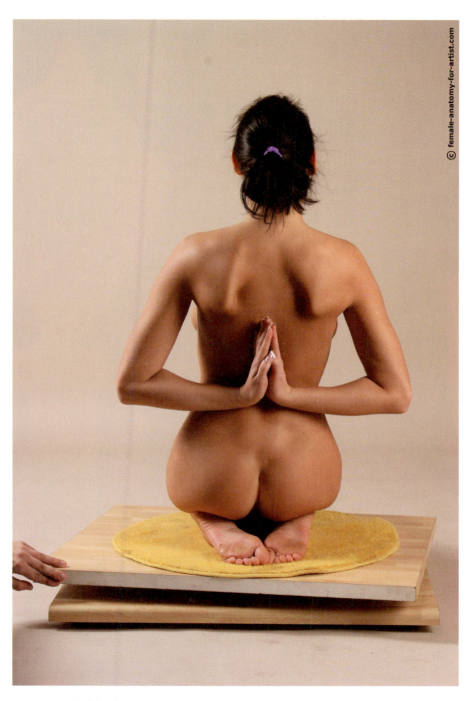

FIGURE 5-29 Female kneeling.

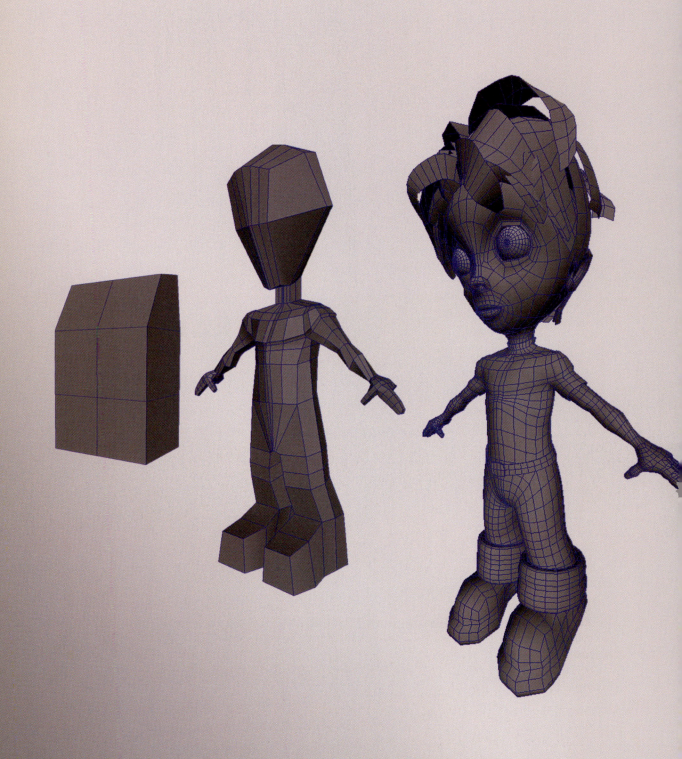

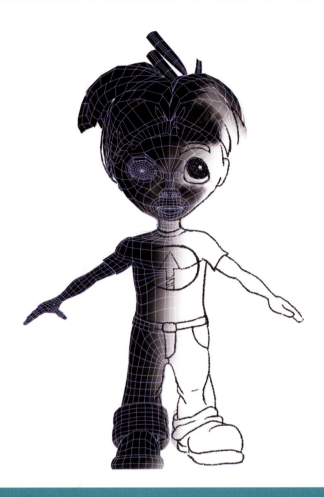

Creating a Video Game Character

Low-resolution characters are typically used in real-time environments like video games. Real-time environments necessitate keeping a low-polygon count on characters. If the polygon count is too high, the game engine won't be able to render with a high enough frame playback speed. Therefore the goal is to create a character with a low enough polygon count so the game engine will playback at a high speed, yet with high enough polygon count to look good. Current low-res characters are approximately 5000 to 6000 polygons.

The term low resolution has an ever-changing definition. As computers become more powerful, the amount of polygons allowable in low-res characters becomes higher. Ten years ago when 3D characters first started being used in games, just a couple hundred polygons was considered cutting

133

edge. With more powerful computers and next generation systems now available, models are pushing well into thousands of polygons per character.

As mentioned, low-polygon characters are mainly used in video game. It's a good idea to play different video games to get a feel for what is the current norm. The XBOX 360, Nintindo Wii, and the Playstation 3 are all sport amazing graphics. And don't forget the current crop of computer games. The increasingly powerful home computers allow for incredibly detailed characters.

The types of images being created on new computers and next generation consoles is amazing. But those amazingly detailed characters have a secret. Though they appear to have hundreds of thousands, this is an illusion. Through a process known as normal mapping, low-polygon characters are made to look like high-res models (normal mapping will be explained later).

Polygons are at a premium with games. That means you'll most likely need to model clothes and hair directly onto the character (movies will do cloth and hair as a separate simulation pass). If you need to do this, make sure you have the character's anatomy worked out. Starting with a solid foundation will help the final character to be much more believable.

That's not to say that low-res characters are only found in games. They are also used in films as background characters, or for independent productions where budget and rendering times are concerns.

For feature films rendering times can skyrocket through the roof. Take Shrek 2 for instance. DreamWorks reported for some scenes that the rendering times were 30 to 40 hours per frame. That's right, per frame. Keeping background characters as simple as possible helps to keep the rendering times down. If you can't see the extra details of a two million polygon background character, then there is no reason to take the rendering hit that comes from such a dense mesh. That being said, for crowd scenes and background characters, low-polygon characters still have a place in movies.

Tutorial: Adding Detail to the Torso

Let's look at detailing the torso first. Before you begin adding clothes or hair, make sure to define the landmark areas. Landmarks are any prominent features on the character. The main bony masses of the torso are the hips, ribcage, and collarbones on the front, and the hips and shoulder blades on the back. The main muscle masses on the front are the pectoral, trapezius, abdominal, and oblique muscles. The main muscles on the back are the latissimus dorsi and trapezius muscles. When it comes to games, however, most of the muscle definition can be faked using textures. That's just one of the ways modelers will try to get around the requirements for low-polygon modeling.

At this point, our character just doesn't have enough polygons to properly define the different features of the torso. What we need to do is to add enough edge loops so that we can shape the landmark areas, yet still keep the polygon count down. Remember our mantra, "Add a loop and shape the components."

1. Open the character that you previously blocked out.

2. Select Edit Mesh>Insert Edge Loop Tool to insert an edge loop just above the edge created during the blocking stage that defines the center of the pectoral muscle. As always shape the edges as you add them. In this case, adjust the edges to better round out the center of the pectorals.

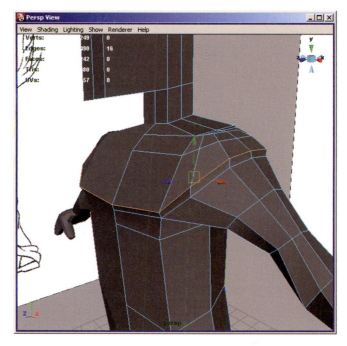

FIGURE 6-1 Creating the chest.

3. Next insert an edge loop at the bottom of the pectoral muscles. This loop will also travel around to the back helping to define the latissimus muscles.

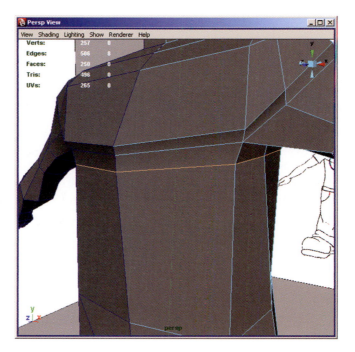

FIGURE 6-2 Defining the bottom of the pectorals.

4. Insert a vertical edge loop near the centerline of your character. This will define the sternal region on the front of the torso and the spinal region on the back.

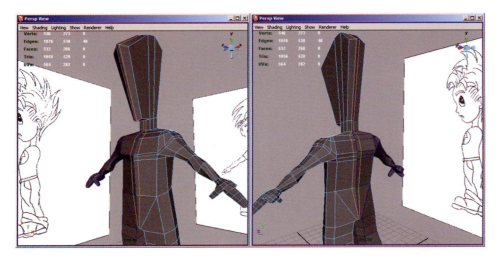

FIGURE 6-3 Creating the sternal and spinal regions.

5. Add another vertical edge loop in the center of the chest. This will help you to correctly define the shape of the torso.

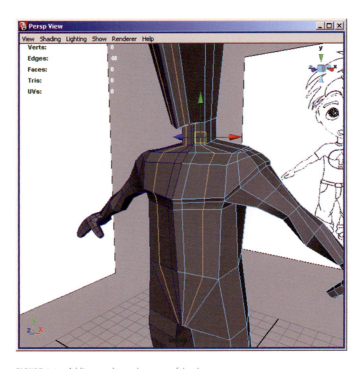

FIGURE 6-4 Adding an edge to the center of the chest.

6. Take some time to round off the edges that you've added. Move edges to get broader adjustment. For finer control, adjust the vertices.

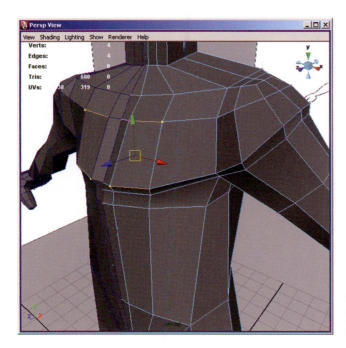

FIGURE 6-5 Adjust the chest. Remember to push in the center vertical edge to define the sternal region.

FIGURE 6-6 While rounding out the back, make sure to push in the center edge to help define the spinal area.

7. Adjust the edges on the side of the torso to define the latissimus muscles.

FIGURE 6-7 Pulling out the latissimus muscles.

8. Next, add two edge loops to define the ribcage and adjust to match your template. It's always a good idea to adjust the entire section of the model as you work, as it will help you keep the correct proportions. Typically, I will add some detail and adjust the front, shift around and work on the back, and finally move back to the front for more adjustments.

FIGURE 6-8 Adding the ribcage.

9. Add two edge loops to the stomach. Remember to keep them evenly spaced and round off the mesh.

FIGURE 6-9 Adding edge loops to the stomach.

10. If you find that your model doesn't have enough polygons in the torso, insert more edge loops as needed. Just remember to try to keep them evenly spaced, and round off the model as you work. Also remember that the vertical edge loops will travel through multiple sections of the character. As you become more familiar with modeling you will probably want to shift around and do some basic shaping in those sections as well.

FIGURE 6-10 New torso edge loop.

FIGURE 6-11 Extra edge loops above the ribs.

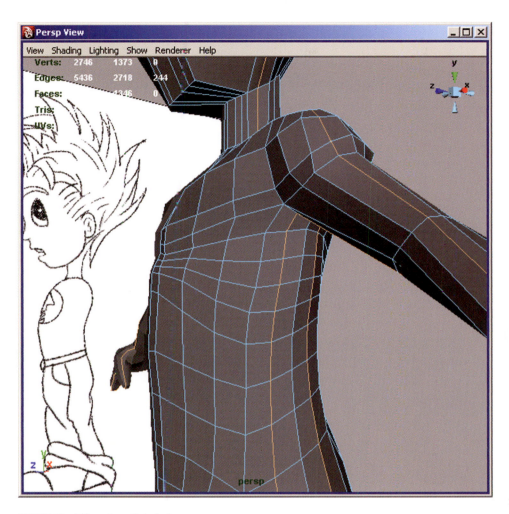

FIGURE 6-12 Adding extra vertical edge loops.

Tutorial: Detailing the Legs

Even though you may model the clothes directly onto the character, it's still important to understand where all of the major points are in the leg. The pelvis is the main bony mass visible in the upper leg. You can see the iliac crest where the leg meets the torso. In the middle of the leg, the knee is visible in the front. The tibia is visible running down the front of the lower leg. The main muscles visible in the upper leg are the vastus medialis, vastus lateralis, rectus femoris, and on the front. On the back of the leg, the gluteus maximus, adductor magnus, and biceps femoris are the main visible muscles. In the lower leg, the tibialis posterior is the main visible muscle. For the rear of the lower leg, the main muscles are the gastrocnemius lateral head and medial head.

1. To begin, add evenly spaced edge loops to the legs. Make sure to round off the new edges as you add them.

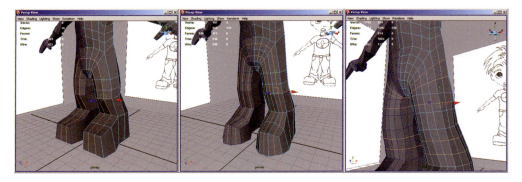

FIGURE 6-13 Adding edge loops to the legs.

2. Joint areas like the knee need to have extra polygons so they will deform correctly when animated. Because of this, you want to add extra edge loops through the knee.

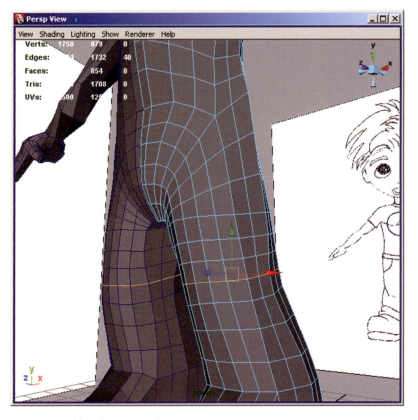

FIGURE 6-14 Adding edge loops to the knee.

3. Now that you have the bone landmarks defined and added extra edge loops, take some time to further shape the legs. You should work on shaping the silhouette of both the upper and lower leg.

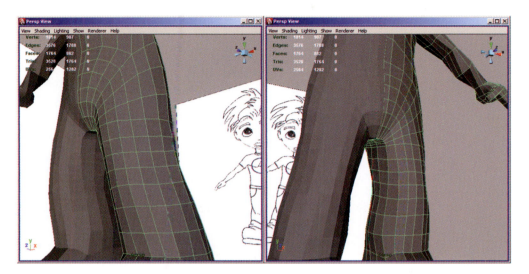

FIGURE 6-15 Shaping the front of the leg.

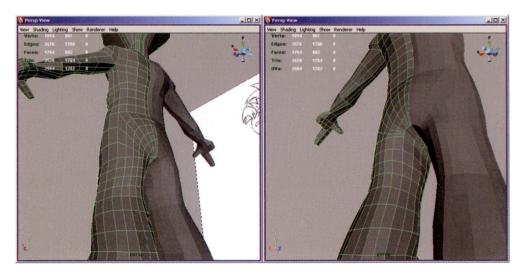

FIGURE 6-16 Shaping the back of the leg.

4. Using component mode, adjust the gluteus maximus into the desired shape. The gluteus maximus muscles are spaced further apart at the top, forming a V shape. The muscle should cup tightly at the bottom. Also, make sure to add a slight dimple where the gluteus maximus meets the upper part of the leg.

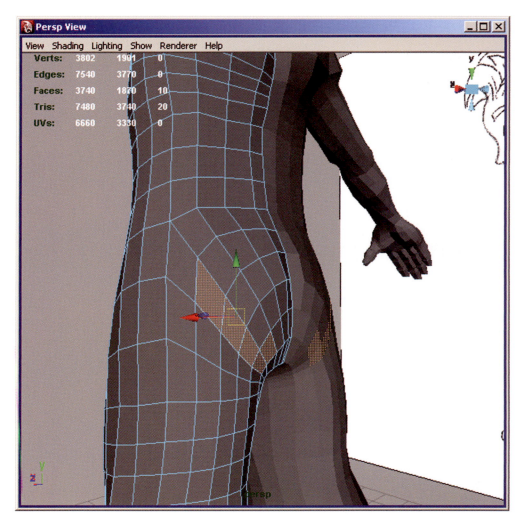

FIGURE 6-17 Creating the gluteus maximus.

Tutorial: Creating the Feet

A pair of shoes is a great accessory for video game models. The polygon count needed for a pair of boots is much less than what is needed to model individual toes. That would give you more polygons for areas that require higher levels of detail, like the face. The inside of the ankle is higher than the outside. The inside of the joint is the base of the tibia bone. The outside of the ankle is the base of the fibula. The four smaller toes all have three joints and are very close together. The big toe only has two

joints and there is a large gap between it and the second toe. Also note that the foot is narrow at the heel and widens at the end of the metatarsal bones (the ball).

1. The foot will be very boxy at this point. Insert two edge loops around the ball of the foot. This allows you to shape the foot properly and it also adds extra polygons so the mesh will deform correctly when animated.

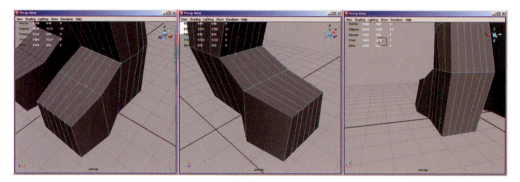

FIGURE 6-18 A very boxy foot.

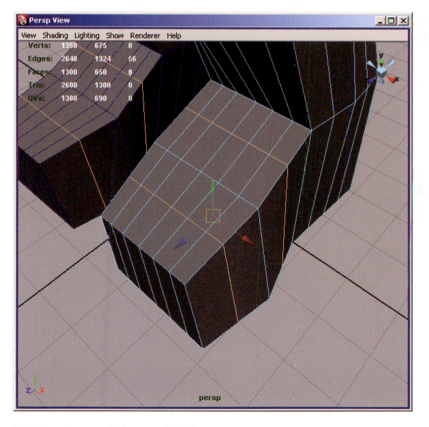

FIGURE 6-19 Insert two edge loops around the ball.

2. Take some time to smooth out the foot by manipulating the vertices and edges.

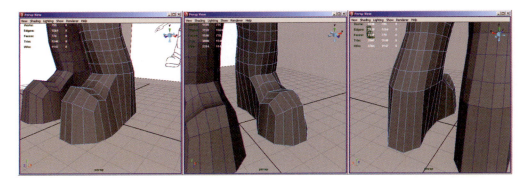

FIGURE 6-20 Smoothing out the foot.

3. Click Edit Mesh>Insert Edge Loop Tool to add a new edge loop around the foot. Remember to round it off around the heel and sides.

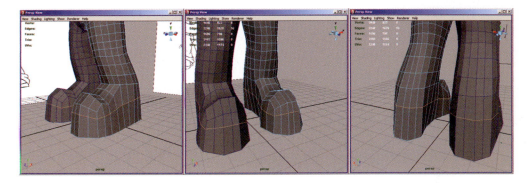

FIGURE 6-21 Insert a horizontal edge loop.

4. Click Edit Mesh>Insert Edge Loop Tool to an edge loop that will start forming the sole of the shoe. This should be pulled in slightly to help define the sole.

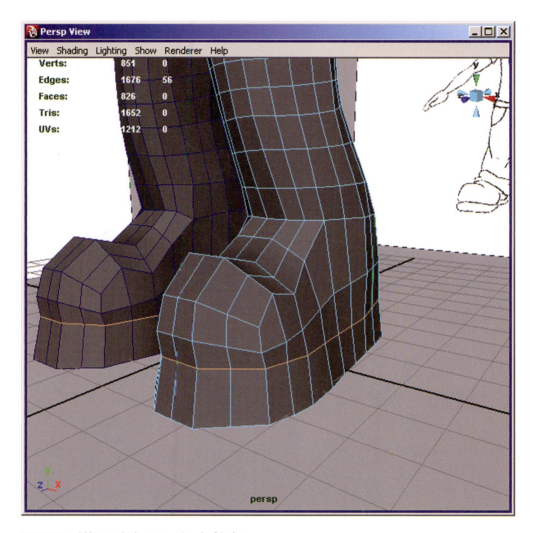

FIGURE 6-22 Adding an edge loop to start the sole of the foot.

5. Add two more edge loops to create the rest of the sole. The soles tend to stick out past the rest of the shoe, so pull the edges out as you rounding out the new polygons.

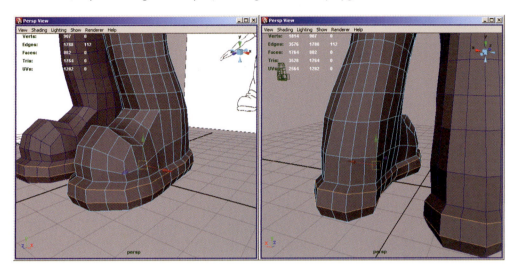

FIGURE 6-23 Finishing the sole.

6. The last thing needed for the foot is some extra edge loops around the ankle. Click Edit Mesh>Insert Edge Loop Tool to add two new edge loops. This is needed so the ankle will bend correctly.

FIGURE 6-24 Adding ankle edge loops.

Tutorial: Finishing the Arms

Detailing the arms for a video game character is fairly straightforward. Most muscle definition will be either painted on your creation using a normal map. Still, it's important to know how the muscles flow in the arms. The elbow and where the radius and ulna bones form the wrist are the main bony landmark masses of the arms. The deltoid, bicep, and triceps muscles are all prominent masses on the upper arm. On the anterior of the forearm, the prominent masses are the brachioradialis, flexor carpi radialis, and flexor carpi ulnaris muscle. On the posterior of the forearm, the main muscles are the flexor carpi ulnaris (wrapping around from the anterior), extensor digitorum, and extensor carpi radialis longus.

1. The vertical edge loops you earlier added to the torso run down the length of the arm. That means all you need to do is add the cross sections.
2. Click Edit Mesh>Insert Edge Loop Tool to add the extra edge loops along the arm. Remember to shape them and to keep them evenly spaced.

FIGURE 6-25 Adding arm edge loops.

3. Move the vertices and edges to round out the shoulders.

FIGURE 6-26 Adjusting the shoulders.

4. Adjust the edges in the biceps area to help better define the muscle.

FIGURE 6-27 Pulling out the biceps.

5. Adjust the vertices and edges on the rear of the arm to define the elbow.

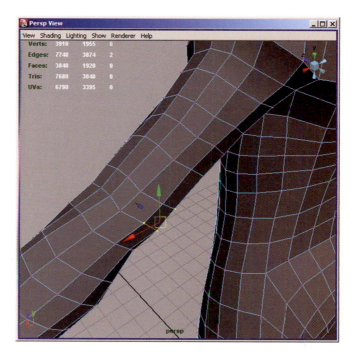

FIGURE 6-28 Creating the elbow.

6. Push and pull the edges and vertices in the forearm to help define the region.

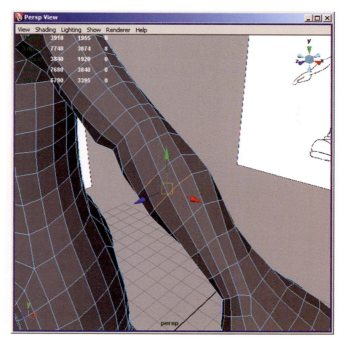

FIGURE 6-29 Shaping the forearm.

Tutorial: Creating the Hands

The hands can be fairly difficult to detail. Just keep an extra close eye on your anatomy references as you work and you should be okay. For video games, most of the work will be implied, but because the hands are so important, you will definitely want to add the extra detail to back of the hand. The knuckles, of course, are the main landmark areas on the backside of the hand. The thumb has two knuckles, while the remaining fingers each have three. Also visible on the back of the hand is the trapezium bone at the base of the thumb. The palm of the hand has a few predominant muscle groups: the thenar muscles (the large fleshy pad at the base of the thumb), the hypothenar muscles (the fleshy pad) on the pinky side of the hand, and lumbricales (the pads at the base of the fingers).

1. Because of the vertical edge loops added to the torso earlier, there are already enough polygons to allow you to begin working on the finger. Take some, to round off the index finger and the thumb.

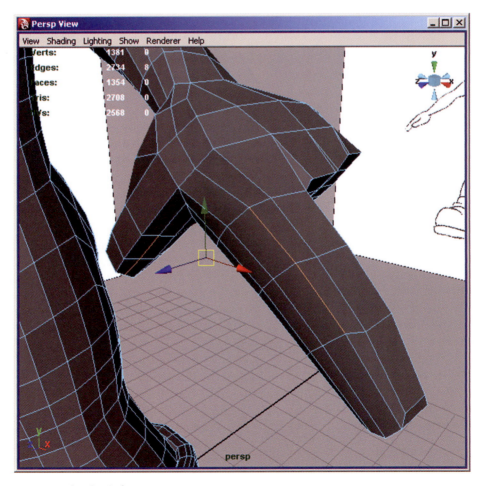

FIGURE 6-30 Rounding the fingers.

2. Click Edit Mesh>Insert Edge Loop Tool to add an edge loop mid-hand and continue shaping.

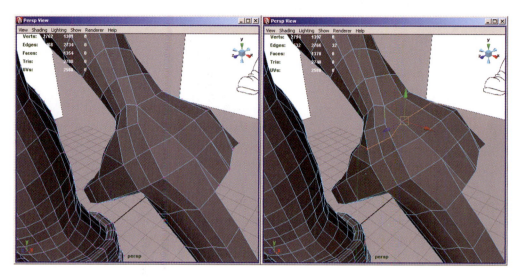

FIGURE 6-31 Hand edge loop.

3. Add another edge loop that travels through the middle of the thumb.

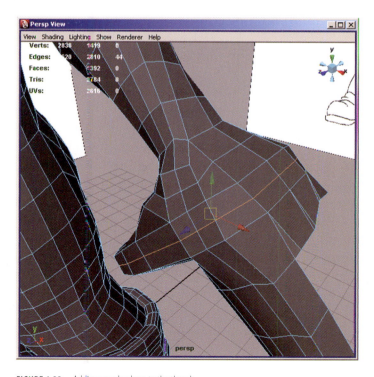

FIGURE 6-32 Adding an edge loop to the thumb.

4. Add an edge loop lengthwise through index finger. Make sure to round out the hand.

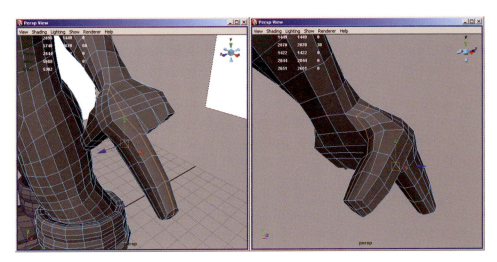

FIGURE 6-33 Edge loop through the index finger.

5. Now comes the hardest part of the hands, the knuckles. Insert two edge loops around the second joint of the index finger. This is the start of the middle knuckle.

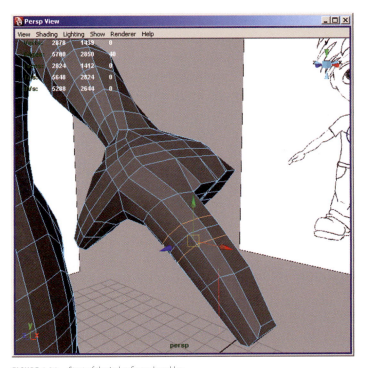

FIGURE 6-34 Start of the index finger knuckles.

6. Select and extrude the faces of the knuckle.

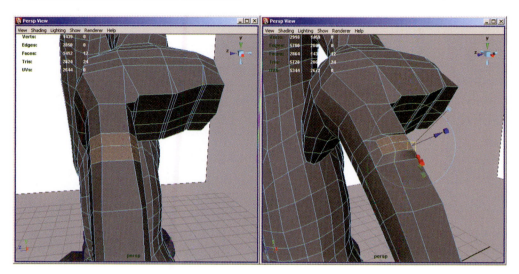

FIGURE 6-35 Extruded faces of the knuckle.

7. Shape the knuckle. Notice how it is flatter toward the base of the finger and has a sharper drop off toward the tip. Also, pull down the vertices on the side of the knuckle so it will blend into the finger.

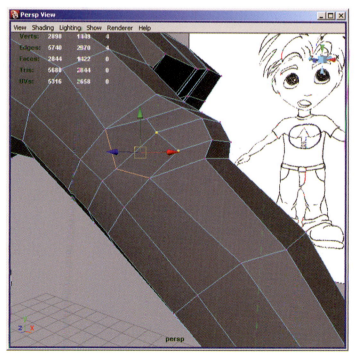

FIGURE 6-36 Shaping the knuckle.

8. Create the crease on the inside of the joint by moving the bottom edge up.

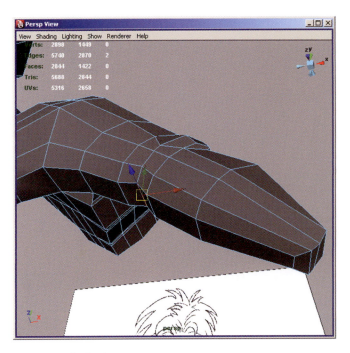

FIGURE 6-37 Creating the crease.

9. Pull the edges on the sides of the knuckle out to make the joint more prominent.

FIGURE 6-38 Finish shaping the knuckle.

Insert two edge loops around the third knuckle.

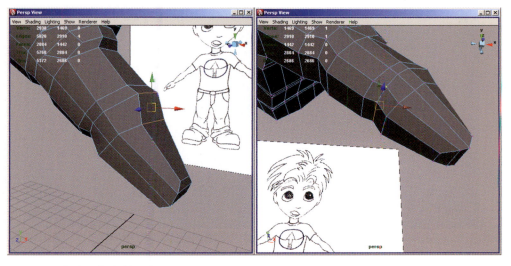

FIGURE 6-39 Starting the third knuckle.

10. Shape the knuckle as similar to the image below. The top edge is shifted up to form the prominent upper part of the joint. The bottom edge is pulled up to create the crease. Also note that top edge of the forward-most edge loop is shifted forward and down to create a base for the fingernail.

FIGURE 6-40 Finishing the third knuckle.

11. Add an edge loop for the base knuckle. Remember to create the crease.

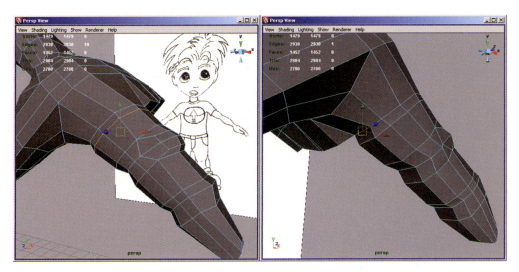

FIGURE 6-41 Starting the base knuckle.

12. Continue shaping the base knuckle by moving the topmost edge of the forward edge loop toward the end of the finger. This will help the knuckle blend into the hand.

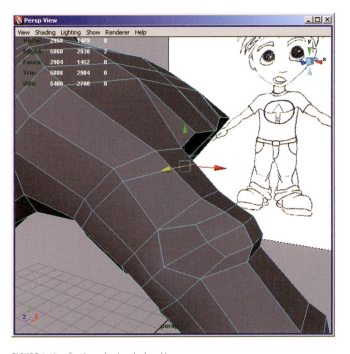

FIGURE 6-42 Continue shaping the knuckle.

13. Select the top two faces of the base knuckle and click Edit Mesh>Extrude. Extrude the knuckle out to its highest point. Switching the extrude operation to local mode by clicking on the transform gizmo will make this easier.

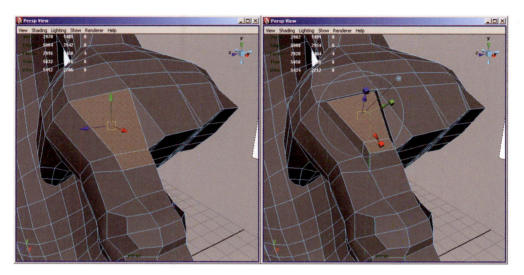

FIGURE 6-43 Extrude the base knuckle.

14. Finish shaping the base knuckle by moving the vertices and edges.

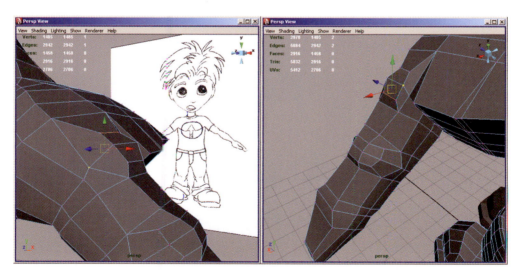

FIGURE 6-44 Finished base knuckle.

15. Now that the index finger is finished, we can easily create the remaining fingers by duplicating the faces. Select the faces of the index finger and click Edit Mesh>Duplicate Face. This will duplicate the selected face and turn them into a separate object. Whenever you perform object

mode operation like duplicate face, any instances you have created will disappear. When you are ready simply press Edit>Duplicate Special to recreate them.

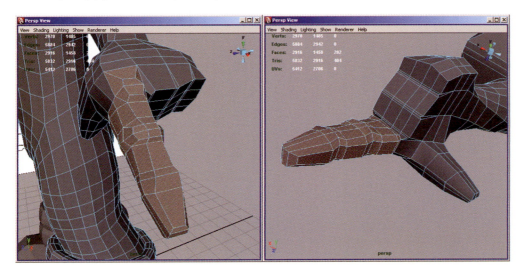

FIGURE 6-45 Faces to duplicate.

16. Select the duplicated faces and click Modify>Center Pivot. This will place the pivot point of the object in its center making it easier to move.
17. Duplicate the new finger object twice more and move them into the correct positions.

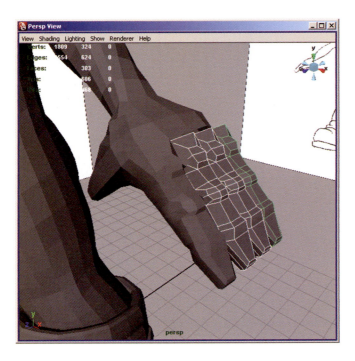

FIGURE 6-46 Duplicated fingers.

18. Use the scale tool to resize the duplicate fingers to the appropriate sizes.

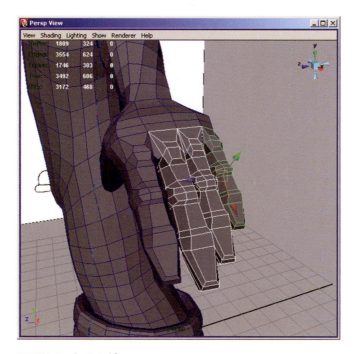

FIGURE 6-47 Duplicated fingers.

19. Before the fingers can be reattached, some polygons on the hand need to be deleted. If you forget to delete these internal faces, you can get strange results during rendering.

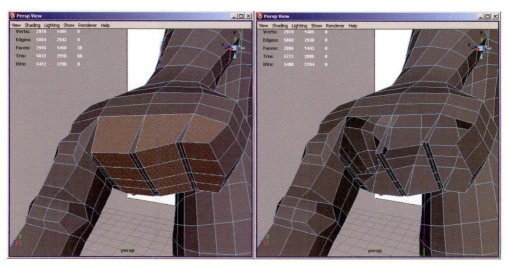

FIGURE 6-48 Faces to delete.

20. Now the objects are ready to combine. Press shift and select each of the fingers and the main character. Click Mesh>Combine. The objects are now a single mesh.

21. Be aware that Combine does not merge the vertices. It leaves double vertices at each of the connection points. Simply drag select all vertices in the hand and click Edit Mesh>Merge Vertices to merge the vertices together. You only want to merge vertices that are sitting directly on top of each other. If your threshold is too high it will have the undesirable result of moving vertices from far away before merging. If this happens simply undo the operation, lower the tolerance in Edit Mesh>Merge>□, and try again. A value of 0.0020 worked fine for me in this example.

22. Insert two edge loops around the second joint of the thumb and adjust the bottom edge to create a crease similar to how you created the middle knuckle on the index finger. This is the start of the second knuckle of the thumb. Remember that the thumb has only two knuckles.

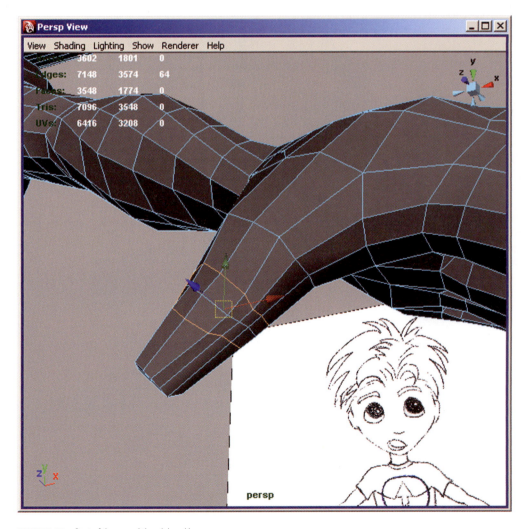

FIGURE 6-49 *Start of the second thumb knuckle.*

23. Select and extrude the faces of the knuckle.

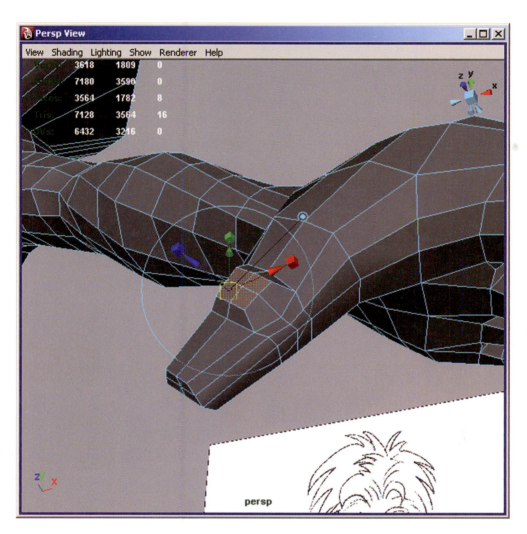

FIGURE 6-50 Extruded faces of the knuckle.

24. Shape the knuckle. Notice how it is flatter toward the base of the finger and has a sharper drop off toward the tip. Also, pull down the vertices on the side of the knuckle so it will blend into the thumb.

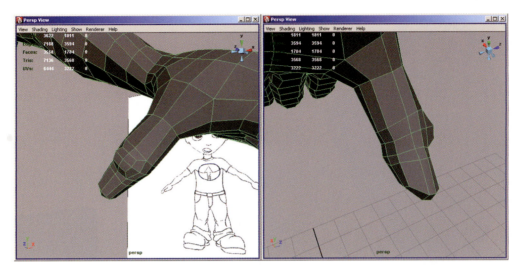

FIGURE 6-51 Finish shaping the knuckle.

25. Add some edge loops so you can round out the thumb.

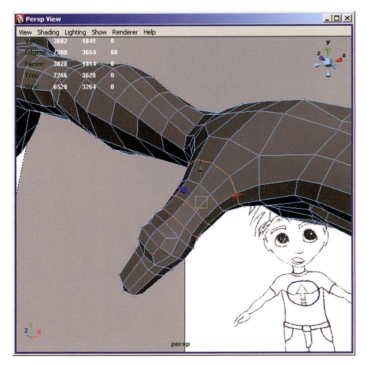

FIGURE 6-52 Extra thumb edge loops.

5. Add another edge loop that travels through the center of the mouth.

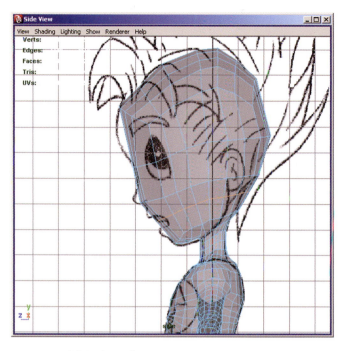

FIGURE 6-59 Splitting the mouth.

6. As you refine the new polygons, you want to start forming the outline of the nose, eyes, and mouth. The edges indicated in Figure 6-60 form a line that travels from the outside of the mouth, to the outside of the nose, and then to the inside of the eyes.

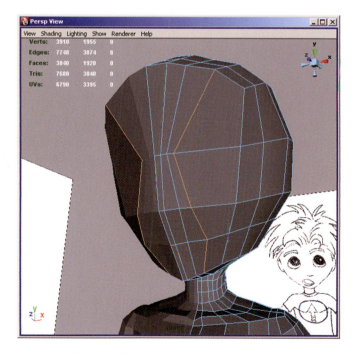

FIGURE 6-60 Shaping the face.

3. Add some edge loops to the neck. We need the extra detail here so the neck will deform correctly.

FIGURE 6-57 Neck edge loops.

4. Insert a new edge loop through the bottom of the nose. As always, refine the new edges after creation.

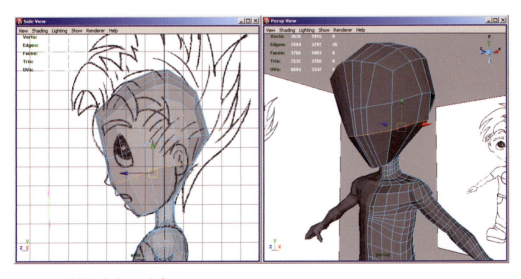

FIGURE 6-58 Adding edge loops to the face.

Tutorial: Finishing the Head

Of course, the head is one of the most intricate and difficult areas that you will model. The head, more than any other single area is what will make or break a character. If the modeling is not rock solid here, then your character won't have any appeal. The landmarks of the head are the eyes, nose, and mouth.

1. There are some new edge loops going through the head from some of the previous steps. Take some time now to adjust and refine the shape of the head by adjusting the edges and vertices.

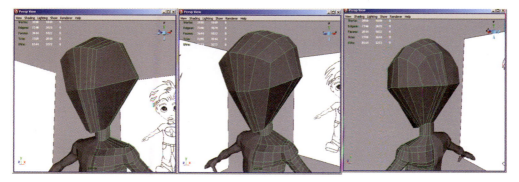

FIGURE 6-55 Refining the shape of the head.

2. We need to build up the transition between the torso and head. Add two edge loops to the trapezius muscle area. Refine the faces by moving the vertices to include the slightly concave shape of the trapezius muscle as well as the bony protrusions of the clavicle.

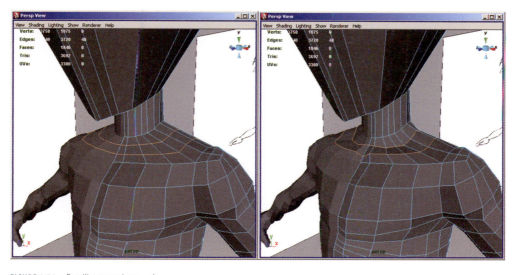

FIGURE 6-56 Detailing trapezius muscle.

26. Select and extrude the faces of the base knuckle of the thumb.

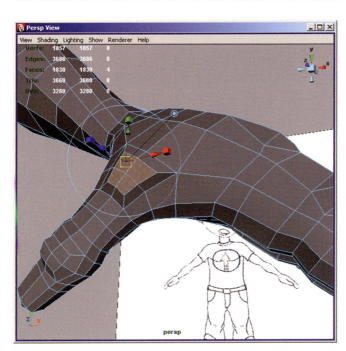

FIGURE 6-53 Extrude the faces of the first thumb knuckle.

27. The final bit of work on the hand is to adjust the vertices of the first thumb knuckle.

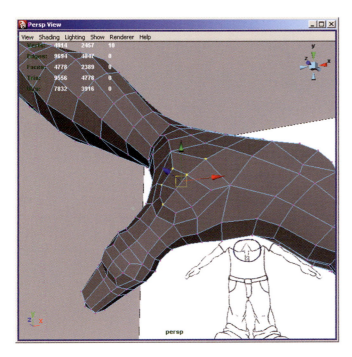

FIGURE 6-54 Final shaping of the first thumb knuckle.

7. Continue shaping the face until the outline of the eyes, nose, and mouth is complete. Here you can clearly see the two large polygons that will later form the eyes. The bump of the nose and mouth is also taking shape.

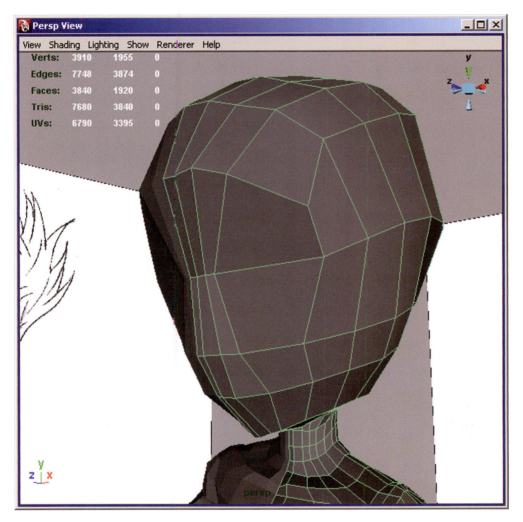

FIGURE 6-61 Continue to refine the face.

8. Select the faces that will form the nose and brow ridge and Click Edit Mesh>Extrude to bring them out to about the tip of the nose.

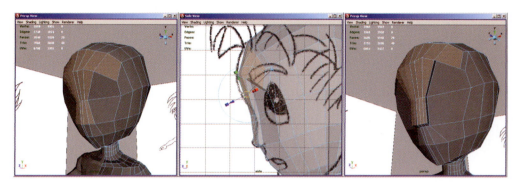

FIGURE 6-62 Creating the nose and brows.

9. Don't forget that any time you extrude along the YZ axis it will add an internal face that needs to be deleted.
10. There may be some errant vertices that are off the center axis. Select those vertices, type move −x 0; in the command line and press enter to have them snap to the YZ axis.
11. Continue refining the face by adjusting the vertices of the new polygons.

FIGURE 6-63 Continue refining the face.

12. Click Create>Polygon Primitives>Sphere to add a sphere that will be used as an eye. Rotate it so the pole can be used as the pupil. Resize it as needed and place it in the appropriate spot. It's very important to have the eye in place before you start shaping the eye socket, otherwise, it becomes very difficult to get the socket mesh to drape around the eye correctly. After the eyeball is in place, you might want to put it on a separate display layer and template it so you won't have to worry about accidentally moving it while you work.

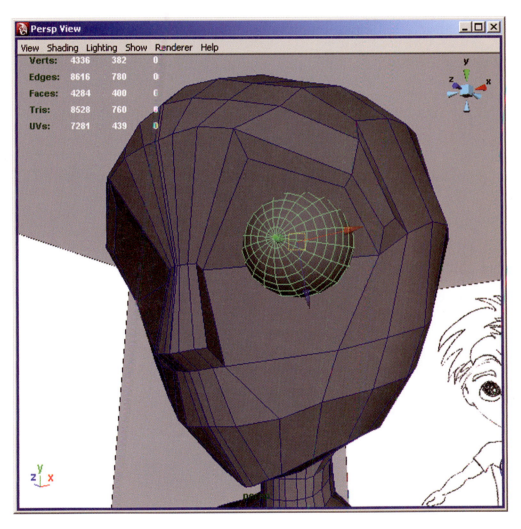

FIGURE 6-64 Placing the eyeball.

13. Select the two faces of the eye socket and click Edit Mesh>Extrude, however, DO NOT extrude them out with the manipulator. Instead use the scale tool to size the new polygons down. This is a great way to add detail. Everything remains in quads and the edge loops flow correctly.

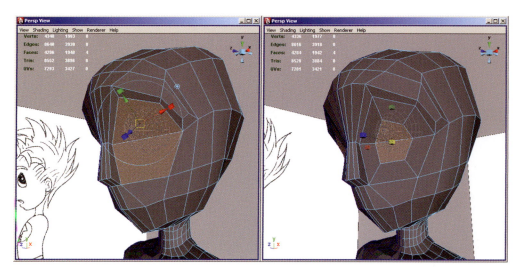

FIGURE 6-65 Starting the socket.

14. Move the vertices so the new faces match the outline of the eyeball.

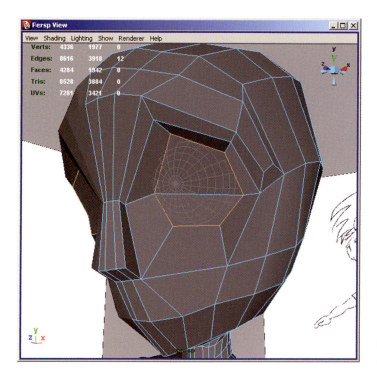

FIGURE 6-66 Shaping the socket.

15. Create a new edge loop that will form the eyelids.

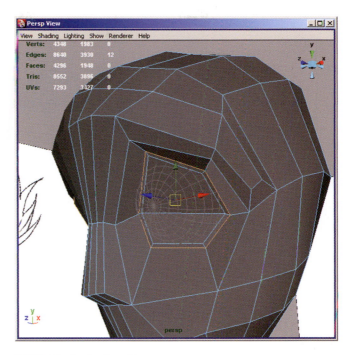

FIGURE 6-67 Creating the eyelids.

16. Select the new faces of the eyelids and extrude them out to add depth to the lids.

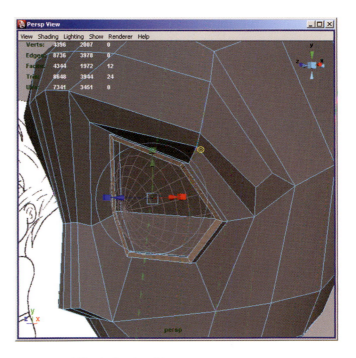

FIGURE 6-68 Adding depth to the eyelids.

17. Right now the lids still need some work. Select the back vertices of the eyelids and move them out to form the outer edges of the lids.

FIGURE 6-69 The outer eyelids.

18. Create an edge loop on the rim of the eyelids and scale it in some to add more depth to the lids.

FIGURE 6-70 The rim of the eyelids.

19. Extrude the original two polygons of the eye socket back, scale them down a bit and then delete them. Scaling them down will allow the eyeball to sit more naturally in the socket. Deleting these faces allows you to later add edge loops that terminate at the back of the eye instead of traveling the entire length of the character.

FIGURE 6-71 Extrude the socket back.

20. Now you need to start adding edge loops so you can mold the eyelids around the ball. Remember to round out the edges all along the length of the newly added edge loops.

FIGURE 6-72 Adding edge loops to the eyelids.

21. Adjust the vertices of the new edge loops where they meet up with the eyeball so that they mold correctly around it.

FIGURE 6-73 Molding the new edge loops to the eyeball.

22. Insert a new edge loop around the eye.

FIGURE 6-74 New edge loop around eye.

23. Start shaping the nose to match your reference.

FIGURE 6-75 Shaping the nose.

24. Select and extrude the nostrils. Don't forget to clean up the middle edge by deleting internal faces and using the move −x 0; to snap the vertices back to correct axis.

FIGURE 6-76 The nostrils.

25. Next form the inside of the nostrils. Select the two faces at the bottom of the nose and click Edit Mesh>Extrude; however, DO NOT extrude them out with the manipulator. Instead use the scale tool to size the new polygons.

FIGURE 6-77 Starting the inner nostrils.

26. With the inner nostril faces still selected extrude them up into the nose.

FIGURE 6-78 Extrude nostrils into nose.

27. Add an edge loop to the inside of the nose and adjust it to give a nice round transition to the inside of the nostril.

FIGURE 6-79 Rounding the nostrils.

28. To create the mouth, select the two polygons of the lips and click Edit Mesh>Extrude; however, DO NOT extrude them out with the manipulator. Instead use the scale tool to size the new polygons. You will need to clean up the middle edge by deleting the internal faces and using the move −x 0; to snap the vertices back to correct axis.

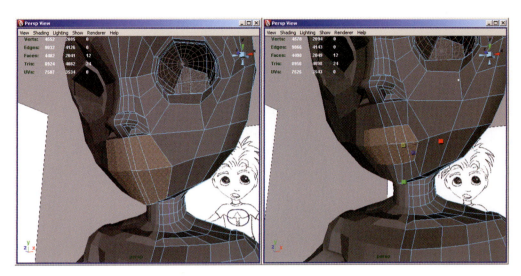

FIGURE 6-80 Starting the mouth.

29. Adjust the vertices to get the desired mouth shape.

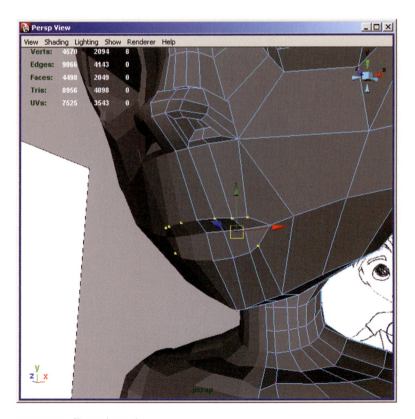

FIGURE 6-81 Shaping the mouth.

30. Add an edge loop around the mouth. Keep shaping the mouth until you get the correct outline.

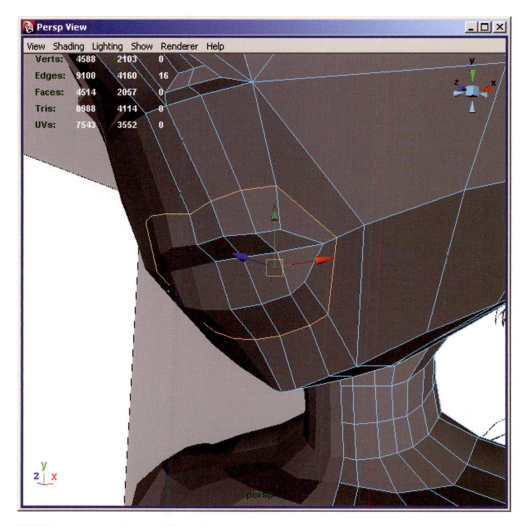

FIGURE 6-82 Insert an edge loop around the mouth.

31. Select the faces of the lips and extrude them forward and inward slightly. By using a series of small extrudes, the lips can be rounded off and still have the correct topology.

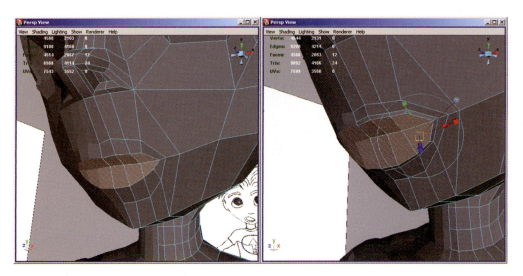

FIGURE 6-83 *Beginning lip extrude.*

32. Continue to perform extrudes and rounding them off until you get the character's outer lips complete. Don't add too many polygons. Four rows of polygons were fine for my character.

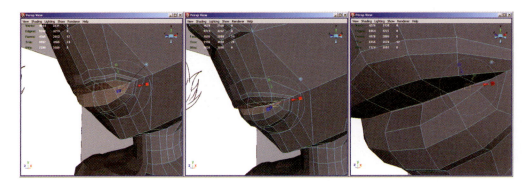

FIGURE 6-84 *Finishing outer lips.*

33. Extrude the inner-most polygons of the lips back to start forming the inside of the mouth. Remember to delete the faces created on the YZ axis.

FIGURE 6-85 Starting inside of mouth.

34. Continue to extrude in small amounts as you curl the edge to form the inside of the lips.

FIGURE 6-86 Forming the inside of the lips.

35. Once you have the inside of the lips done, extrude the faces back to form the inside of the mouth and down into the throat.

FIGURE 6-87 Finishing the interior mouth.

36. Before moving on to the rest of the head, finish up the face, add extra edge loops if needed or change the flow of any that are errant. These can all be done by using the Split Polygon Tool to rebuild the polygons or with an auto face spinning script (remember there are some really good ones available on Highend3D.com).

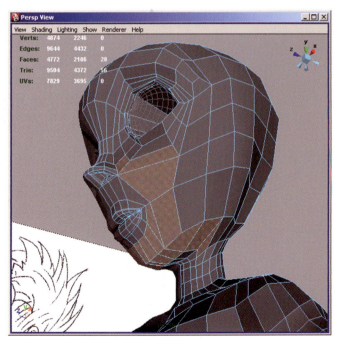

FIGURE 6-88 Areas that need touch up on the face.

37. Insert an edge loop at the bottom corner of the mouth. We actually only need the part of this edge loop that goes into corner of the mouth. The remaining edges that go around the head will be deleted later.

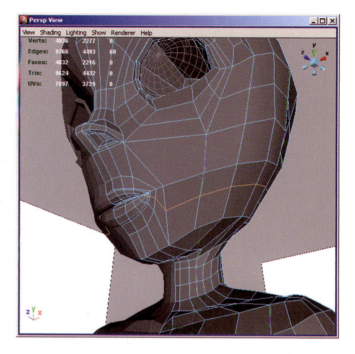

FIGURE 6-89 Edge loop at bottom corner of mouth.

38. Use the Split Polygon Tool to create a new row of edges around the bottom part of the chin.

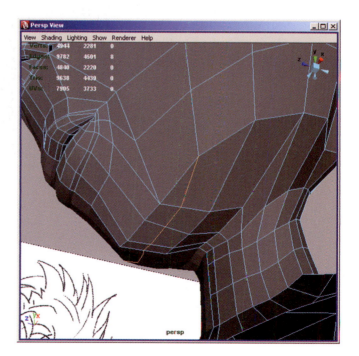

FIGURE 6-90 Splitting the chin.

39. Use the Split Polygon Tool to change direction along the newly created edge loop. This may leave you with some triangles that should be deleted.

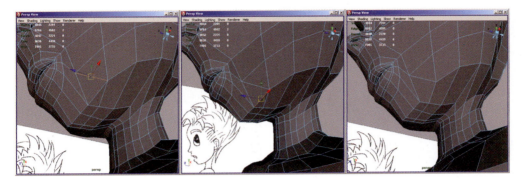

FIGURE 6-91 Changing direction.

40. Delete the left-over edges. Because we changed direction on a few edges, these edges are now unused.

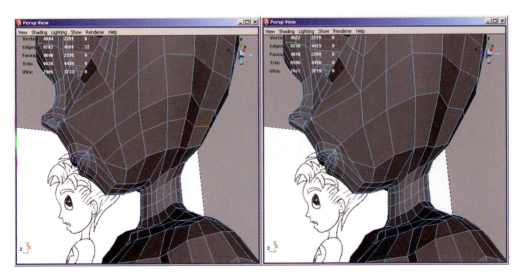

FIGURE 6-92 Remove unused edges.

41. Long, thin, and pointy polygons like the one under the chin should be avoided if possible, especially in an area that can deform. Use the Split Polygon Tool to create a new edge through the polygon. Then delete the offending edges and vertices.

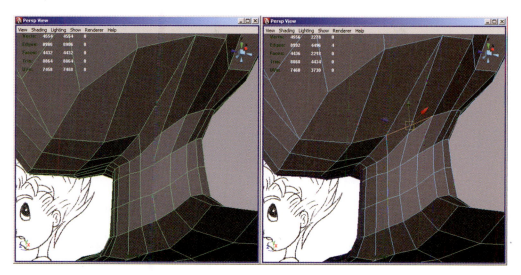

FIGURE 6-93 Cleanup long thin polygons.

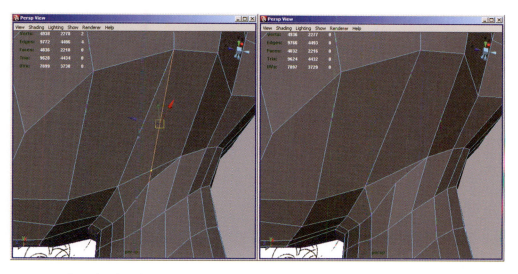

FIGURE 6-94 Cleanup long thin polygons.

42. Now that the edge loops through the chin are all correct, take some time to round out the area.

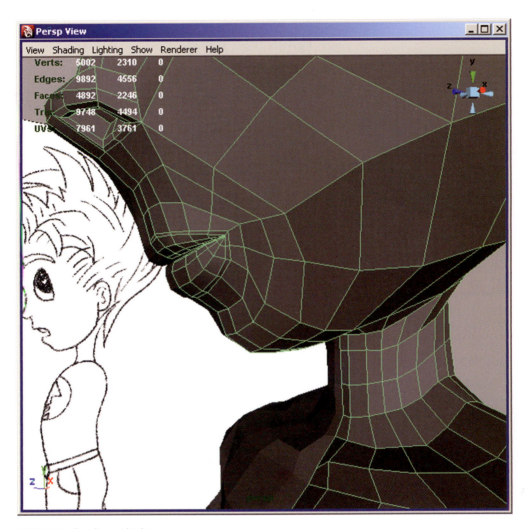

FIGURE 6-95 Rounding out the chin.

43. Change the direction of the faces that form the start of the nasolabia folds.

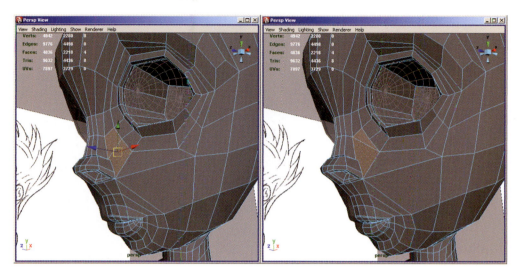

FIGURE 6-96 Start of nasolabia folds.

44. Next change the direction for the faces comprising the rest of the nasolabia folds.

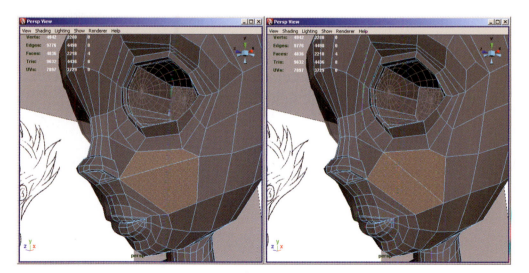

FIGURE 6-97 The rest of the nasolabia folds.

45. Split the polygon just above the nasolabia folds into a triangle. It would be good to have more detail around the upper corner of the mouth. Keeping in mind that an edge loop terminates at a triangle, we can use that for our advantage. Just remember to clean up the triangle afterward.

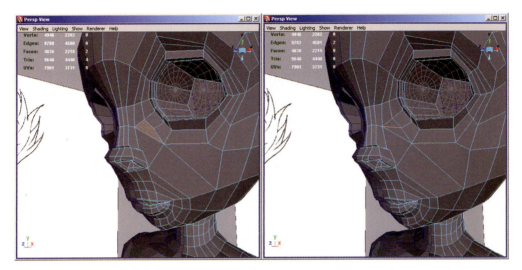

FIGURE 6-98 Adding detail.

46. Insert a new edge loop at the upper corner of the mouth. Notice how it travels around the eye then stops at the triangle we added. We only need the extra detail at the corner of the mouth, so delete the edges traveling around the eye.

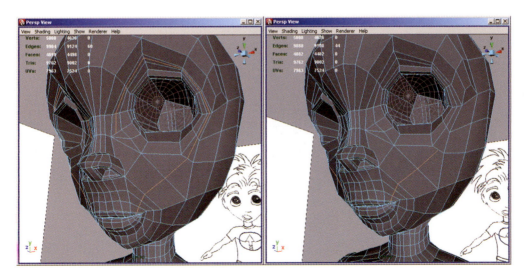

FIGURE 6-99 Adding edge loop.

47. Now we need to clean up the triangles. Split the polygon just outside the nostril.

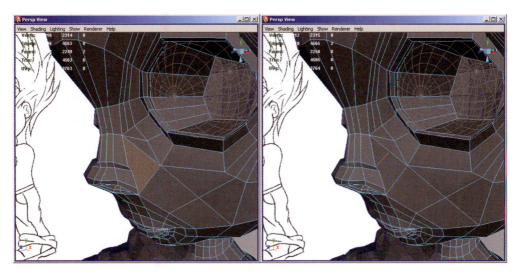

FIGURE 6-100 Cleaning up the triangles.

48. Snap the upper vertex to the top of the new edge and then merge the two vertices together.

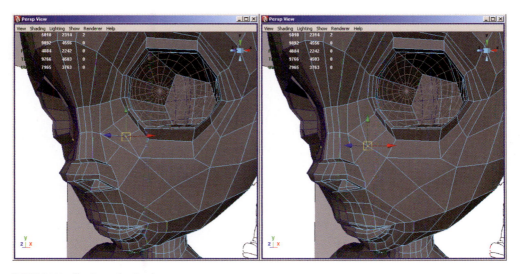

FIGURE 6-101 Cleaning up the triangles.

49. To finish cleaning up the triangle, use the Split Polygon Tool and merge vertices to redo the edges near the bridge of the nose.

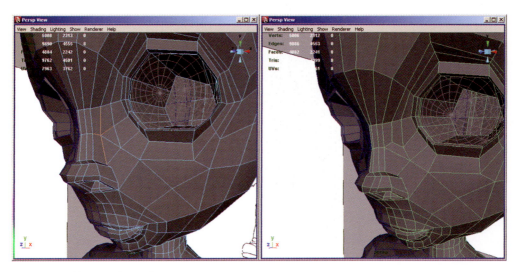

FIGURE 6-102 Cleaning up the triangles.

50. Next insert a new edge loop at the bottom of the eyelid and delete the last half of the edges. This will allow us to clean up the cheek area.

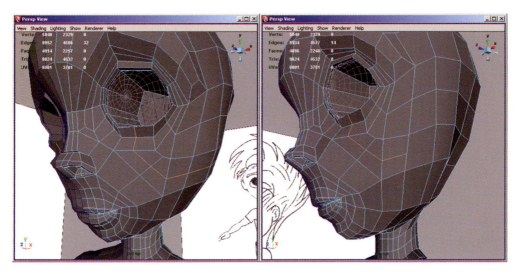

FIGURE 6-103 Adjusting the cheek.

51. Move and merge the vertices. The upper vertex merges with the one next to it, while the lower highlighted vertex merges with the one under it.

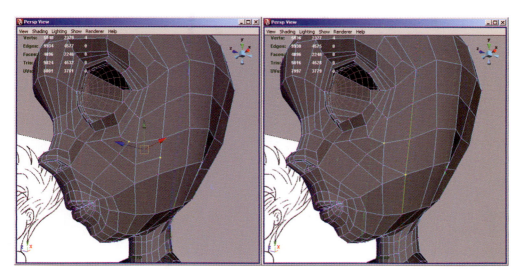

FIGURE 6-104 Adjusting the cheek.

52. Delete the edges that are causing the triangles.

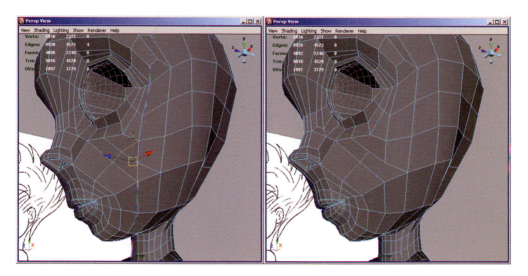

FIGURE 6-105 Delete edges.

53. Move and merge the final vertex to finish changing the cheek into clean quads. Take some time to smooth out the polygons.

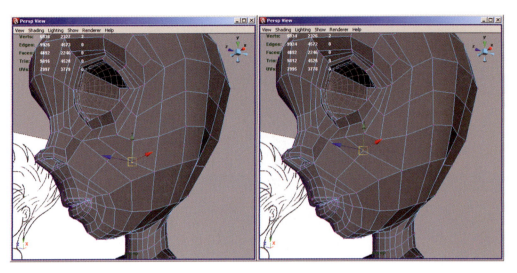

FIGURE 6-106 Merging the final cheek vertex.

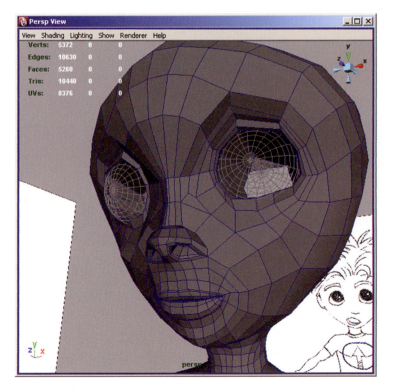

FIGURE 6-107 Smoothing out the face.

54. Using the extrude/scale method, shape the base for the ear on the side of the head.

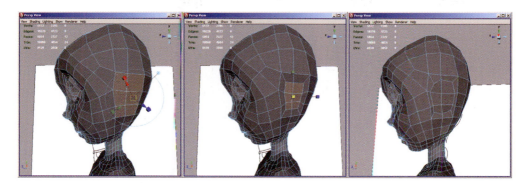

FIGURE 6-108 Starting the ear.

55. Extrude the ear polygons.

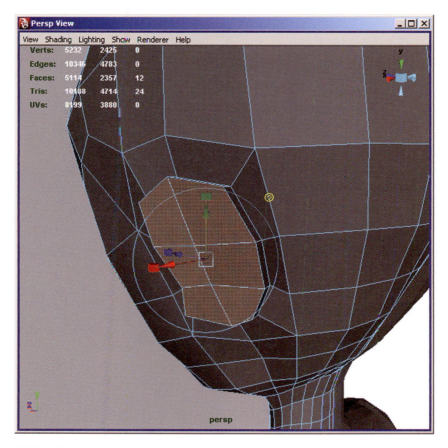

FIGURE 6-109 Extrude the ear.

56. Use the extrude/scale method to get the ridge of the ear.

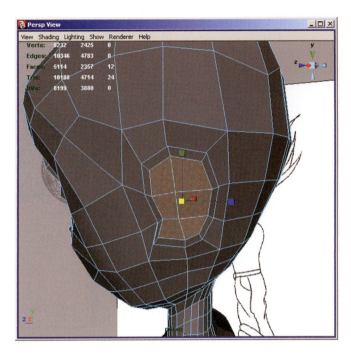

FIGURE 6-110 Ear ridge.

57. Use the Split Polygon Tool to change the direction of the edges in order to define the crus (or front part) of the helix of the ear.

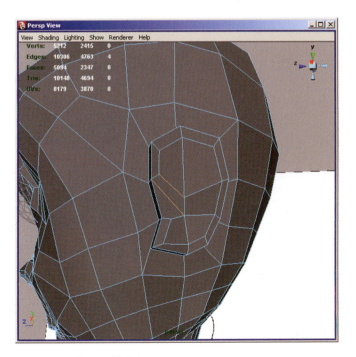

FIGURE 6-111 The crus of the helix.

58. Extrude the helix and lobe.

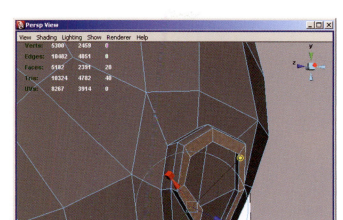

FIGURE 6-112 Creating the helix and lobe.

59. Extrude the inner face inward twice so that you get a plateau.

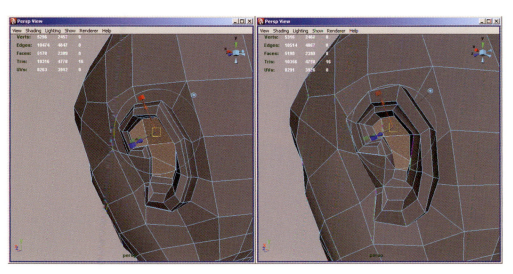

FIGURE 6-113 Creating the inside of the ear.

60. Finish the ear by changing direction of the intertragic incisure (the hard part above the lobe) so it blends into the surrounding ear. If the ear isn't deep enough, simply push in the faces to your liking.

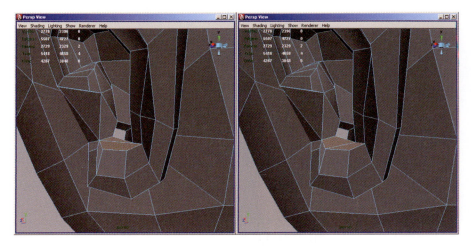

FIGURE 6-114 Finishing the ear.

Tutorial: Creating Clothes

All of the character's extras like clothing and hair are now ready to be created. Because a low-polygon count must be strictly enforced, many video game characters will have these items built directly into the mesh.

Before the cuffs of the pants can be created a bit of prep work is needed on the legs. This is done by extruding selected edges of the lower leg and wrapping them back down around the ankles to give them depth.

1. Click Select>Select Edge Loop Tool to select the mid-calf edge loop and move it down to the ankle. This does two things for us. One, it adjusts the topology so we can begin creating the cuffs. Two, it gives us more polygons around the ankle so it will deform correctly.

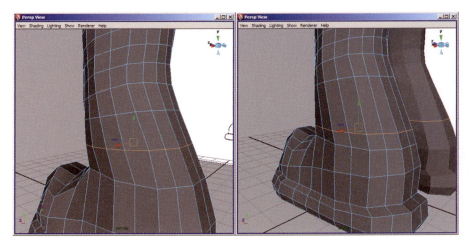

FIGURE 6-115 Preparing for the pants cuffs.

2. If needed insert an extra edge loop through the ankle.

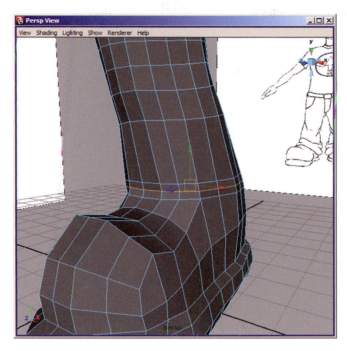

FIGURE 6-116 Inserting extra ankle loop.

3. Select the faces where you want to insert the cuffs and click Edit Mesh>Cut Faces Tool. Click in the middle of the select faces and drag the manipulator until you get the desired angle for the cut. The Cut Faces Tool can work on an entire object or, as in this case, only on selected faces.

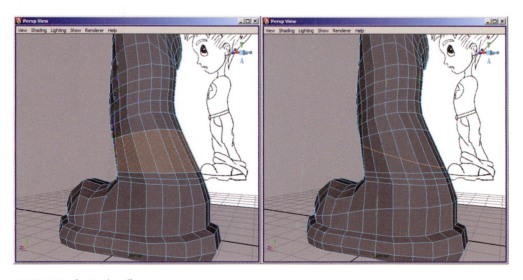

FIGURE 6-117 Starting the cuffs.

4. Select the edges that you just inserted and extrude them out to begin forming the cuffs of the pants.

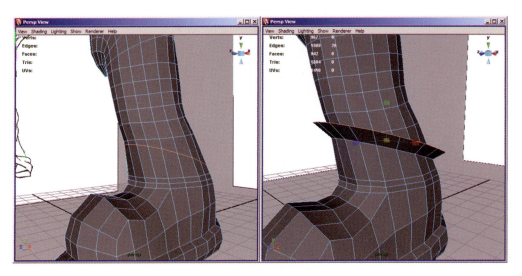

FIGURE 6-118 Creating the cuffs.

5. Continue extruding the cuffs, shaping as you go.

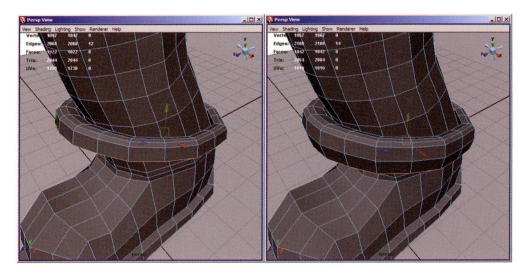

FIGURE 6-119 Continuing work on the cuffs.

6. After extruding the cuffs, take some time to shape them into a more interesting final design.

FIGURE 6-120 Finishing the cuffs.

The short sleeve shirt is created in the same fashion as the cuffs of the pants. By extruding just a few edges, the polygon count for the low-res characters stays within the limits of your pipeline.

Extruding edges to form the shirt sleeve

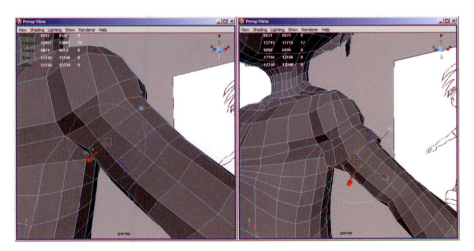

FIGURE 6-121 Starting the sleeves.

Extrude the edges down to create the sleeve. Remember to curl the edges back in the sleeve to add some depth.

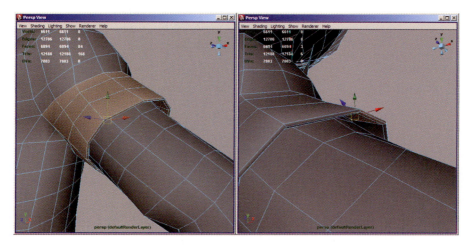

FIGURE 6-122 Finishing the sleeves.

Tutorial: Adding Hair

Hair for low-res characters is best created as polygonal strips. By layering the strips you can give the illusion of a full head of hair yet still achieve a reasonable polygon count.

The other option for creating hair is to use dynamics. Unfortunately, because of the real-time game engine demands, dynamic hair can't be used for in-game characters.

1. Go to Create>Polygon Primitives>Plane□. Set the width to 12 and the height to 1. Make sure that Create UVs is checked. This will create a simple polygon plane that can be used to create strips of hair. It's important to use the fewest amount of polygons needed for each hair strip. You also want to make sure to have the UVs created at the beginning, as they would be too difficult to create after the hair has been shaped.

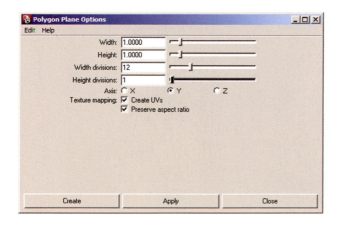

FIGURE 6-123 Polygon plane options for creating hair.

FIGURE 6-124 Hair plane.

2. Press Ctrl + d to duplicate the plane. Rather than creating a new plane for each hair strip, simply duplicate the first one created when a new one is needed.
3. Use move and rotate to position the duplicate plane where the hair would connect at the root of the scalp.

FIGURE 6-125 Positioning the hair plane.

4. Scale the hair to the appropriate length and width.

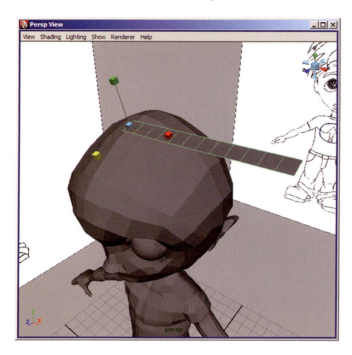

FIGURE 6-126 Lengthening the hair.

5. Using component mode, shape the hair to follow the head.

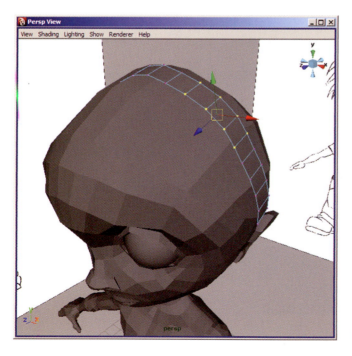

FIGURE 6-127 Shaping the hair plane.

6. Taper the end of the hair. This will give a more natural look to the hair.

FIGURE 6-128 Tapering the end.

7. Duplicate the shaped hair strip and position along the root of the scalp.

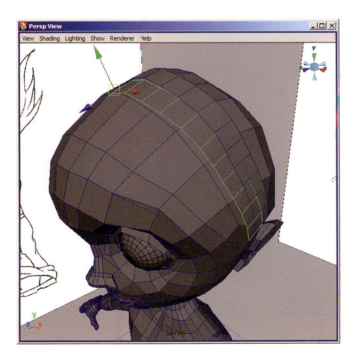

FIGURE 6-129 Placing duplicated hair strips.

8. If needed, use component mode to shape the duplicate strip.

9. Continue duplicating and shaping the strips until you have a base layering of hair.

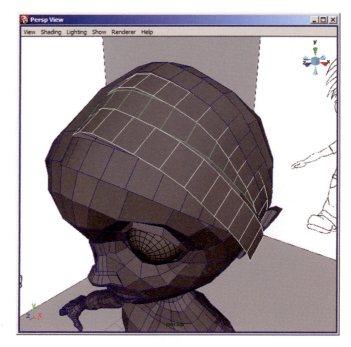

FIGURE 6-130 Continuing to place the hair strips.

10. Duplicate the original plane and begin adding smaller strips of hair. These extra strips add volume and are needed to make the hair more believable. It's okay to have these strips flow in slightly different directions to make them behave more like real hair.

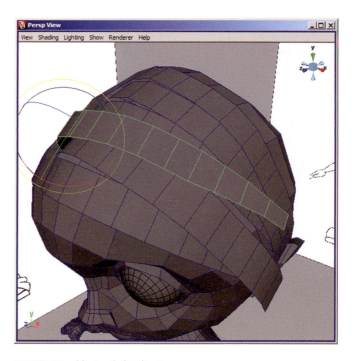

FIGURE 6-131 Adjusting the hair direction.

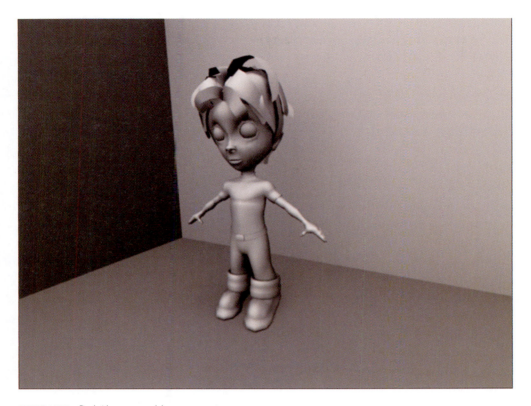

FIGURE 6-132 Final video game model.

Now that you've built your video game character, it's time to move on to UV mapping and texturing in Chapter 9. Keep in mind, when modeling video game characters it's very important to stick to the polygon limits given for the engine you are using. If you end up going over the limit, it can be difficult to remove the extra polygons from the model. Also keep in mind that it's more important to remove any *n*Gons that might slip into the mesh. An *n*Gon is a polygon with more that four sides. These will not work within a game engine.

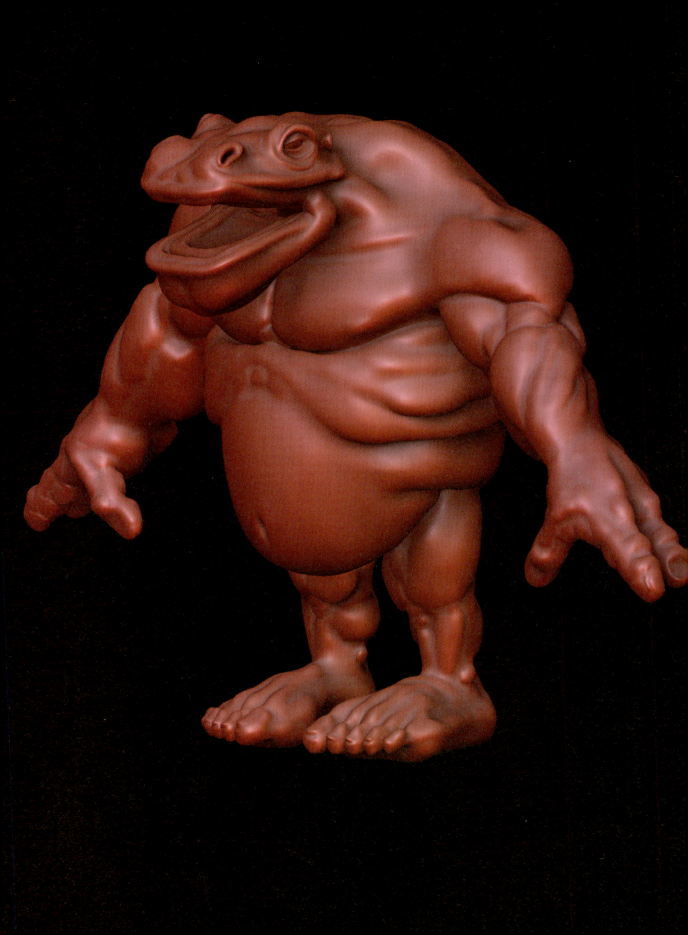

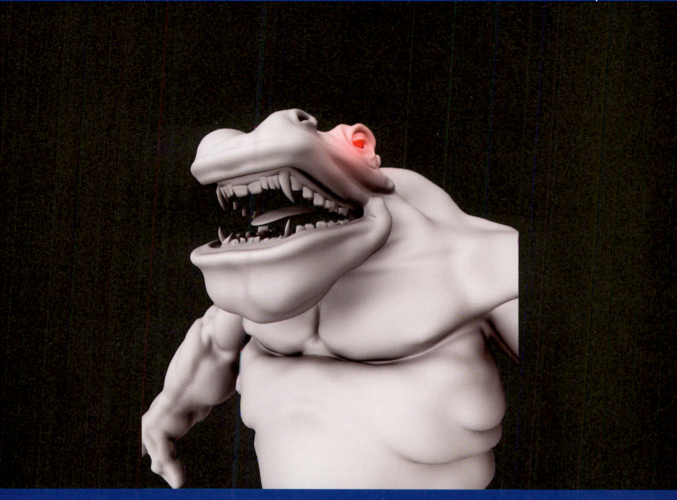

Creating a Hyperreal Character

Hyperreal characters are seen in virtually every science fiction and fantasy film that comes out. Hyperreal is a term used to describe realistic characters that are not based on a specific real-world reference. You can't just take a cat, throw wings on it and call it hyperreal. In order for the character to come across as realistic, there must be some logic to its anatomy. The wings must be attached to the body correctly. Care then must be given when designing a hyperreal character.

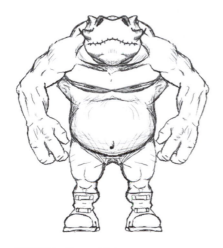
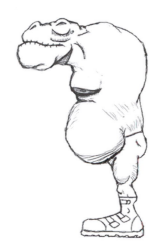

FIGURE 7-1 Hyperreal design.

For example, take Davy Jones from the movie *Pirates of the Caribbean: Dead Man's Chest*. First off, he is humanoid; he has two arms, the mouth and eyes are set where a normal human's mouth and eyes would be. Secondly, he has realistic octopus tentacles on his face and head. Because the human and octopus parts are blended in a believable way, the character can be considered hyperrealistic. In this case, the anatomy of a human and an octopus were blended seamlessly together to create an unforgettable character. If the differing anatomies hadn't been blended together well enough, the character would have come across as unbelievable.

FIGURE 7-2 Troll.

When designing a hyperreal character, I can't stress enough how important it is to pull open the anatomy books and do research on the web. Using proper references, you can design just about anything.

FIGURE 7-3 Troll.

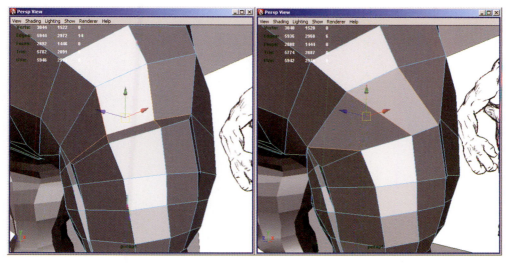

FIGURE 7-4 Creature.

Creating believable characters is always your main goal. Be it a monkey-bear or human with shark teeth, by designing the character with sound anatomy, you can make your hyperreal character believable.

With the blocking complete, it's time to begin adding detail to the mesh. Just as we did during the blocking stage, it's important to build your detail slowly and shape the model as you work.

Tutorial: Adding Detail to the Torso

Let's look at detailing the torso first. The main bony masses of the torso are the hips, ribcage, and collarbones on the front and the hips and shoulder blades on the back. The main muscle masses on the front are the pectoral, trapezius, abdominal, and oblique muscles. The main muscles on the back are the latissimus dorsi and trapezius muscles.

At this point, our character just doesn't have enough polygons to properly define the different features of the torso. What we need to do is add enough edge loops so we can shape the landmark areas yet still keep the polygon count down. Remember our mantra, "Add a loop and shape the components."

1. Open the character that you previously blocked out.
2. Select Edit Mesh>Insert Edge Loop Tool to insert an edge loop just above the edge created during the blocking stage that defines the center of the pectoral muscle. As always, shape the edges as you add them. In this case, scale the edges to better round out the center of the pectorals.

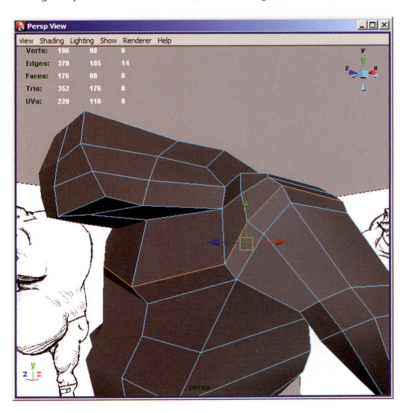

FIGURE 7-5 Creating the pectoral muscles.

3. Next, insert an edge loop at the bottom of the pectoral muscles. This loop will also travel around to the back helping to define the latissimus muscles.

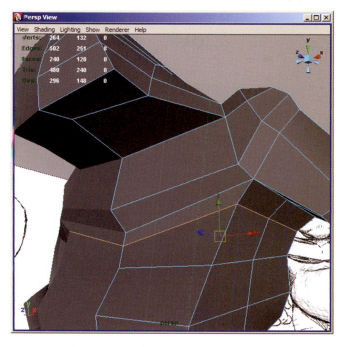

FIGURE 7-6 Defining the bottom of the pectorals.

4. Insert a vertical edge loop near the centerline of your character. This will define the sternal region on the front of the torso and the spinal region on the back.

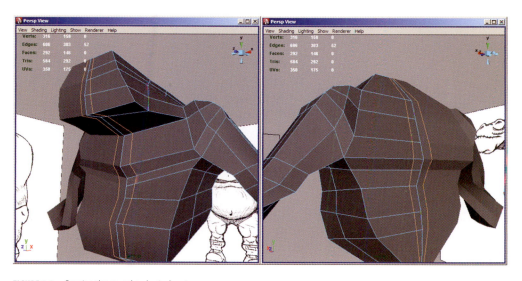

FIGURE 7-7 Creating the sternal and spinal regions.

5. Add another vertical edge loop in the center of the chest. This will help you to correctly define the shape of the torso.

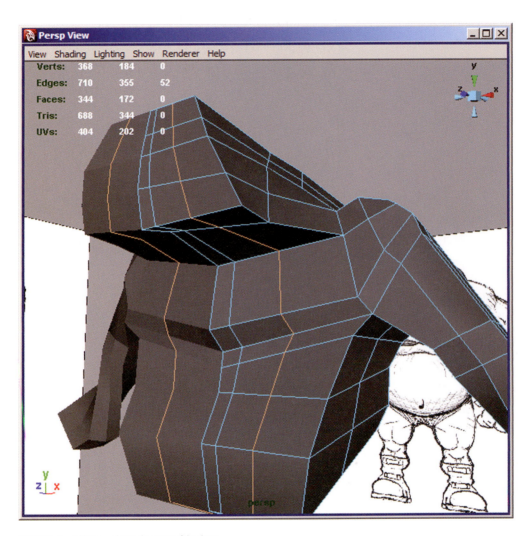

FIGURE 7-8 Adding an edge to the center of the chest.

6. Take some time to round off the edges that you've added. Move edges to get broader adjustment. For finer control, adjust the vertices.

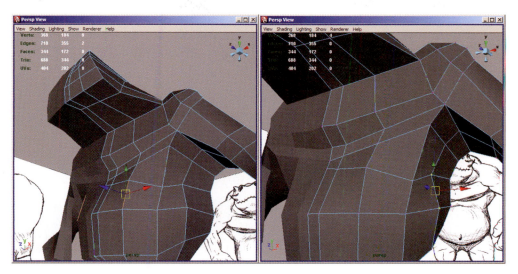

FIGURE 7-9 Round off the new edges in the belly.

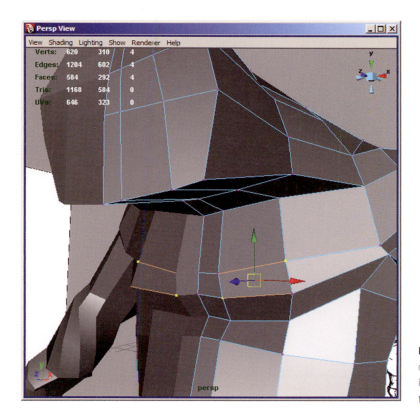

FIGURE 7-10 Adjust the chest. Remember to push in the center vertical edge to define the sternal region.

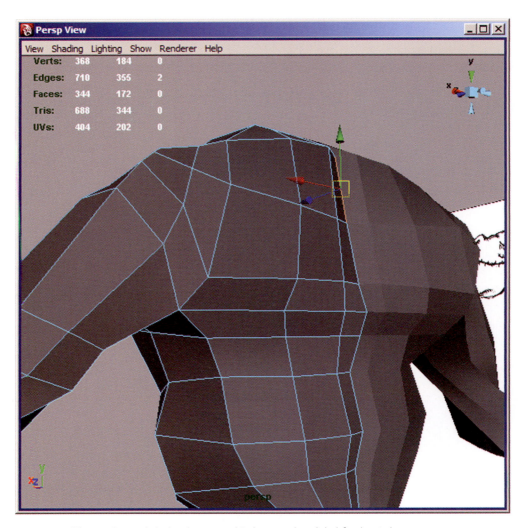

FIGURE 7-11 When rounding out the back, make sure to push in the center edge to help define the spinal area.

7. Adjust the edges on the side of the torso to define the latissimus muscles.

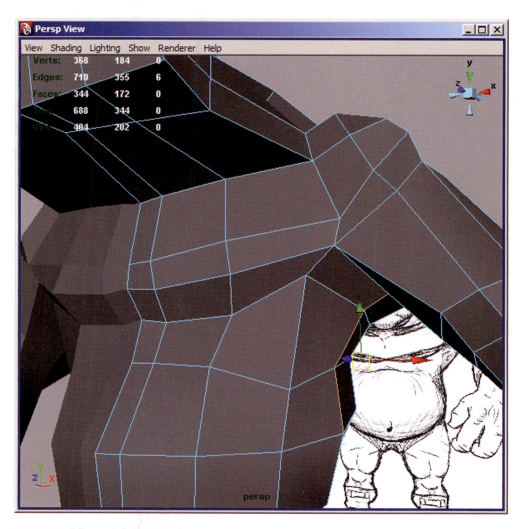

FIGURE 7-12 Pulling out the latissimus muscles.

8. Next, add an edge loop to define the ribcage and adjust to match your template. It's always a good idea to adjust the entire section of the model as you work, as it will help you keep the correct proportions. Typically, I will add some detail to the front, then shift around and add a bit to the back, and finally move back to the front for more adjustments.

FIGURE 7-13 Adding the ribcage.

9. Select and extrude the faces of the back that makeup the trapezius, infraspinatus, and teres major muscles. The infraspinatus and teres major muscle sit on top of the shoulder blade.

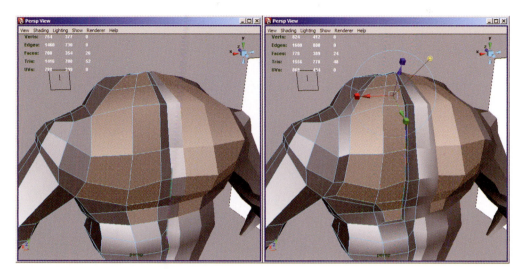

FIGURE 7-14 Creating the muscles of the back.

10. Select and delete the edges indicated in Figure 7-81. The muscles are not flowing very well near the shoulders. By changing the direction of the polygons at the start of the row, you can get the muscles to blend into the mesh quite nicely.

FIGURE 7-15 Preparing to change muscle direction of the shoulders.

11. Use Edit Mesh>Split Polygon Tool to insert new edges effectively changing the direction of the muscle flow. There are some really nice scripts available on the web that allow you to automatically change the direction of adjacent polygons so you don't have to split them manually. This can be a huge time saver. Take a look at http://www.highend3d.com to see what is available.

FIGURE 7-16 Completing the change in muscle flow.

12. Select the faces on the side of the body and extrude out to form the obliques (a.k.a. love handles).

FIGURE 7-17 Adding the obliques.

13. Similar to the shoulders, you also want to change the direction of the polygons leading into the obliques to give more natural muscle flow. Select the edges at the front of the oblique and delete them.
14. Use Edit Mesh>Split Polygon Tool to insert the new edges effectively changing the direction of the muscle flow.

FIGURE 7-18 Changing the muscle flow of the obliques.

FIGURE 7-19 *Completed changes to the oblique muscles.*

15. Don't forget to adjust the back of the obliques. Using the same method as with the front, delete edges and split the polygons (or use an Automatic Polygon Spin Tool for this) of the back to give a more natural muscle flow.

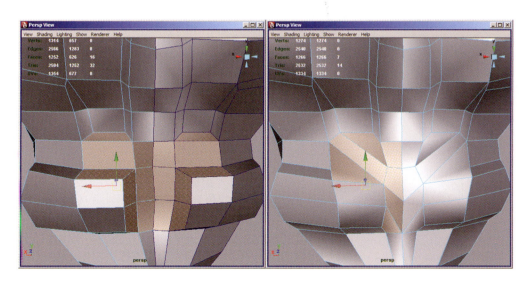

FIGURE 7-20 *Changing the obliques of the back.*

16. Select and extrude the faces on the side of the torso to create the latissimus muscles. Keep in mind the latissimus muscles wrap around from the side to the back of the torso.

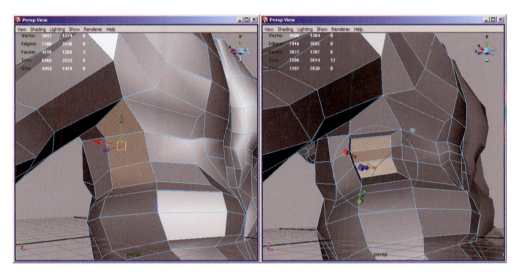

FIGURE 7-21 Defining the latissimus muscles.

17. Use the delete edge, split polygon method to adjust the edges so the latissimus muscles blend into the mesh properly. When you start changing the edge loops to blend into the muscle flow, it changes the direction of the loops. Because of this, you want to try to complete all of your blocking before changing the muscles.

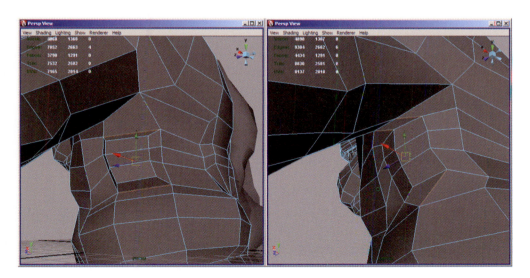

FIGURE 7-22 Blending the latissimus muscles into the mesh.

18. Select and extrude the faces on the shoulder that makeup the infraspinatus and teres major muscles.

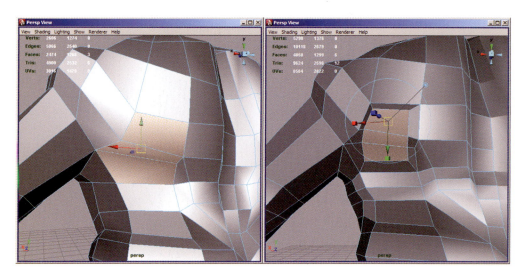

FIGURE 7-23 Extruding the infraspinatus and teres major muscles.

19. As with the other muscles, you want to adjust how the muscle blends into the rest of the mesh. To do this delete the edges on the inside lower edge of the muscle.

20. Using the Split Polygon Tool (or an automated polygon spin script), rebuild the muscle so it flows in the correct direction.

FIGURE 7-24 Deleting edges for better muscle blending on the teres major muscle.

FIGURE 7-25 Rebuilding the teres major muscle.

Tutorial: Detailing the Legs

The legs are usually easy to detail because the landmark bony protrusions and muscles all flow in the same direction. Starting at the top of the leg, the outside area is higher than the inner, crotch region. The pelvis is the main bony mass visible in the upper leg. You can see the iliac crest where the leg meets the torso. In the middle of the leg, the knee is visible in the front. The tibia is visible running down the front of the lower leg. The main muscles visible in the upper leg are the vastus medialis, vastus lateralis, rectus femoris, and on the front. On the back of the leg, the gluteus maximus, adductor magnus, and biceps femoris are the main visible muscles. In the lower leg, the tibialis posterior is the main visible muscle. For the rear of the lower leg, the main muscles are the gastrocnemius lateral head and medial head.

1. To begin, add some extra, evenly spaced, edge loops to the legs. Make sure to round off the new edges as you add them.

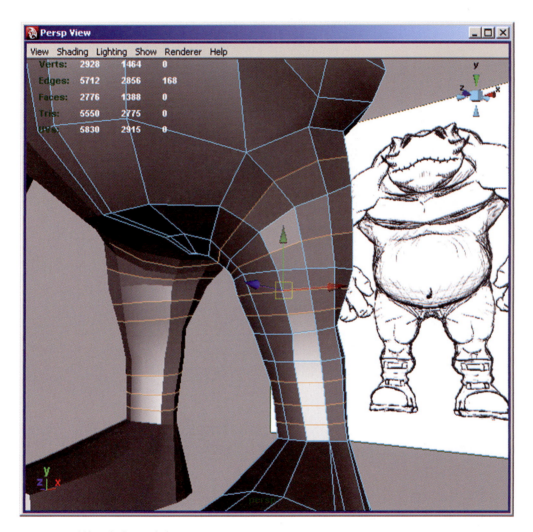

FIGURE 7-26 Adding edge loops to the legs.

2. Joint areas like the knee need to have extra polygons so they will deform correctly when animated. Because of this, you want to add extra edge loops through the knee.

FIGURE 7-27 Adding edge loops to the knee.

3. To define the knee, select and extrude the polygons.

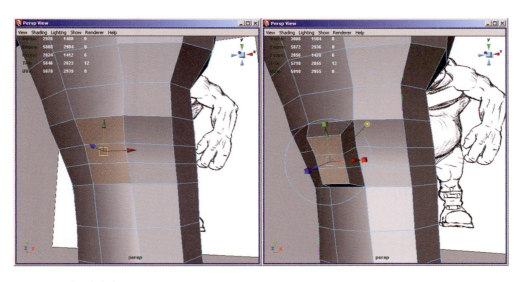

FIGURE 7-28 Extrude the knee.

227

4. Next, shape the knee using component mode.

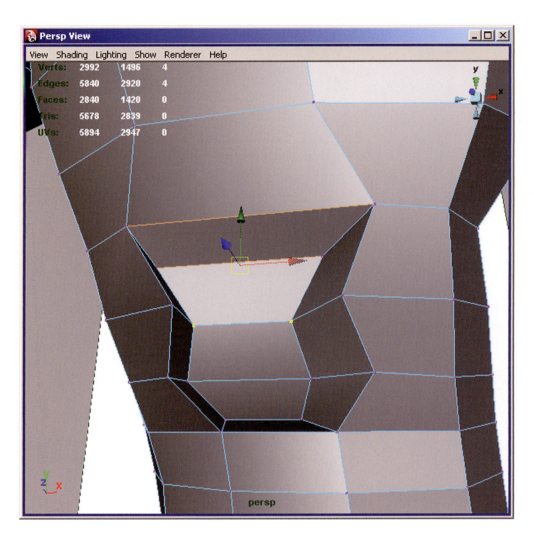

FIGURE 7-29 Shaping the knee.

5. Now that you have the bone landmarks defined and added extra edge loops, take some time to further shape the legs. You should work on shaping the silhouette of the main muscles for both the upper and lower leg.

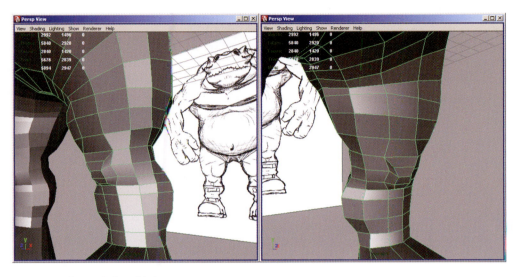

FIGURE 7-30 Shaping the front of the leg.

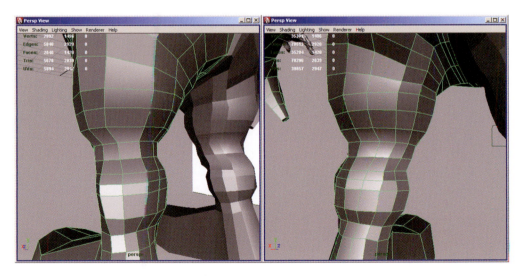

FIGURE 7-31 Shaping the back of the leg.

6. Select and extrude polygons to create the rectus femoris muscle. This is the muscle that runs up the center of the thigh. Make sure to shape it using component mode. The muscle is flush with the leg just above the knee and tapers out at the top of the thigh.

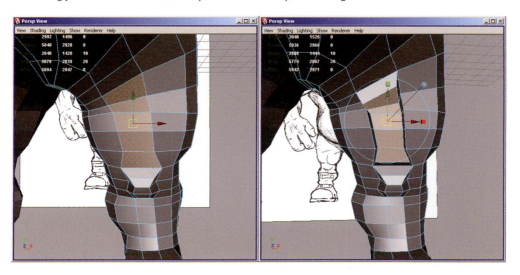

FIGURE 7-32 Extruding the rectus femoris muscle.

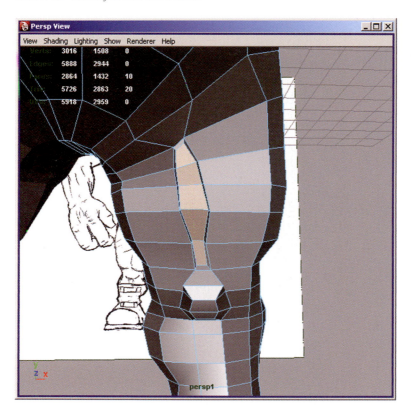

FIGURE 7-33 Shaping the rectus femoris muscle.

7. Next select and extrude the muscles to form the vastus lateralis. This is the large muscle on the outside of the thigh. As always, shape as you create. The vastus lateralis tapers in at the top of the thigh.

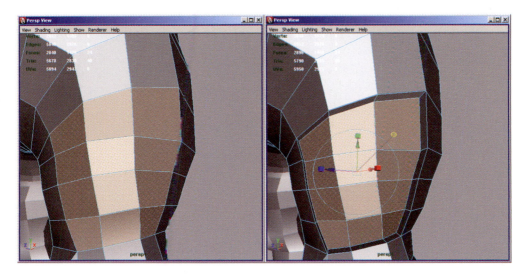

FIGURE 7-34 Creating the vastus lateralis muscle.

8. Delete the edges at the top of the vastus lateralis and rebuild them using the Split Polygon Tool so the muscle blends better into the surrounding mesh.

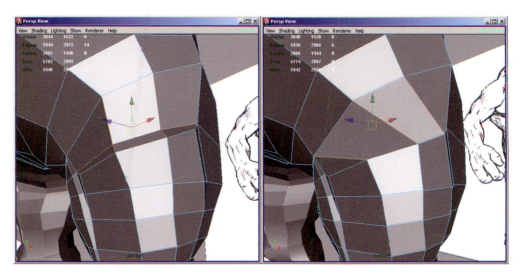

FIGURE 7-35 Blending the vastus lateralis muscle into the mesh.

9. Select and extrude polygons to create the vastus medialis muscle. This is the large muscle of the inner thigh. Make sure to shape it using component mode. The muscle tapers in near mid-thigh.

FIGURE 7-36 Creating the vastus medialis muscle.

FIGURE 7-37 Shaping the vastus medialis muscle.

10. Delete the edges at the top of the vastus medialis and rebuild them using the Split Polygon Tool so the muscle blends better into the surrounding mesh.

FIGURE 7-38 Blending the vastus medialis muscle into the mesh.

11. Using component mode, adjust the gluteus maximus into the desired shape. The gluteus maximus muscles are spaced further apart at the top, forming a "V" shape. The muscle should cup tightly at the bottom. Also make sure to add a slight dimple where the gluteus maximus meets the upper part of the leg. The muscles on the upper back of the leg can all be implied. What does this mean? Well in terms of modeling, an implied muscle means you can adjust the existing geometry to get the desired shape without having to change the direction of the edge loops.

FIGURE 7-39 Creating the gluteus maximus.

12. Adjust the adductor magnus muscle. The muscle should have a slight bulge to it. The adductor magnus wraps around from the back to mid-way through inner thigh before it tucks under the vastus medialis muscle.

FIGURE 7-40 *Creating the adductor magnus.*

13. There is a slight bulge in the back of the knee. There are also vertical tendons on both sides of the rear of the knee that should be pulled out.

FIGURE 7-41 Rear knee bulge.

14. Select and extrude the faces that form the outer part of the calf muscle. The gastrocnemius or calf muscle is split into two vertical groups on the rear of the lower leg.

FIGURE 7-42 Outer part of the calf muscle.

15. Next select and extrude the faces that form the inner part of the calf muscle.

FIGURE 7-43 Inner part of the calf muscle.

16. Right now, the calf is not blending into the leg very well. As before, we'll need to change directions on some of the edges to get the proper blend.

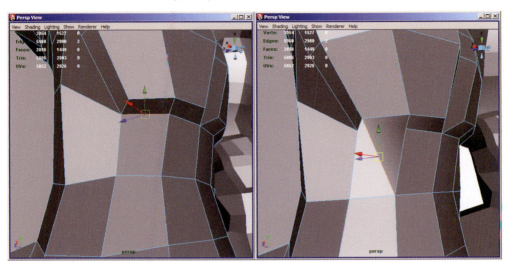

FIGURE 7-44 Blending the calf into the leg.

17. Repeat the blending on the outer part of the calf and adjust the components to smooth the transition on adjacent vertices.

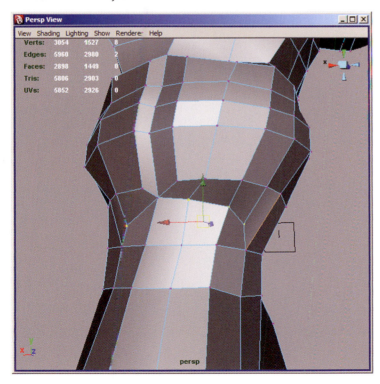

FIGURE 7-45 Final blending of the lower calf into the leg.

18. Change the flow of the polygons on the front of the lower leg by deleting edges and rebuilding them with the Split Polygon Tool. The front of the lower leg has a slight diagonal flow with the tibialis anterior muscle traveling from the upper outside edge just below the knee to lower inside edge at the ankle.

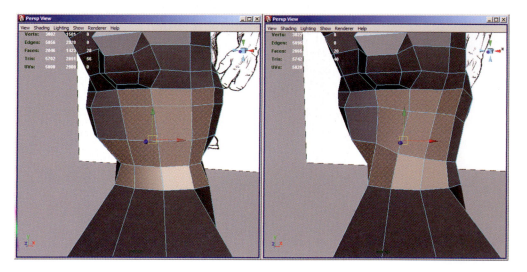

FIGURE 7-46 Changing flow of the front lower leg.

19. Select and extrude the faces extending down the external view of the lower that form the peroneous longus muscle.

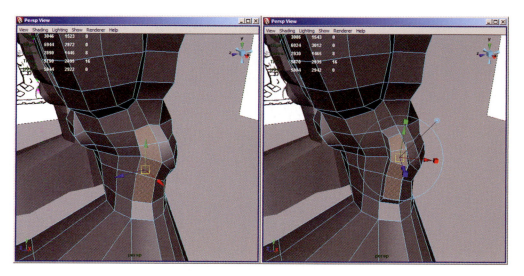

FIGURE 7-47 Creating the peroneous longus muscle.

20. Adjust the flow of the polycons at the top of the peroneous longus muscle so it blends into the surrounding mesh.

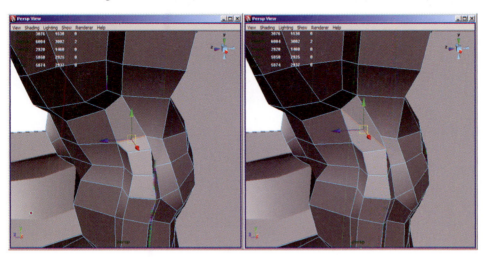

FIGURE 7-48 Blending the top of the peroneous longus muscle.

Tutorial: Creating the Feet

When detailing the feet I like to start at the ankles and work my way down to the toes. The inside of the ankle is higher than the outside. The inside of the joint is the base of the tibia bone. The outside of the ankle is the base of the fibula. The four smaller toes all have three joints and are very close together. The big toe has only two joints and there is a large gap between it and the second toe. Also note that the foot is narrow at the heel and widens at the end of the metatarsal bones (the ball).

1. Select and extrude polygons that form the interior of the ankle.

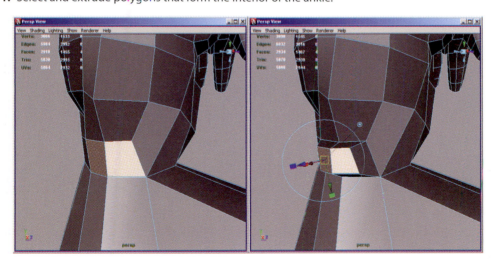

FIGURE 7-49 Creating the interior ankle.

2. The ankle doesn't blend in very well, so you'll need to rebuild the top edges by deleting them and recreating them with the Split Polygon Tool or with a script that automates spinning quad faces. Only blend the top of the ankle. The bottom juts out quite far.

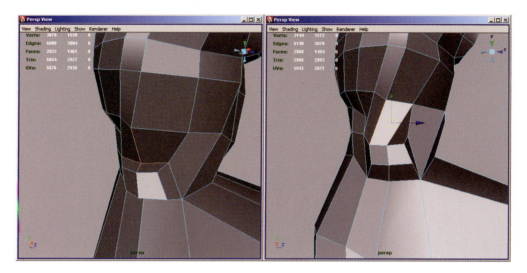

FIGURE 7-50 Blending the interior ankle.

3. Using the same steps, extrude the exterior of the ankle. Remember that the exterior ankle is much lower than the interior. Also take extra care getting the top of the exterior ankle to blend properly with the bottom of the peroneous longus muscle. Where the peroneous longus muscle reaches the ankle it is nearly flush with the surrounding tissue.

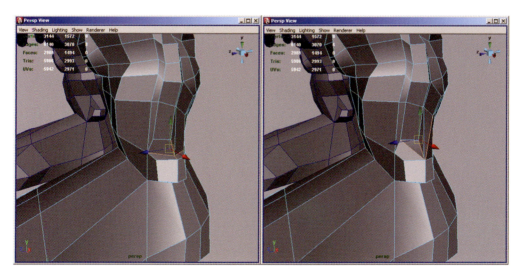

FIGURE 7-51 Creating the exterior ankle.

4. Select and extrude the polygons that will form the fifth metatarsal (the pinky side of the foot). As stated earlier, the foot widens at the ball section.

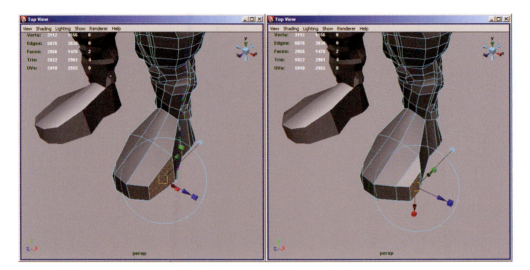

FIGURE 7-52 Extruding the fifth metatarsal.

5. Next, select and extrude the polygons of the first metatarsal bone.

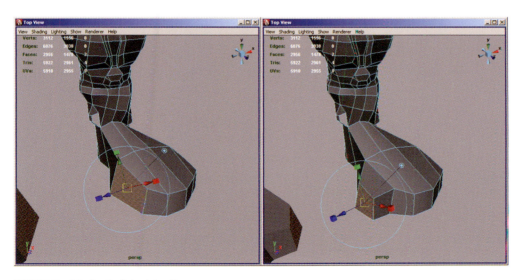

FIGURE 7-53 Extruding the first metatarsal bone.

6. Click Edit Mesh>Insert Edge Loop Tool to add a new edge loop around the foot. Remember to round it off around the heel and sides.

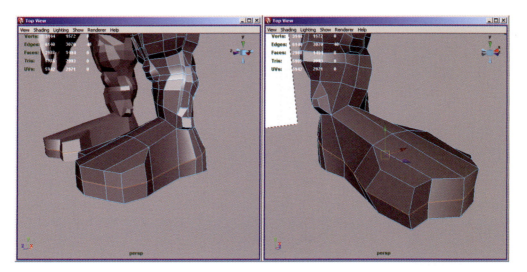

FIGURE 7-54 Adding an edge loop to the foot.

7. Next select and extrude the faces of the big toe out to the first joint. The first joint of the big toe is raised. Also keep in mind that unlike the rest of the toes, the big toe has only two joints.

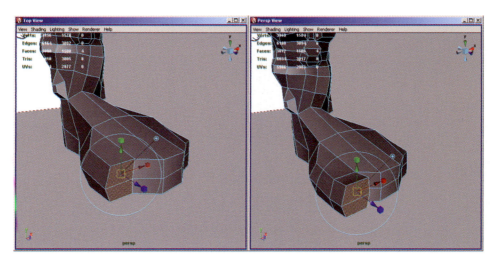

FIGURE 7-55 Extruding to the first joint of the big toe.

8. Extrude the faces again to create the rest of the big toe.

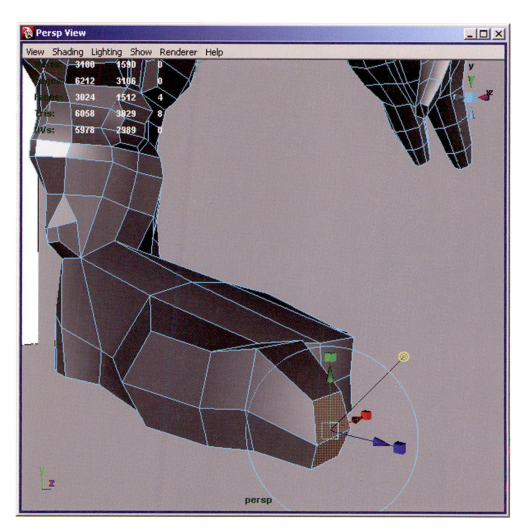

FIGURE 7-56 Finishing the big toe.

9. Add an edge loop to better define the shape of the metatarsal bones. Before we can extrude the rest of the toes, there is a bit of preparation that needs to be done.

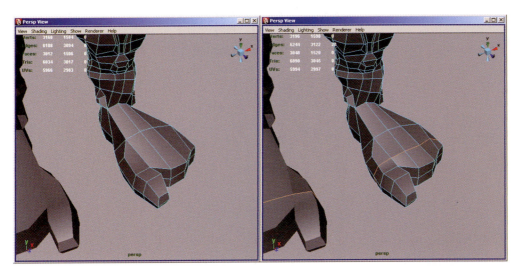

FIGURE 7-57 Defining the metatarsals.

10. Using the Split Polygon Tool, create a new edge that extends from the top of the metatarsal edge loop, around the front of the foot and ends at the bottom of the metatarsal loop. This will define the space between the toes.

FIGURE 7-58 Creating spacing between the toes.

11. Of course, this will create triangles on the top and bottom of the foot. Use the split polygon to change the triangles into quads.

FIGURE 7-59 Changing the triangles to quads.

12. Repeat the spacing steps for the rest of the toes.

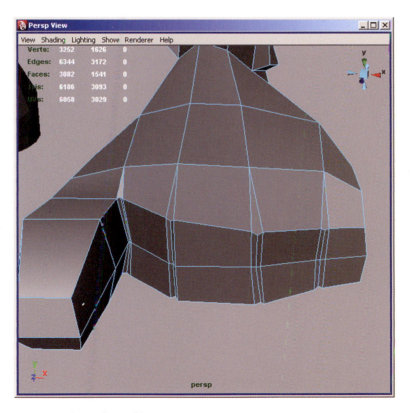

FIGURE 7-60 Spacing the rest of the toes.

13. Extrude the faces of the second toe out to the first joint. Note that the first and second joints are slightly raised.

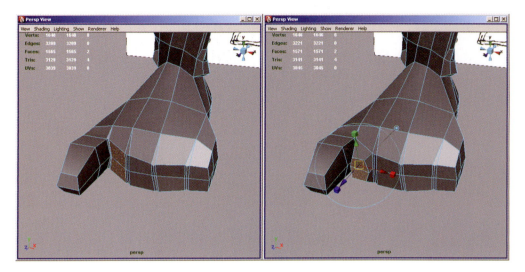

FIGURE 7-61 Beginning the second toe.

14. Extrude twice more to create the rest of the toe.

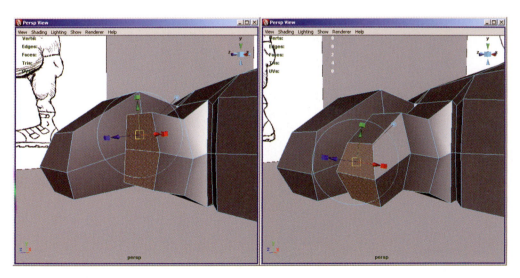

FIGURE 7-62 Finishing the second toe.

15. Select all of the faces comprising the second toe and click Edit Mesh>Duplicate Face. This will create a new mesh consisting of only the selected faces of the toe. Because the remaining toes are similar to the second digit, it's best to duplicate this toe, saving yourself from extra work.

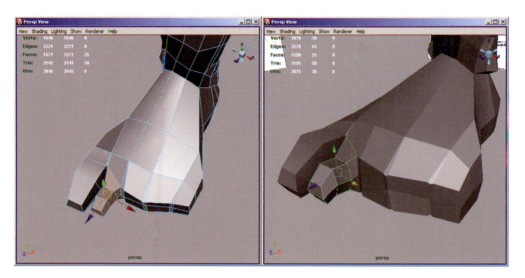

FIGURE 7-63 Duplicating the toe.

16. Select the new toe mesh and click Modify>Center Pivot. This will center the pivot point on the mesh, making it much easier to manipulate.

17. Move and resize the duplicated toe mesh so it becomes the third toe.

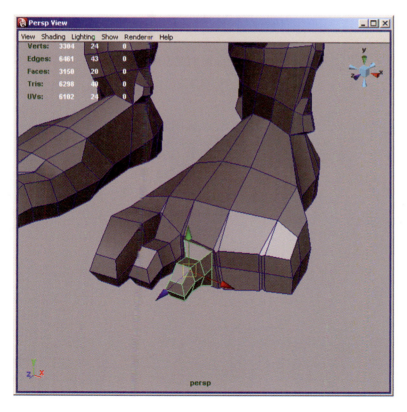

FIGURE 7-64 Creating the third toe.

18. Duplicate the third toe twice more to create the final toes.

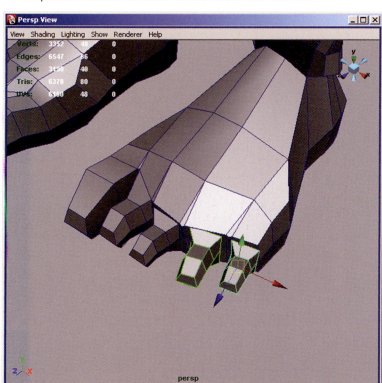

FIGURE 7-65
Duplicating the rest of
the toes.

19. Because you want to avoid internal faces, you need to delete faces before you can attach the newly duplicated toes.

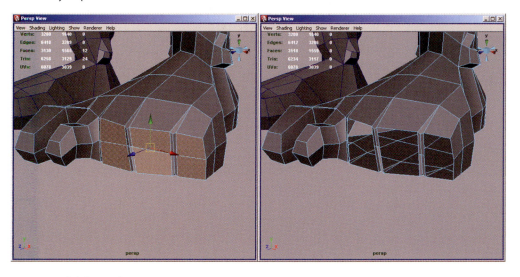

FIGURE 7-66 Deleting extra faces.

20. Press "v" (the shortcut key for snap to points) and snap the vertices of the third toe to corresponding point on the character mesh.

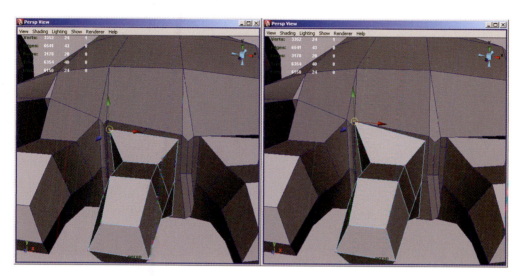

FIGURE 7-67 Aligning points of the toes.

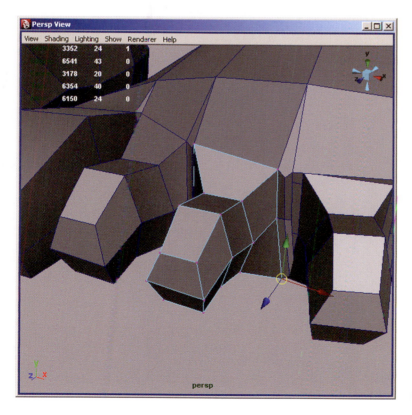

FIGURE 7-68 Final point snapping for third toe.

21. Repeat the vertex snapping for the remaining toes.

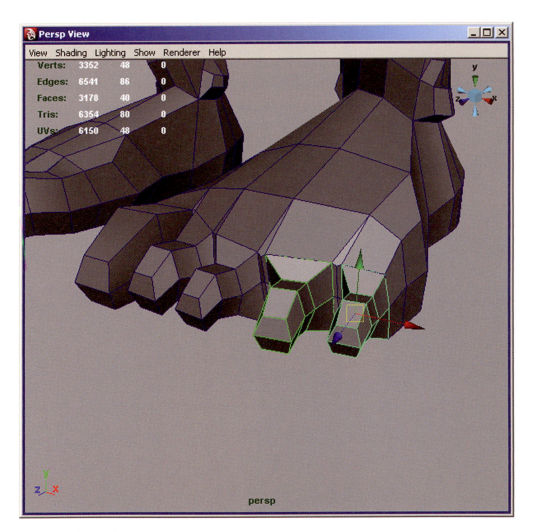

FIGURE 7-69 *Snapping the remaining toes.*

22. Next select the character and the toes and click Mesh>Combine to attach the toes. This is a good time to delete history if you haven't done so in a while.
23. Drag select the vertices of the foot and click Edit Mesh>Merge☐. Set the Threshold to a low enough number that it only merges vertices that lie directly on top of each other. The combine operation does not merge vertices, so you have to perform the merge.
24. Select the character and click Edit>Duplicate Special☐. Set the Geometry type to Instance. Change the X scale to −1 and press apply. The combine operation also removes the instance that you initially created so you will have to redo the duplication.

25. Take some time to shape the toes and foot. The big toe is angled slightly toward the other toes. The toes should also get smaller and rest further down on the foot.

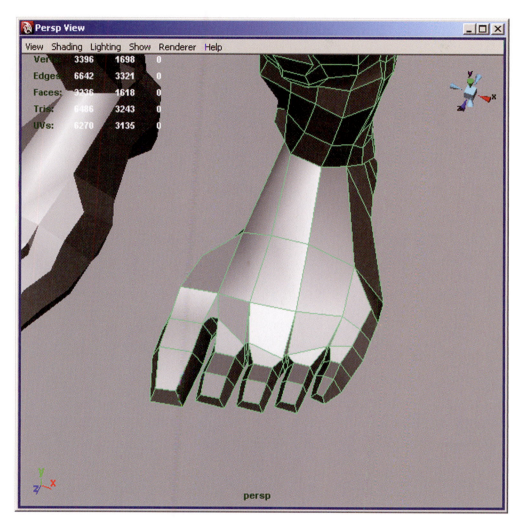

FIGURE 7-70 *Further shaping of the foot.*

Once the overall shape is completed, add some extra edge loops for more detail and finish shaping the foot. As you finish shaping the foot, don't forget the arch and the fatty pads at the heel and ball. For a character where polygon count limits need to be strictly adhered to, you can save a large amount of faces by painting the toenails into the image file instead of modeling them.

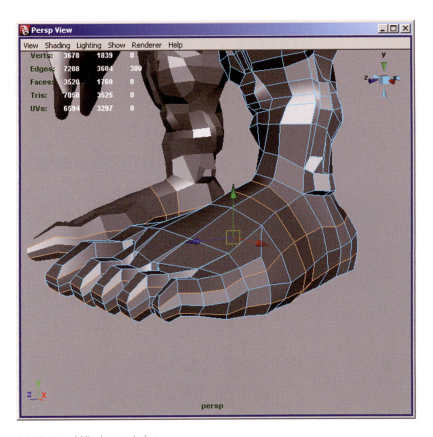

FIGURE 7-71 Adding loops to the foot.

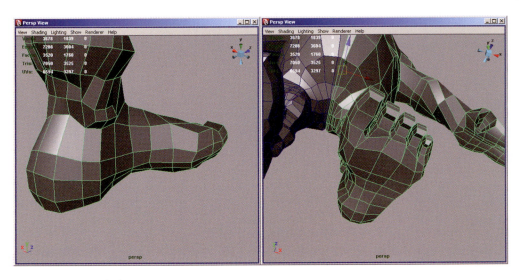

FIGURE 7-72 Finishing the foot.

Tutorial: Adding Detail to the Arms

Detailing the arms can be tricky because the muscles flow in different directions. The elbow and where the radius and ulna bones form the wrist are the main bony landmark masses of the arms. The deltoid, bicep, and triceps muscles are all prominent masses on the upper arm. On the anterior of the forearm, the prominent masses are the brachioradialis, flexor carpi radialis, and flexor carpi ulnaris muscle. On the posterior of the forearm, the main muscles are the flexor carpi ulnaris (wrapping around from the anterior), extensor digitorum, and extensor carpi radialis longus.

1. To start, add extra edge loops along the arm. Remember to keep them in shape and to keep them evenly spaced.

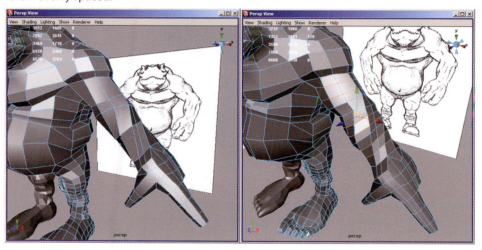

FIGURE 7-73 Adding arm edge loops.

2. Select and extrude the faces that form the elbow. The elbow is the main bony mass on the arm so it's a good idea to start here because a number of muscles flow out from this spot.

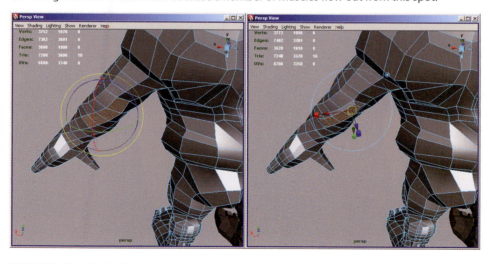

FIGURE 7-74 Extruding the elbow.

3. Change the direction of the polygons at the base of the elbow by deleting the edges and rebuilding with the Split Polygon Tool so it blends better into the surrounding mesh.

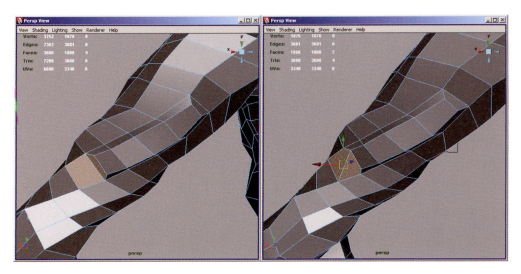

FIGURE 7-75 Blending elbow.

4. Select and extrude the faces that form the triceps muscle. Note how it wraps around the top of the elbow.

FIGURE 7-76 Creating the triceps.

5. Blend the bottom of the triceps muscle into the surrounding mesh by changing the direction of the polygons.

FIGURE 7-77 Blending the triceps into the surrounding mesh.

6. The triceps muscle is split lengthwise down the middle. Using the Split Polygon Tool, add extra edges to create this split.

FIGURE 7-78 Fine tuning the triceps.

7. Of course, this will leave us with some triangles that need to be cleaned up. Press the "v" key to activate snap to points and move the vertex at the top of the elbow to first point of your newly created edge.

FIGURE 7-79 Further refinement to the triceps.

8. Keep in mind that point snapping will not merge the vertices. Drag select the two vertices and click on Edit Mesh — Merge to merge them into a single vertex.
9. Select the edges on either side of the mid-triceps edge and pull them out to create the split in the muscle.

FIGURE 7-80 Accentuating the split in the triceps.

10. Select the edge in between the two triangles and delete it so you have a one quad.

FIGURE 7-81 Cleaning up the mesh.

11. Change the direction of the polygons at the top of the triceps so they better blend with the surrounding mesh.

FIGURE 7-82 Blending the top of the triceps.

FIGURE 7-83 Blending the top of the triceps.

12. Insert an edge at the top of the triceps to change the *n*Gon into two quads.

FIGURE 7-84 Fixing the *n*Gon at the top of the triceps.

13. Select and extrude the faces of the biceps. Remember to round them off.

FIGURE 7-85 Extruding the biceps.

14. Adjust the vertices and edges on the rear of the arm to define the elbow.

On the anterior of the forearm, the prominent masses are the brachioradialis, flexor carpi radialis, and flexor carpi ulnaris muscle. On the posterior of the forearm, the main muscles are the flexor carpi ulnaris (wrapping around from the anterior), extensor digitorum, and extensor carpi radialis longus.

15. Compared to the upper arm, the forearm is fairly easy to create. Select the muscles that form the extensor digitorum muscle and extrude them out.

FIGURE 7-86 Extruding the extensor digitorum muscle.

16. Using the Split Polygon Tool (or a face spinning script), change the direction of the extensor digitorum muscle near the top so that it inserts correctly under to the carpi radialis longus. Make sure to delete any extra edges.

FIGURE 7-87 Blending the top of the extensor digitorum muscle.

17. Using the Split Polygon Tool, change the direction of the extensor digitorum muscle near the wrist so that it blends better into the arm. Make sure to delete any extra edges.

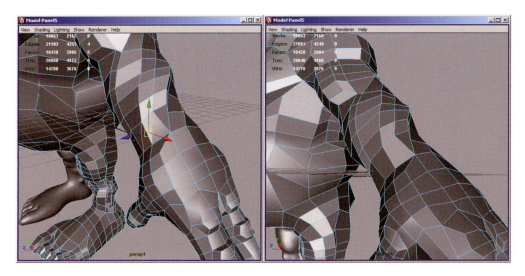

FIGURE 7-88 Blending the bottom of the extensor digitorum muscle.

18. Select and extrude the faces that form the brachioradialis and carpi radialis longus muscles.

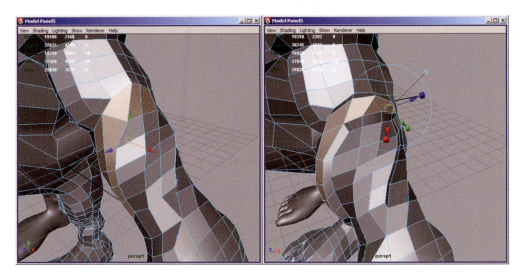

FIGURE 7-89 Creating the brachioradialis and carpi radialis longus.

19. Select and extrude the extensor carpi ulnaris muscle.

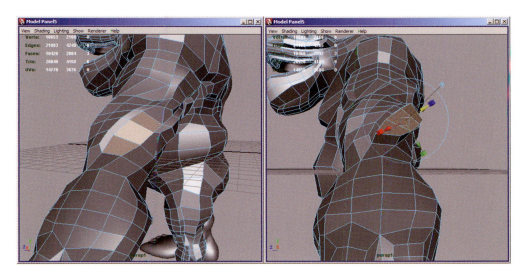

FIGURE 7-90 Creating the extensor carpi ulnaris muscle.

20. Using the Split Polygon Tool, change the direction of the extensor carpi ulnaris muscle near the ends so that it blends better into the arm. Make sure to delete any extra edges.

FIGURE 7-91 Blending the extensor carpi ulnaris muscle.

21. Select and extrude the flexor carpi ulnaris muscle.

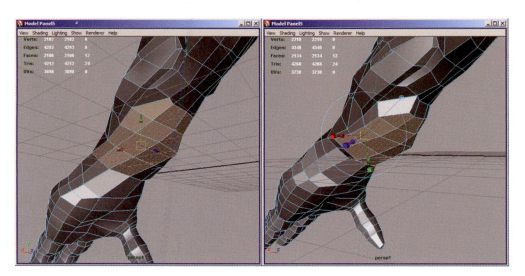

FIGURE 7-92 Creating the flexor carpi ulnaris muscle.

22. Using the Split Polygon Tool, change the direction of the flexor carpi ulnaris muscle near the ends so that it blends better into the arm. Make sure to delete any extra edges.

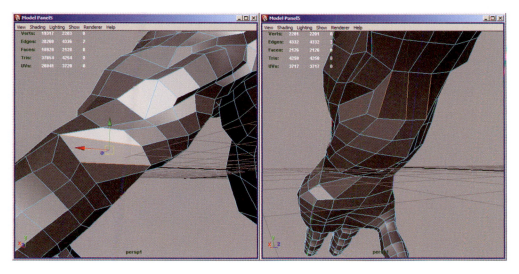

FIGURE 7-93 Blending the flexor carpi ulnaris muscle.

Tutorial: Creating the Hands

The hands can be fairly difficult to detail. Just keep an extra close eye on your anatomy references as you work and you should be okay. The knuckles, of course, are the main landmark areas on the backside of the hand. The thumb has two knuckles, while the remaining fingers each have three. Also visible on the back of the hand is the trapezium bone at the base of the thumb. The palm of the hand has a few predominant muscle groups: the thenar muscles (the large fleshy pad at the base of the thumb), the hypothenar muscles (the fleshy pad) on the pinky side of the hand, and lumbricales (the pads at the base of the fingers).

1. Because of the vertical edge loops added to the torso earlier, there are already enough polygons to allow you to begin working on the finger. Take some to round off the index finger and the thumb.

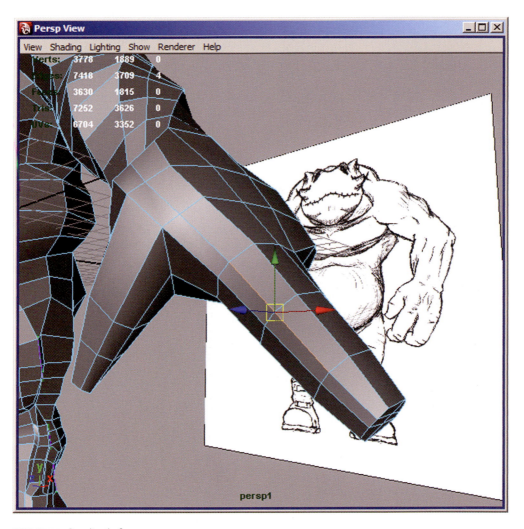

FIGURE 7-94 Rounding the fingers.

2. Click Edit Mesh — Insert Edge Loop Tool to add an edge loop mid-hand and continue shaping.

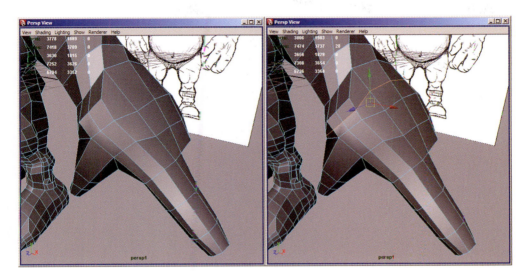

FIGURE 7-95 Hand edge loop.

3. Add another edge loop that travels through the middle of the thumb.

FIGURE 7-96 Adding an edge loop to the thumb.

4. Now comes the hardest part of the hands, the knuckles. Insert two edge loops around the second joint of the index finger. This is the start of the middle knuckle.

FIGURE 7-97 Start of the index finger knuckles.

5. Select and extrude the faces of the knuckle.

FIGURE 7-98 Extruded faces of the knuckle.

6. Shape the knuckle. Notice how it is flatter toward the base of the finger and has a sharper drop off toward the tip. Also pull down the vertices on the side of the knuckle so it will blend into the finger.

FIGURE 7-99 Shaping the knuckle.

7. Create the crease on the inside of the joint by moving the bottom edge up.

FIGURE 7-100 Creating the crease.

8. Pull the edges on the sides of the knuckle out to make the joint more prominent.

FIGURE 7-101 Finish shaping the knuckle.

Insert two edge loops around the third knuckle.

9. Shape the knuckle as similar to the image below. The top edge is shifted up to form the prominent upper part of the joint. The bottom edge is pulled up to create the crease. Also note that the top edge of the forward most edge loop is shifted forward and down to create a base for the fingernail.

FIGURE 7-102 Starting the third knuckle.

FIGURE 7-103 Finishing the third knuckle.

10. Add an edge loop for the base knuckle. Remember to create the crease.

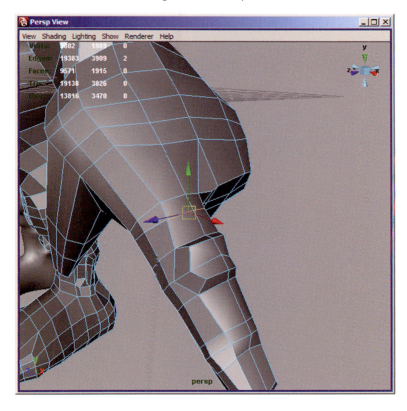

FIGURE 7-104 Starting the base knuckle.

11. Continue shaping the base knuckle by moving the topmost edge of the forward edge loop toward the end of the finger. This will help the knuckle blend into the hand.

FIGURE 7-105 Continue shaping the knuckle.

12. Select the top two faces of the base knuckle and click Edit Mesh>Extrude. Extrude the knuckle out to its highest point. Switching the extrude operation to local mode by clicking on the transform gizmo will make this easier.

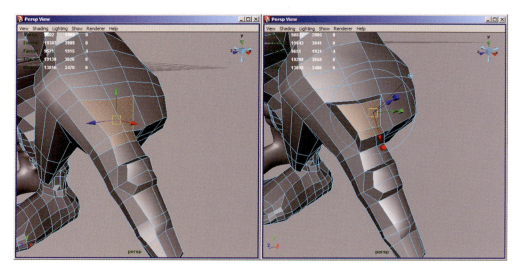

FIGURE 7-106 Extrude the base knuckle.

13. Finish shaping the base knuckle by moving the vertices and edges.

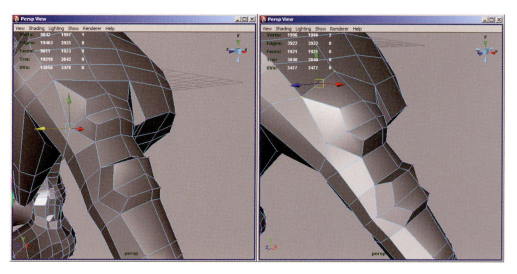

FIGURE 7-107 Finished base knuckle.

14. Now that the index finger is finished, we can easily create the remaining fingers by duplicating the faces. Select the faces of the index finger and click Edit Mesh>Duplicate Face. This will duplicate the selected face and turn them into a separate object. Whenever you perform object mode operation like duplicate face, any instances you have created will disappear. When you are ready simply press Edit>Duplicate Special to recreate them.

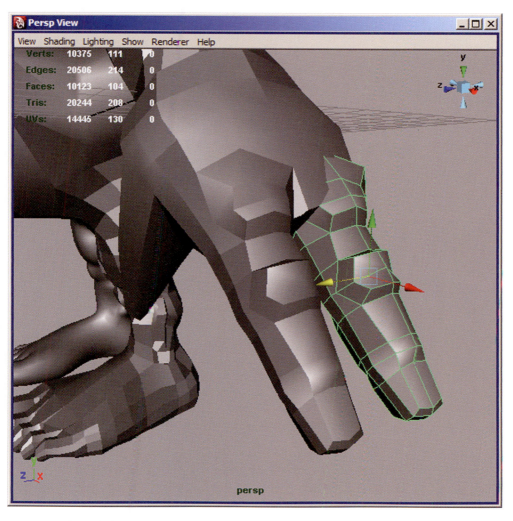

FIGURE 7-108 Faces to duplicate.

15. Select the duplicated faces and click Modify>Center Pivot. This will place the pivot point of the object in its center making it easier to move.
16. Duplicate the new finger object twice more and move them into the correct positions.

FIGURE 7-109 Duplicated fingers.

17. Use the scale tool to resize the duplicate fingers to the appropriate sizes.
18. Before the fingers can be reattached, some polygons on the hand need to be deleted. If you forget to delete these internal faces, you can get strange results during rendering.

FIGURE 7-110 Faces to delete.

19. Now the objects are ready to combine. Press shift and select each of the fingers and the main character. Click Mesh>Combine. The objects are now a single mesh.
20. Be aware that Combine does not merge the vertices. It leaves double vertices at each of the connection points. Simply drag select all vertices in the hand and click Edit Mesh>Merge Vertices to merge the vertices together. You only want to merge vertices that are sitting directly on top of each other. If your threshold is too high it will have the undesirable result of moving vertices from far away before merging. If this happens simply undo the operation, lower the tolerance in Edit Mesh>Merge>□, and try again. A value of 0.0020 worked fine for me in this example.

21. Insert two edge loops around the second joint of the thumb and adjust the bottom edge to create a crease similar to how you created the middle knuckle on the index finger. This is the start of the second knuckle of the thumb. Remember that the thumb has only two knuckles.

FIGURE 7-111 Start of the second thumb knuckle.

22. Select and extrude the faces of the knuckle.

FIGURE 7-112 Extruded faces of the knuckle.

23. Shape the knuckle. Notice how it is flatter toward the base of the finger and has a sharper drop off toward the tip. Also pull down the vertices on the side of the knuckle so it will blend into the thumb.

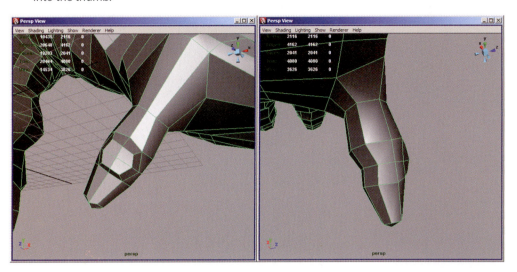

FIGURE 7-113 Finish shaping the knuckle.

24. Add some edge loops so you can round out the thumb.

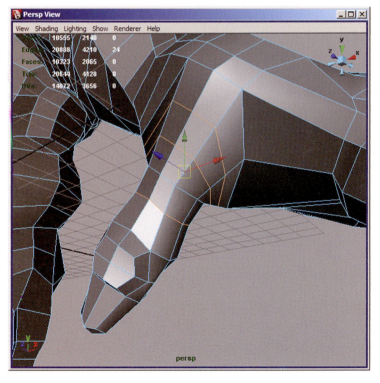

FIGURE 7-114 Extra thumb edge loops.

25. Select and extrude the faces of the base knuckle of the thumb.

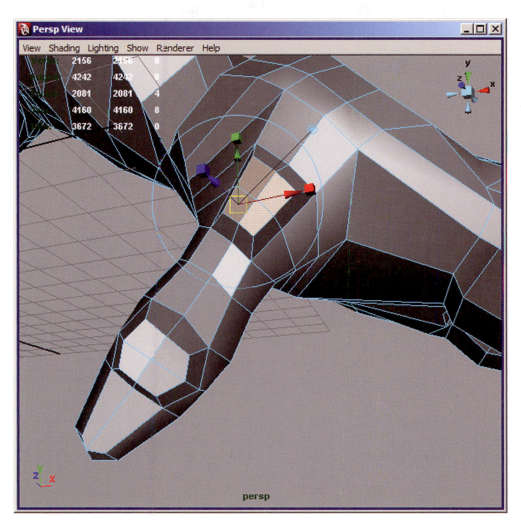

FIGURE 7-115 Extrude the faces of the first thumb knuckle.

26. The final bit of work on the hand is to adjust the vertices of the first thumb knuckle.

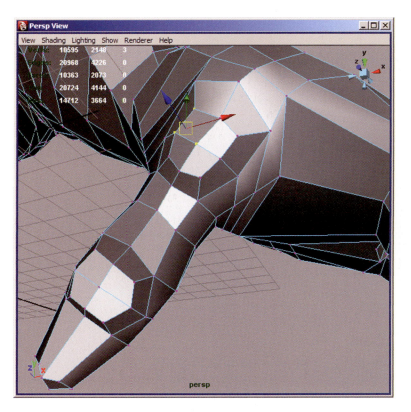

FIGURE 7-116 Final shaping of the first thumb knuckle.

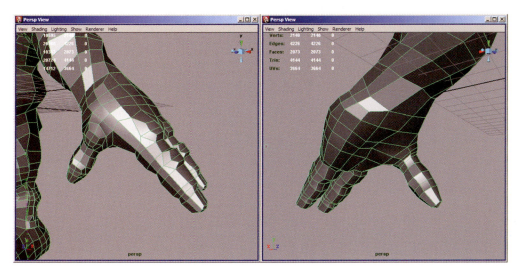

FIGURE 7-117 Final hand.

Tutorial: Finishing the Head

Of course, the head is one of the most intricate and difficult areas that you will model. The head, more than any other single area is what will make or break a character. If the modeling is not rock solid here, then your character won't have any appeal. The landmarks of the head are the eyes, nose, and mouth.

1. There are some new edge locps going through the head from some of the previous steps. Take some time now to adjust refine the shape of the head by adjusting the edges and vertices.

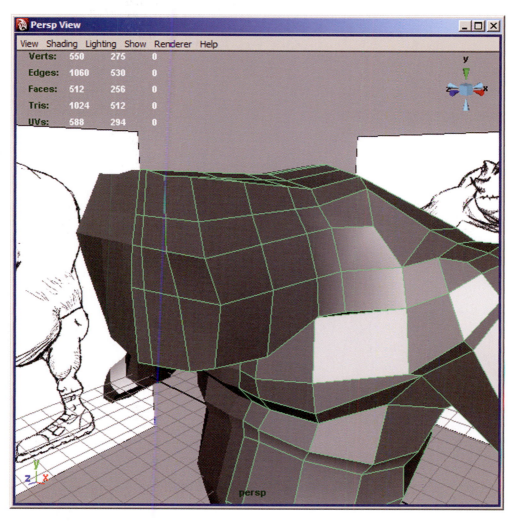

FIGURE 7-118 Refining the shape of the head.

2. Click Select>Select Edge Loop Tool and double click on the forward edge loop.

3. Click Edit Mesh>Slide Edge Tool to activate the Slide Edge Loop Tool. MMB drag in your viewport slide the entire edge loop forward while retaining the overall shape of the polygons. Repeat for the middle edge loop.

FIGURE 7-119 Slide edge loop.

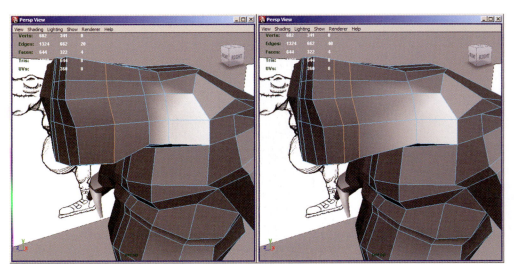

FIGURE 7-120 Edges moved using the Slide Edge Tool.

4. Add an edge loop to the neck. We need the extra detail here so the neck will deform correctly.

FIGURE 7-121 Adding an edge loop to the face.

5. Select the polygon of the eye socket click Edit Mesh>Extrude. Extrude it out to form the eye socket. For a hyperreal creature like a troll, the socket is external. It looks like a bump.

FIGURE 7-122 Starting the socket.

6. Select the center of the new eye socket and press Edit Mesh>Extrude. This time, don't pull out the extrude handles. You want to immediately scale it down to the correct size. This is a great way to add detail. Everything remains in quads and the edge loops flow correctly.

FIGURE 7-123 Continuing the eye.

7. Insert a vertical edge loop through the center of the eye. This gives you more control over shaping the still low-res model.

FIGURE 7-124 Eye edge loop.

8. Click Create>Polygon Primitives>Sphere to add a sphere that will be used as an eye. Rotate it so the pole can be used as the pupil. Resize it as needed and place it in the appropriate spot. It's very important to have the eye in place before you start shaping the eye socket, otherwise, it becomes very difficult to get the socket mesh to drape around the eye correctly. After the eyeball is in place, you might want to put it on a separate display layer and template it so you won't have to worry about accidentally moving it while you work.

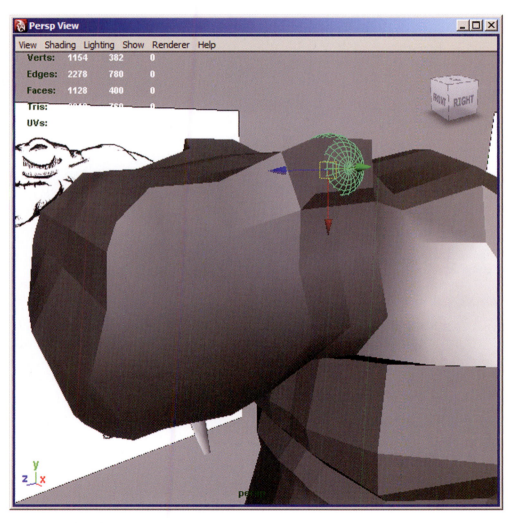

FIGURE 7-125 Placing the eyeball.

9. Move the vertices so the new faces match the outline of the eyeball.

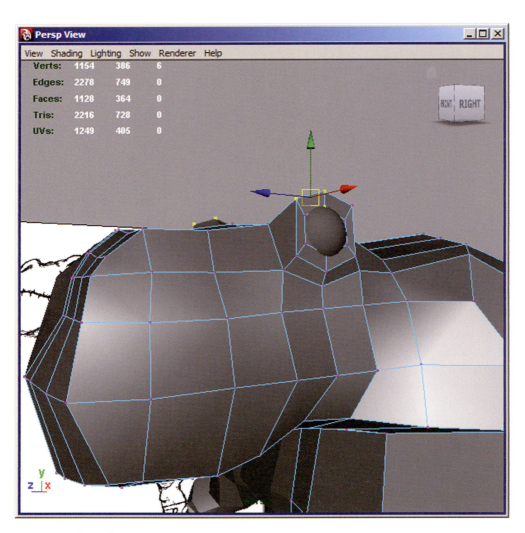

FIGURE 7-126 Shaping the socket.

10. Extrude the central polygons of the eye socket back, scale them down a bit and then delete them. Scaling them down will allow the eyeball to sit more naturally in the socket. Deleting these faces allows you to later add edge loops that terminate at the back of the eye instead of traveling the entire length of the character.

FIGURE 7-127 Extrude the socket back.

11. Insert extra edge loops around the eyes to build up depth. Remember to shape the new polygons as they are added.

FIGURE 7-128 Shaping the eye socket.

12. Now you need to start adding edge loops so you can mold the eyelids around the ball. Remember to round out the edges all along the length of the newly added edge loops.

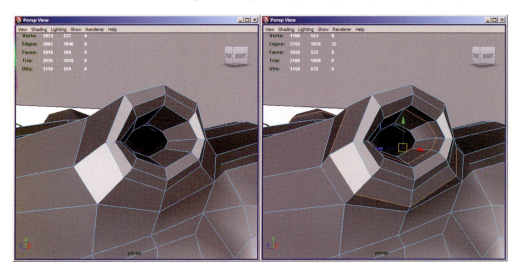

FIGURE 7-129 Adding edge loops to the eyelids.

13. Adjust the vertices of the new edge loops where they meet up with the eyeball so they mold correctly around it.

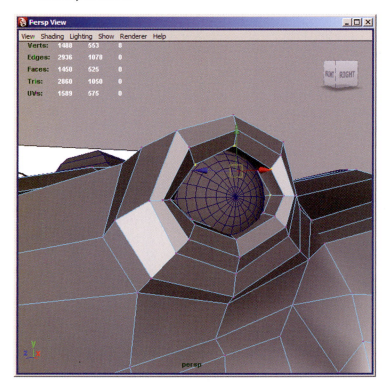

FIGURE 7-130 Molding the new edge loops to the eyeball.

14. For this character, the nose is formed in the same fashion as the eyeball. Start by selecting and extruding the nostril polygons in.

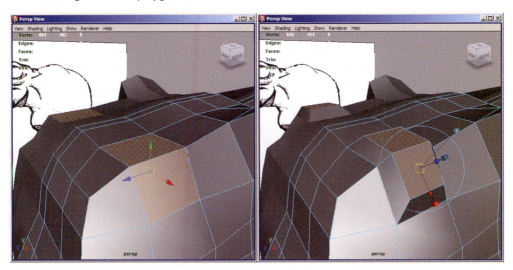

FIGURE 7-131 Beginning the nose.

15. Shape the nose to match your reference image.

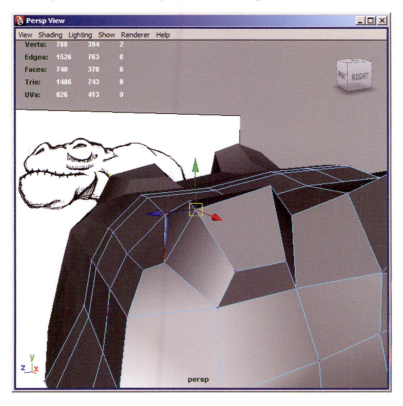

FIGURE 7-132 Shaping the nose.

16. Next form the inside of the nostrils. Select the two faces that form the nostril and click Edit Mesh>Extrude; however, DO NOT extrude them out with the manipulator. Instead use the scale tool to size the new polygons. Remember to shape the nostrils.

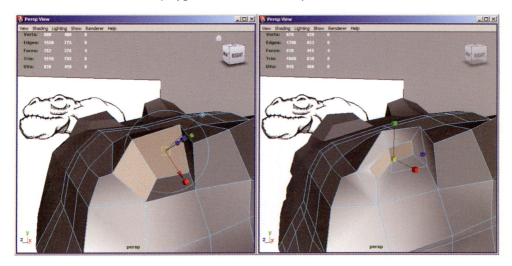

FIGURE 7-133 Starting the nostrils.

17. With the inner nostril faces still selected extrude them into the nose.

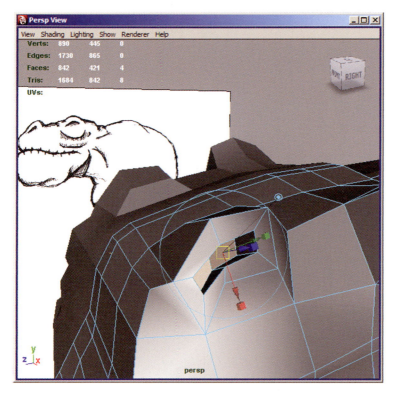

FIGURE 7-134 Extrude nostrils into nose.

18. Add an edge loop to the inside of the nose and adjust it to give a nice round transition to the inside of the nostril.

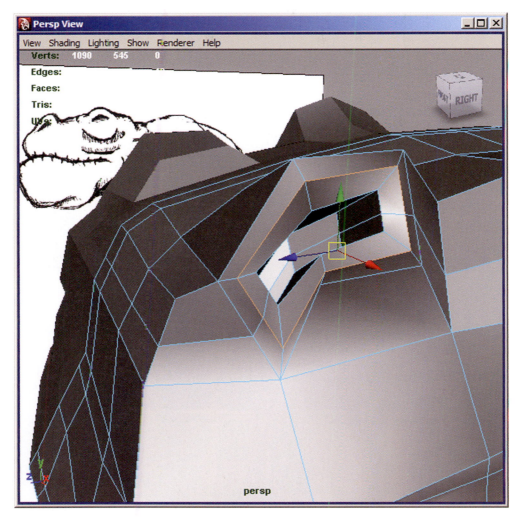

FIGURE 7-135 Rounding the nostrils.

19. Insert a horizontal edge loop through the center of the mouth. The mouth can be very tricky to create, but by moving slowly and adjusting the shape during each step you will have a mouth ready for animation.

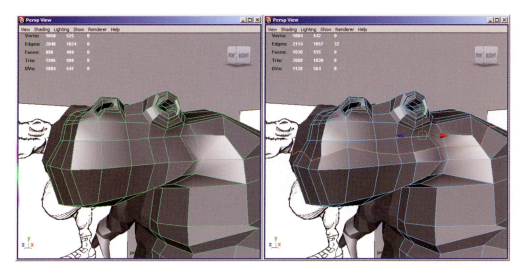

FIGURE 7-136 Starting the mouth.

20. To create the mouth, select the polygons of the lips and click Edit Mesh>Extrude; however, DO NOT extrude them out with the manipulator. Instead use the scale tool to size the new polygons. You will need to clean up the middle edge by deleting any internal faces and using the command move −x 0; to snap the vertices back to correct axis.

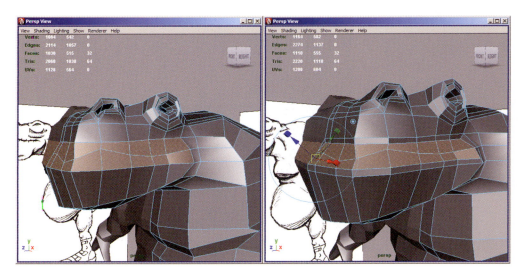

FIGURE 7-137 Creating the lips.

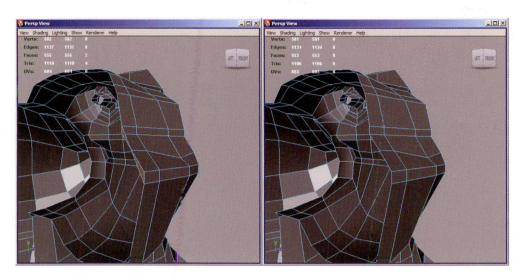

FIGURE 7-138 Deleting internal faces.

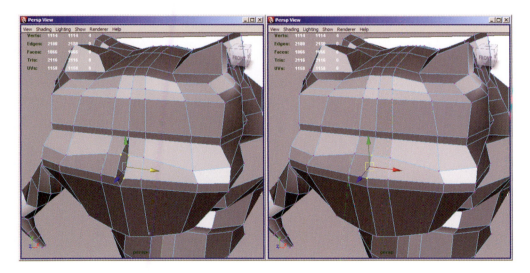

FIGURE 7-139 To fix any vertices have moved off center use the command, move −*x* 0.

21. Select the faces of the lips and extrude them down and inward slightly. By using a series of small extrudes, the lips can be rounded off and still have the correct topology.

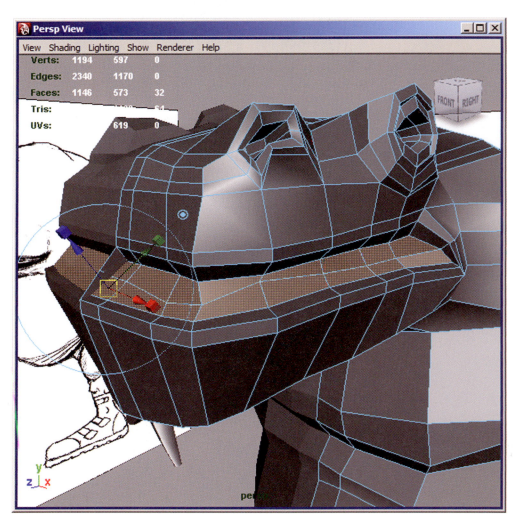

FIGURE 7-140 Beginning lip extrude.

22. Continue to perform extrudes and rounding them off until you get the character's outer lips complete. Don't add too many polygons. Just a few rows of polygons were fine for my character.

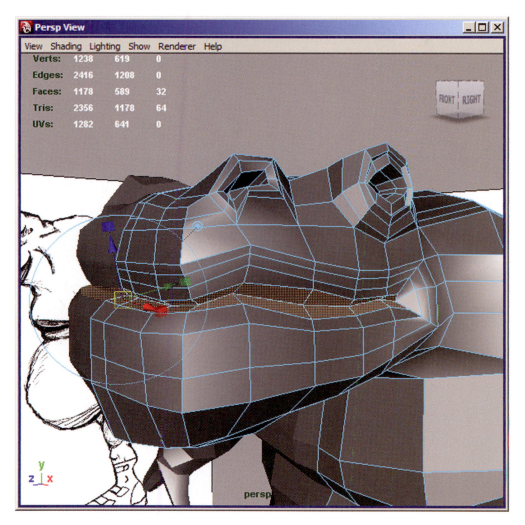

FIGURE 7-141 Finishing outer lips.

23. Extrude the inner most polygons of the lips back to start forming the inside of the mouth. Remember to delete the faces created on the *YZ* axis.

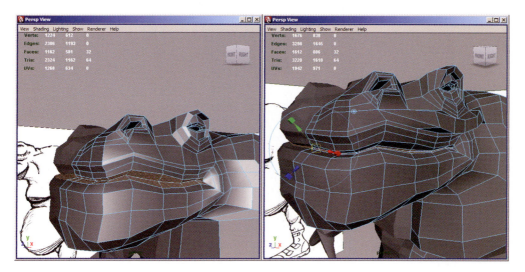

FIGURE 7-142 Starting inside of mouth.

24. Continue to extrude in small amounts as you curl the edge to form the inside of the lips. Remember to delete any faces that form on the inside edge.

FIGURE 7-143 Forming the inside of the lips.

FIGURE 7-144 Remove interior faces.

25. Once you have the inside of the lips done, you are ready to create the throat. Because this character has a side opening mouth, similar to an alligator, you will need to form the throat sack in a slightly different fashion. Instead of continuing to extrude back for the throat, select and delete the inside faces.

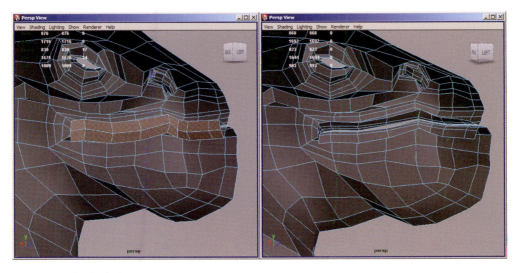

FIGURE 7-145 Starting the throat.

26. Next select and extrude the edges that form the inside edge of the front lips back into the throat. Extrude in small amounts so that each new extrude operation lines up with the existing polygons of the side lips.

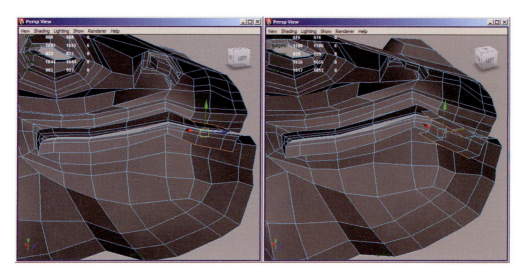

FIGURE 7-146 Starting the throat.

FIGURE 7-147

Continuing the throat.

27. Extrude the back edges down so they meet up.

FIGURE 7-148 Preparing to close the throat.

28. To finish closing the throat, select the vertices of the newly extruded faces and snap them to the adjacent vertices. Pressing and holding the "v" key while moving a vertex toward a second vertex will cause it to snap to the new position.

FIGURE 7-149 Snapping the vertices together.

29. Finally click Edit Mesh — Merge to combine the vertices resting on top of each other. If the merge value is too high, undo, lower the merge strength and apply a second time.

30. Select the back row of faces and extrude back into the neck to finish the throat. As usual, delete any faces that are created on the inside *YZ* plane of the character.

FIGURE 7-150 Finishing the throat.

31. Shape the inside of the mouth.

FIGURE 7-151 Final shaping of the inner mouth.

The gums are created in the same fashion as the lips with small extrudes that curl down into the mouth. For a character like my troll, it's a good idea to form the gums as part of the mesh to reduce the chance of any gaps showing during animation.

32. Select the faces of the top gum and extrude them down. Extrude in small chunks so you can get nice round gums.

FIGURE 7-152 Creating the top gum.

33. Select the faces of the bottom gum and extrude them up. Extrude in small chunks so you can get nice round gums.

FIGURE 7-153 Creating the bottom gum.

34. Create a cube and scale it to the size of a canine tooth. Position it along the top gum line.

35. Click Edit Mesh — Sculpt Geometry Tool and sculpt the mesh into the shape of the canine.

FIGURE 7-154 Creating the canine tooth.

36. Use the same method of sculpting a subdivided cube for creating the remaining upper teeth.

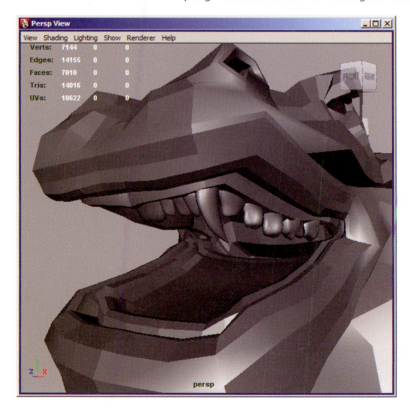

FIGURE 7-155 The remaining upper teeth.

37. Duplicate the finished teeth and place them along the remaining gum line. I like to duplicate the teeth instead of instancing them so that I can slightly change the size, shape, and orientation of each one as they are placed. It doesn't have to be much, just enough to break up the symmetry.

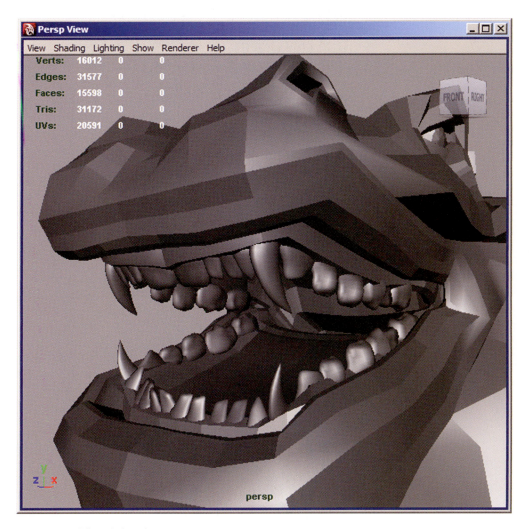

FIGURE 7-156 Fully toothed mouth.

38. For the tongue, create a cube, position it inside the mouth and scale it to the correct size.
39. Click Edit Mesh — Smooth. Subdivide it around three or four times. There needs to be enough polygons for proper deformation. I subdivided the tongue to level 4.

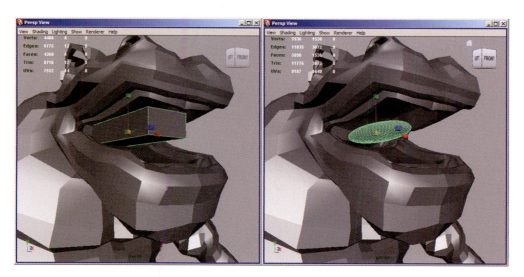

FIGURE 7-157 Creating the tongue.

40. Use Edit Mesh — Sculpt Geometry Tool to shape the tongue.

FIGURE 7-158 The final tongue.

41. Select and extrude the faces above the upper lip to create the troll's jaw ridge. Remember to change directions of the faces at each end so it blends better into the surrounding mesh.

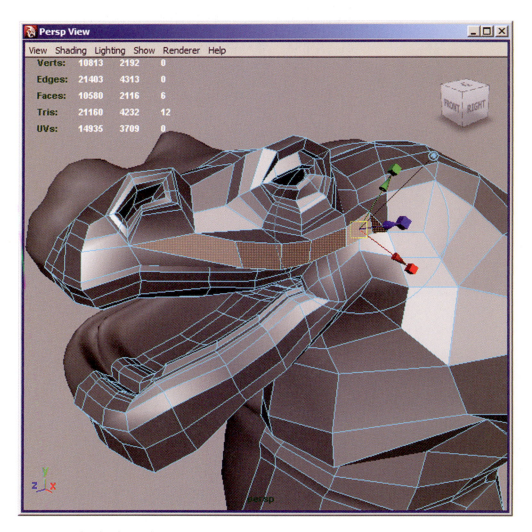

FIGURE 7-159 Extruding the jaw ridge.

42. Insert an edge loop through the back of the head. We need to do this so the ear can be properly shaped.

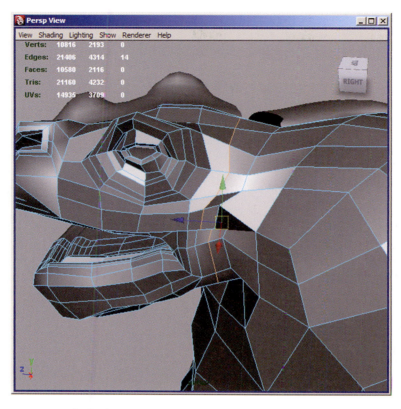

FIGURE 7-160 Starting the ear.

43. Select and extrude the faces needed for the ear.

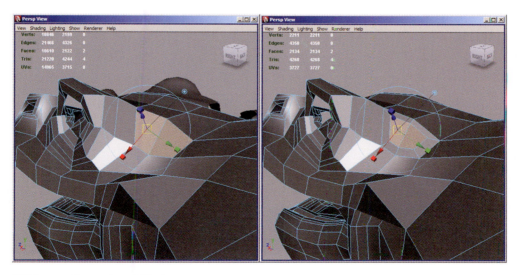

FIGURE 7-161 First extrude needed for the ear.

44. Extrude the ear faces a second time. This will allow depth to be added to the ear.

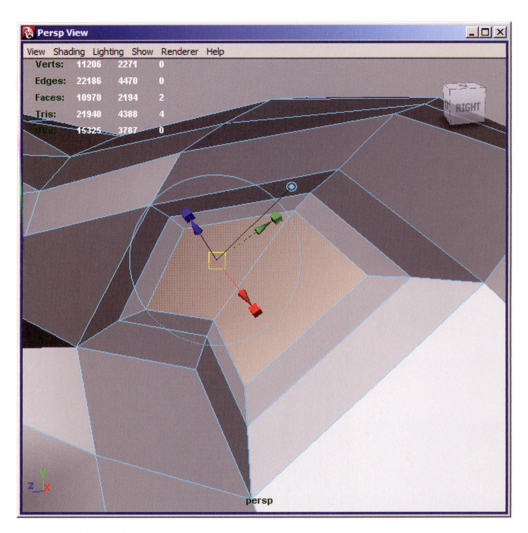

FIGURE 7-162 Adding depth to the ear.

45. Select the faces of the ear and extrude them down to form the ear canal. Scale the ear faces down as they go deeper into the canal.

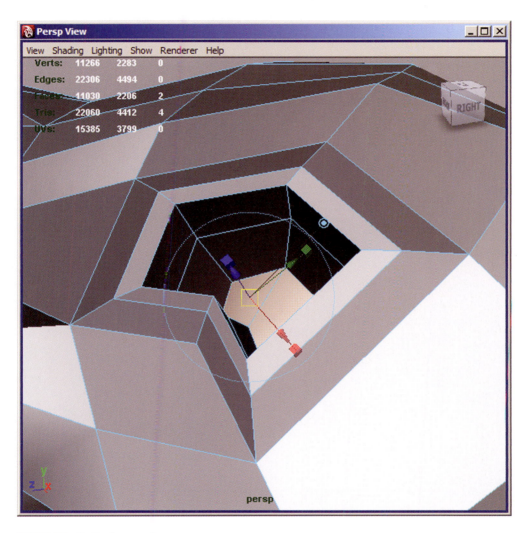

FIGURE 7-163 Creating the ear canal.

Select the inner face and extrude it in to create the tragus.

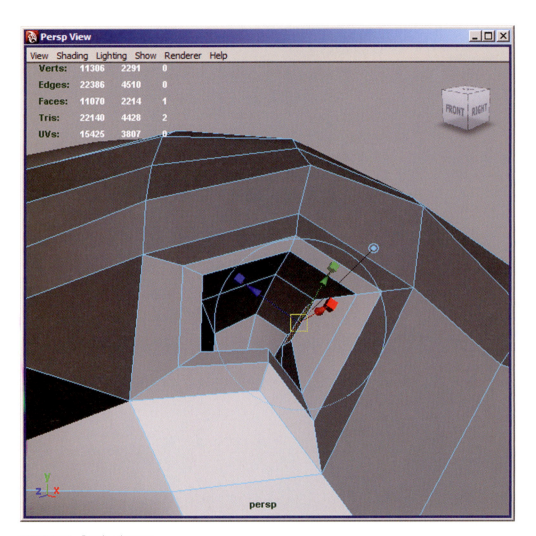

FIGURE 7-164 Extruding the tragus.

46. Select the forward faces and extrude it up to build the stalk. The troll's ear is similar to a hippo's so it will need to be concave.

FIGURE 7-165 Extruding the stalk.

47. Continue extruding upward until you have enough subdivisions to shape the ear. Three or four should be fine for the troll.

FIGURE 7-166 Shaping the upper ear.

Tutorial: Sculpting the Final Details in Maya

With the major muscle masses and bone landmarks defined, all that remains is to finish shaping the mesh. For this stage I like to use the Sculpt Geometry Tool to do the final adjustments. The Sculpt Geometry Tools is similar to ZBrush in that it allows you to paint deformation. However, keep in mind that it is much more limited in functionality compared to ZBrush. In Maya you can only push, pull, smooth, relax, or erase brush strokes.

1. Open your character in Maya.
2. Select the mesh and click Mesh — Smooth.
3. In the channel box find the Input for the polySmoothFace node and change the divisions to the desired amount. I set mine to 3 to give myself around 275,000 polygons. Keep in mind, you can't readily move between subdivision levels like you can in ZBrush. You get limited functionality using the Polygon Smooth Tool. You can only move backward to a lower resolution. Moving to a higher division after using the sculpting tools will cause weird deformations in your mesh.

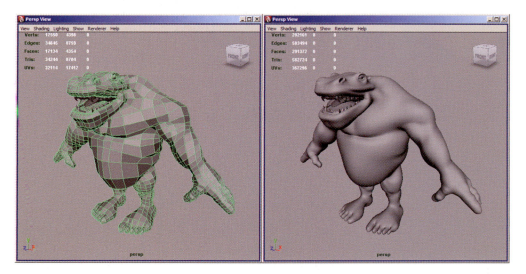

FIGURE 7-167 Before and after smooth.

4. Select Mesh — Sculpt Geometry Tool.
5. If the tool options are not visible, double click on the sculpt icon in the toolbox to open the attribute editor.
6. In the Brush section set the following options. Adjust the Radius (U) to change the brush size. Pressing the "b" key while clicking and dragging the LMB will interactively change the brush size. Set the Opacity slider to a lower value. I like to work with 0.125 or less. A high value will cause too drastic deformation in the mesh. Select a brush profile. For character work, I stick with one of the first three profiles. I like the feel of the round brush tips.

7. Under the Sculpt Parameters select a brush operation (Push, Pull, Smooth, etc.). Uncheck Auto smooth; this can cause unwanted results. Set the Reference vector to Normal. Normal will displace each polygon according to the direction of its normal. Most of the time I leave this set to Normal, but if needed, I will set it to a different option.

8. Under the Stroke section, set Reflection to *X* if you want to mirror the strokes across the model. This is a great time saver.

9. Using combinations of push and pull, define the muscles and protruding bones. If a stroke is too strong, switch to smooth to clean it up. Then lower the opacity to draw with less strength.

10. If you later find unwanted bumps or creases in the mesh, you can use the Relax setting in the Sculpt Parameters section to it while keeping the overall shape of the main mass of polygons.

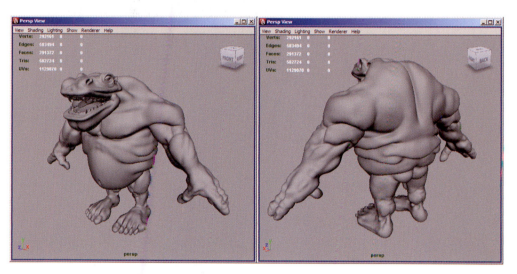

FIGURE 7-168 Final sculpted model

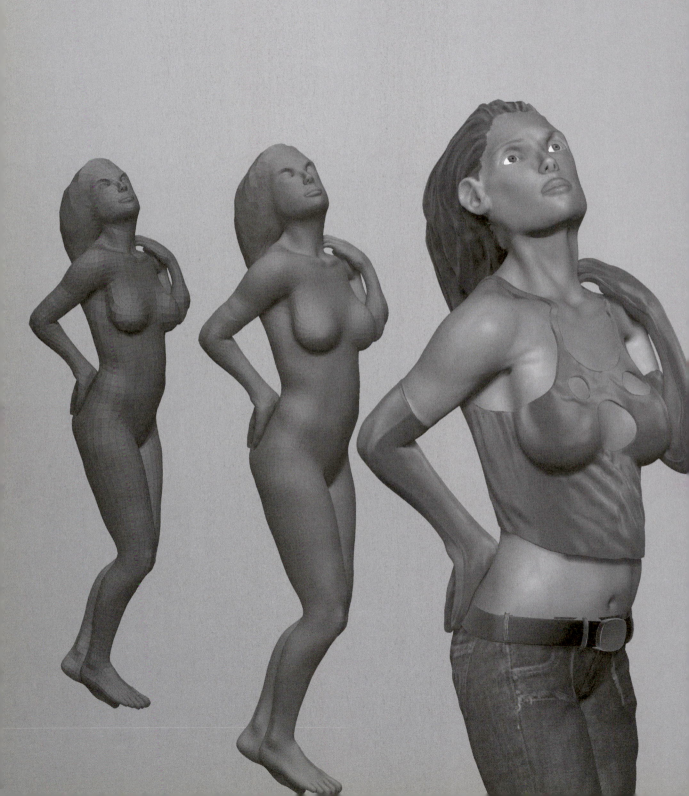

Creating a Photo-Real Character

Photo-realistic characters are perhaps the most difficult to create. Because we see people every day, photo-realistic CG characters are judged by the highest of standards. That means during the creation phase reference images and maquettes should be followed meticulously.

True photo-realistic characters are typically reserved for pre-rendered film work. Of course, next generation consoles are able to deliver stunning characters, but they are still limited to what can be delivered in a real-time environment (that means thousands of polygons, perhaps tens of thousands). Photo-realistic characters of films can command millions of polygons. In fact, the x64-bit computers available today can handle characters upward of 20 million polygons or more, allowing artists to achieve truly amazing characters.

315

As I mentioned previously, my favorite anatomy website is http://www.3d.sk/. There are thousands of photos available ranging from modeling poses, to clothed humans, to action poses.

Before a model can be brought into ZBrush, the UV coordinates should be laid out. While ZBrush does have automatic UVs (gUV and aUV), Maya doesn't work too well with them. Therefore, you should take some time to set your own UVs.

Tutorial: ZBrush Blocking

Just as we did during the blocking stage in Maya, it's important to build detail slowly and shape the model as you work. This is where ZBrush really shines. ZBrush 3 has some incredible modeling tools available.

1. Open ZBrush, click Tool>Import and navigate to the .obj model. Click and drag in the work area to place the model in the scene.
2. Immediately press the "t" shortcut key to enter edit mode. This is important. If you try to do anything else, the model will be dropped to the canvas and will no longer be a 3D object.
3. You are currently looking at the lowest resolution of the mesh.

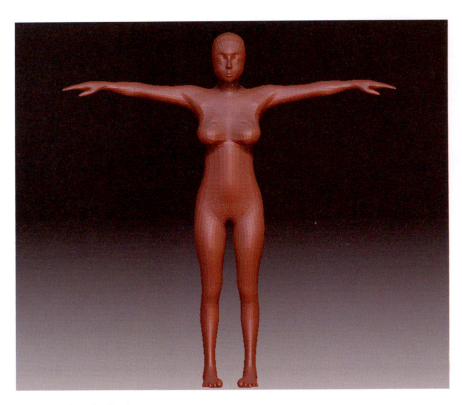

FIGURE 8-1 The tool in ZBrush.

4. In the Transform menu make sure Mirror Symmetry is on for the X axis. Because the character was modeled in Maya and mirrored on the X axis, it's possible to work in a similar fashion in ZBrush.

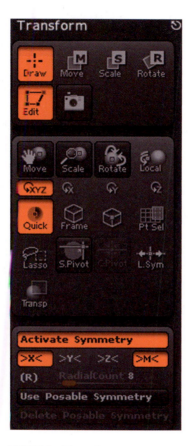

FIGURE 8-2 Mirror options.

5. Use the Move, Scale, and Rotate buttons along the right side of the window to position the model for sculpting. Remember, if you need to zoom in on the model in ZBrush, you will usually use Scale. The Zoom button actually zooms the entire document and will cause artifacts. You can also rotate the model by LMB clicking and dragging a blank area of the canvas. The shortcut to move around the model is pressing ALT+LMB clicking and dragging in a blank area of the canvas.

Now that you are ready to begin blocking out the character, remember to hold off subdividing the mesh until absolutely necessary. Blocking out the mesh in ZBrush means defining the major muscle and bone masses. Do not try to add smaller details too early or you will have a hard time editing the mesh later.

1. Locate the major bone masses on your reference images. Because the skeleton is the framework of the body in real life, it is always a good idea to start there.

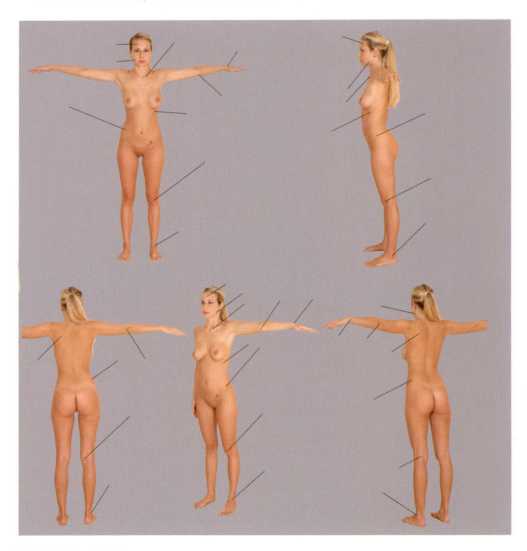

FIGURE 8-3　Bone landmarks.

2. After the bony areas are defined, sculpt the larger muscle masses.

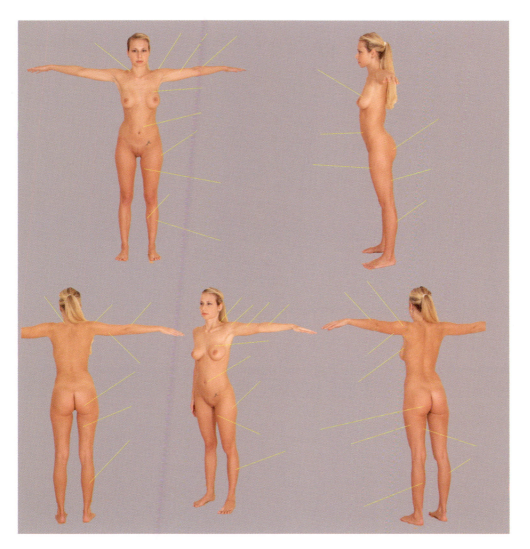

FIGURE 8-4 Muscle masses.

3. When sculpting, you will mainly be using the Inflate, Standard, Smooth, and Move brushes. The Inflate brush is the best way to expand small sections like the fingers and toes. The Standard brush is good for general use. The Move brush is great for moving or "tweaking" the mesh. The Smooth brush will smooth out any undesired bumps or creases.

FIGURE 8-5 The Inflate brush.

4. If the brush is too large or the intensity is too high, adjust the Z Intensity and Draw Size respectively. The lower the value here, the smaller the effect will be.

FIGURE 8-6 Brush options.

5. If you need to deflate while using the Inflate brush press and hold the ALT key as you sculpt. This will temporarily enable the Zsub shortcut.
6. Likewise, if you need to smooth out any section, press the SHIFT key while sculpting to temporarily enable the smooth brush.
7. Continue sculpting until you have defined all of the main bony masses and large muscle landmarks.

Tutorial: Working with 3D Layers

3D Layers are a great feature in ZBrush. They allow you to add detail which can be turned on or off at anytime during the creation of the model. Think of these layers like the ones in a 2D program like Adobe Photoshop. You can add new detail to the layers without damaging your original model.

1. With your model loaded, click Tools>Layers>New. This will create a new 3D layer with your model. Rename this to Base layer.

2. Click Tools>Layers>New to create a second layer. This layer can contain new sculpting details without affecting the original. Any sculpting you do on this layer will be added to and blended with the main layer without damaging the original. You can even pose the model and switch between the posed and original versions by turning off the pose layer.

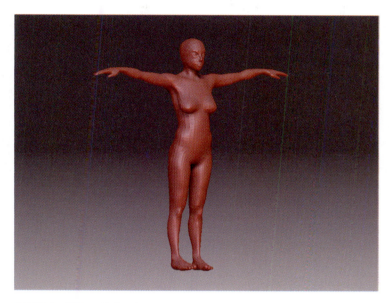

FIGURE 8-7 3D layers: the base layer.

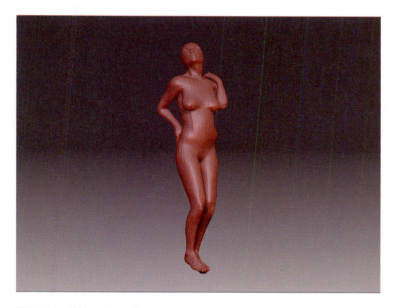

FIGURE 8-8 3D layers: the pose layer.

Tutorial: Sculpting with Symmetry

Now that you have a pose layer, you can switch back to the original layer whenever you need to do any symmetrical sculpting. This works okay, but anytime you divide the mesh, you lose the ability to switch between the pose layers without first stepping down to the lower subdivision. This can be problematic when you are working with higher resolutions. A better option is to use Posable Symmetry.

1. Load your model that contains the pose layer.

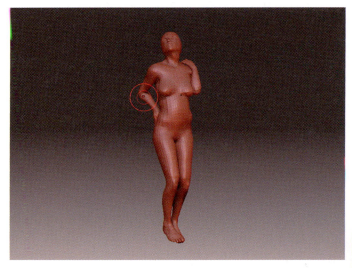

FIGURE 8-9 Lost symmetry.

2. Click Transform>Activate Symmetry. Check X for the symmetry to mirror across the X axis.
3. Click Transform>Use Posable Symmetry. ZBrush will calculate the symmetry of the model. When sculpting with symmetry, the cursor will turn green.

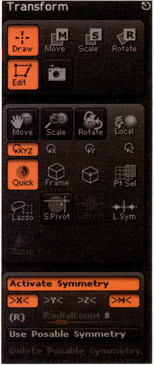

FIGURE 8-10 Symmetry options.

The model will now have
symmetry. Meaning you can
sculpt with symmetry on
a posed model. The cursor
will turn green indicating
you are using Posable
Symmetry. If you move to a
different division level, you
will need to reapply the Use
Posable Symmetry too.

FIGURE 8-11 Symmetry.

Tutorial: Using Alpha Images

ZBrush allows you to use alpha images to sculpt detail into the mesh. If none of the pre-loaded
alphas work for the detail you would like, then you will need to create one. I prefer to make alphas
in Photoshop.

1. Open Photoshop
and create a new
document.

FIGURE 8-12 Alpha creation.

2. Set the background to black and the foreground to white or gray.

3. Paint out the desired alpha shape.

4. Click Image>Mode>Grayscale to remove the color information.

FIGURE 8-13 Set to grayscale.

5. Save the document as a psd file.

I like creating alphas in Photoshop because it's very easy to create much more complex images. In the images below, instead of starting with a black background, I started with a close-up photograph of some skin.

FIGURE 8-14 Various alpha images.

FIGURE 8-15 Various alpha images.

Tutorial: Creating Wrinkles and Skin Pores

Now it's time to detail the characters in ZBrush. This is where the program really shines. The amount of detail you can add to a model is amazing.

Traditionally, wrinkles and skin pores would have to be created as a texture/bump map combination. With ZBrush, however, it's incredibly easy to add crow's feet, laugh lines, etc.

1. Load your character into a new session of ZBrush.
2. Make sure your character has been divided into at least a million polygons. You will need the extra detail in order for the alpha to deform correctly.
3. Click Alpha>Import and load the wrinkle alpha you created.

FIGURE 8-16 Loading the alpha in ZBrush.

4. Under the Stroke menu change the brush stroke to DragRect. This will make it much easier to place wrinkle alpha.

5. Check either Zadd or Zsub to add or subtract the alpha.

6. Adjust the Z Intensity to the desired amount.

7. Drag on the mesh where you want to add wrinkles.

FIGURE 8-17 Rectangle brush stroke.

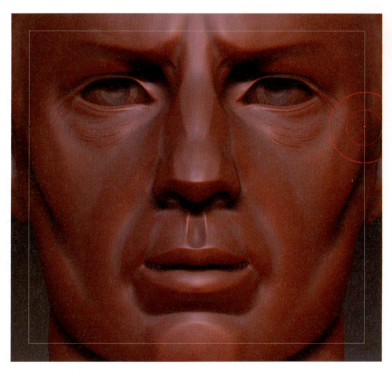

FIGURE 8-18 Adding wrinkle.

8. Continue until you like the amount of detail. Keep in mind that you can adjust the Z Intensity every time you make a stroke. That way you can have some wrinkles deeper than others.

9. When sculpting with alphas they tend to be a bit flat. Turn off the alpha and use a low-intensity Inflate brush to puff out the skin between the wrinkles.

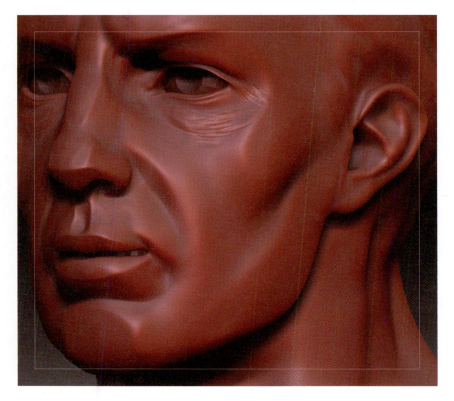

FIGURE 8-19 Puff out the alpha.

10. Click Alpha>Import and select the alpha skin pore file you created. This will load it as the current alpha image.

11. Under the Stroke menu change the brush stroke to DragRect. This will make it much easier to place the skin pore alpha as you work.

12. Click the Zsub button to subtract the alpha.

FIGURE 8-20 Skin pore alpha.

13. Adjust the Z Intensity to the desired amount.
14. Drag on the mesh where you want to add the pores.
15. As with wrinkles, the pores can appear somewhat flat. Turn off the alpha, puff out the pores by using a low-level Inflate brush.
16. Use different sized dots for the different sections of the face.

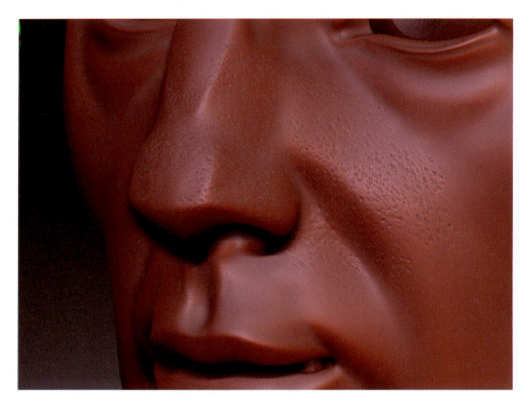

FIGURE 8-21 Final skin pores.

Tutorial: The Extract Tool

The new extract function is a great feature of ZBrush. Extract allows you to copy and separate selected areas of the mesh. This is a great way to add clothes or other props.

1. Load your character in ZBrush and place the tool onto the canvas.
2. Press Ctrl and LMB click to paint a mask of the areas you would like to extract.

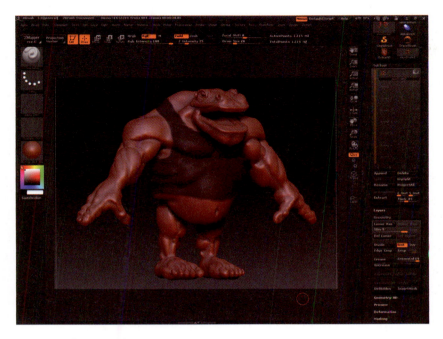

FIGURE 8-22 Painting a mask to extract.

3. If desired, select alpha and remove parts of the mask. This will create holes in the extraction. The drag rectangle works great for this.

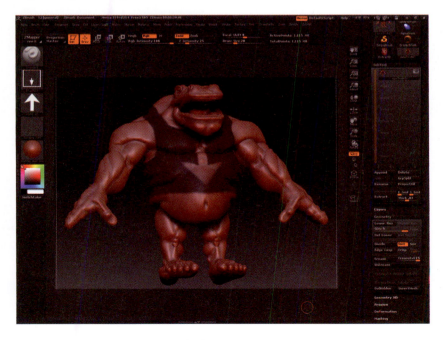

FIGURE 8-23 Using an alpha to create complex shapes.

4. In Tool>Subtool set a thickness for the new extract.
5. Click Tool>Subtool>Extract. The extracted mesh will be added as a new subtool. If the extracted subtool isn't of the correct thickness, delete it by pressing Tool>Subtool>Delete. Then adjust the thickness and press Extract again. Make sure you have the correct subtool selected before pressing delete.

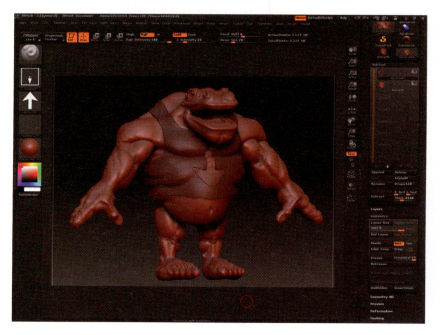

FIGURE 8-24 The extracted subtool.

Tutorial: Sculpting Hair and Cloth

Hair and folds in cloth are also very easy to create in ZBrush. Using a few brush strokes you can quickly get very nice results.

1. Load your model into ZBrush.
2. Make sure it is at least a million polygons.
3. Change the brush to Clay.
4. Adjust the Z Intensity to a higher number.
5. Click on Stroke>Lazy Mouse. This amazing tool gives a drag effect whenever you paint. It really helps in creating hair and folds.
6. Drag along the hair or fold line.

FIGURE 8-25 Lazy Mouse.

7. Now press the Alt key while dragging along and over the hair or fold. This will switch the brush to Zsub. Because you are using a clay brush, it will create blends and folds whenever the Zadd and Zsub strokes move over each other.

8. Continue using the above steps until the hair is complete.

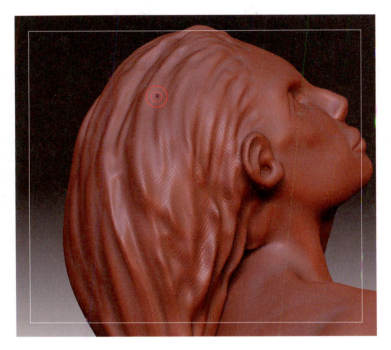

FIGURE 8-26 Hair.

Tutorial: Using ZProject for Texturing

After all of the detail has been added, it's time to create the textures. Texturing in ZBrush has been greatly improved with version 3. Using the ZProject brush, a texture can quickly be applied from a background image onto the desired mesh. Polypaint is another way to texture in ZBrush and will be covered in Chapter 9. ZProject is discussed here because it's done using brushes.

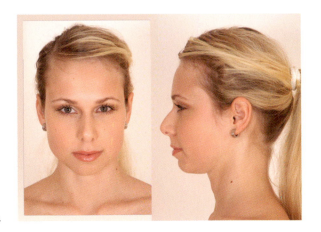

1. First you need to create an image that has views of your character from multiple angles.

FIGURE 8-27 Reference image.

2. Create a new scene in ZBrush.
3. Set the Document width and height to match your image.
4. Import the image file.
5. Place your mesh on the canvas. Remember to press "t" to enter edit mode.
6. Scale and position it next to the front snapshot.
7. Change the material to a white Fast Shader.
8. Click Color>Fill Object.

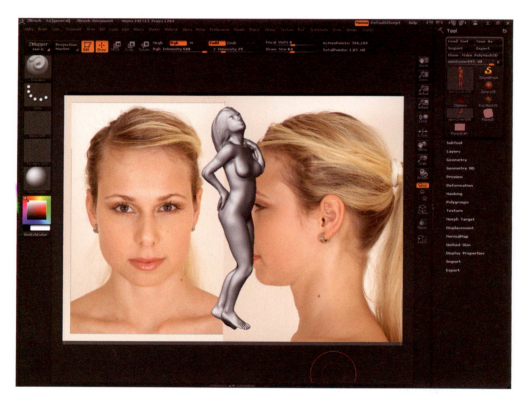

FIGURE 8-28 Position the mesh.

9. Change the brush to ZProject.
10. Turn off Zadd.
11. Turn on RGB.
12. Press "w" to enter Transpose mode. Transpose mode is a new editing mode that allows you to move, rotate, scale, or texture sections of a model.
13. Click on the forehead of the mesh and drag over to the forehead of the image. Release the mouse. You will see the Transpose circles appear.

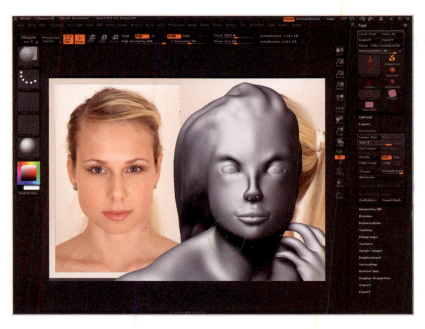

FIGURE 8-29 The Transpose Tool.

14. Press "q" to enter Draw mode.
15. Paint the forehead area.

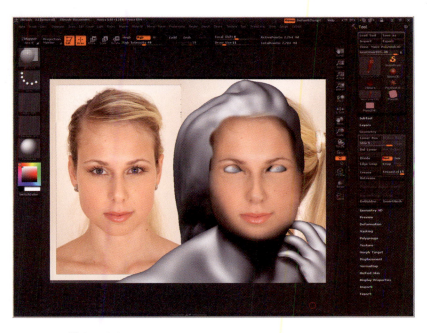

FIGURE 8-30 ZProject painting.

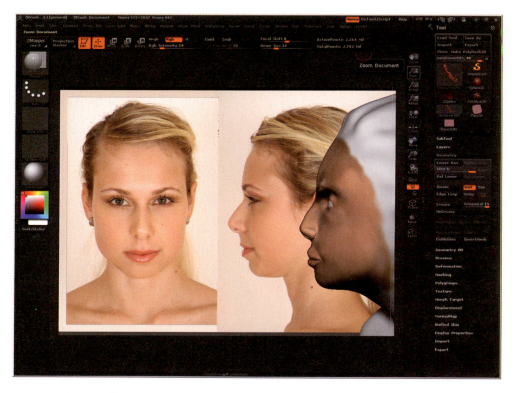

FIGURE 8-31 ZProject strokes.

16. Keep using the above steps to paint the mesh. When you are done painting the front view, position the mesh next to the side view and repeat.

Tutorial: Posing the Character

We looked at some tools that help you work with a model after it has been posed. Thankfully ZBrush has created some easy-to-use posing tools. Keep in mind that because of layers and poseable symmetry, you can pose your model at any time and continue to sculpt symmetrically.

1. Press Ctrl+LMB and drag over the parts of the model you don't want to transpose. The masked areas will remain locked in place.

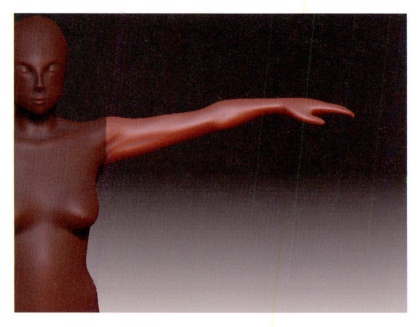

FIGURE 8-32 Masking part of the body.

2. Press Ctrl+LMB click again on the mesh if you want to smooth out the edge of the mask.

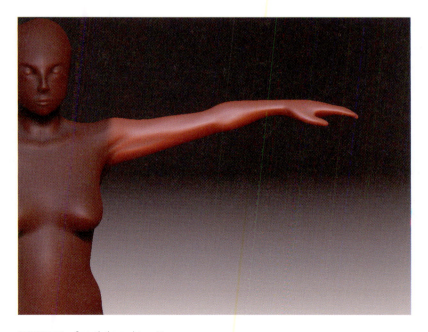

FIGURE 8-33 Smooth the mask transition.

3. Press Rotate to enter the Transpose Tool.

4. Drag from the starting point to the end point to redefine the Transpose Tool.

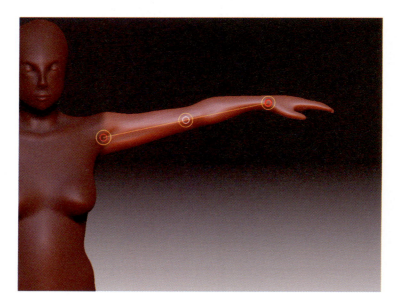

FIGURE 8-34 The Transpose Tool.

5. Click and drag the end circle to rotate the arm down.

FIGURE 8-35 Posing the model.

6. Continue masking parts of the model and posing the mesh.

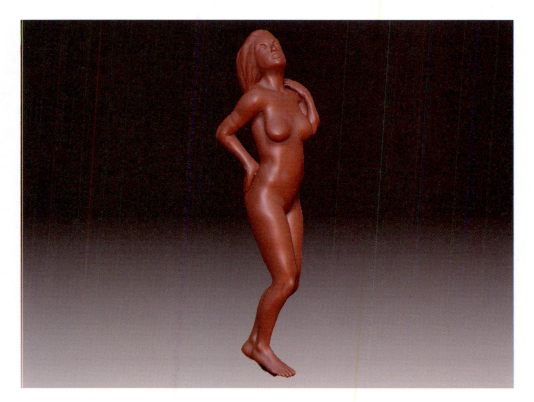

FIGURE 8-36 Final posed model.

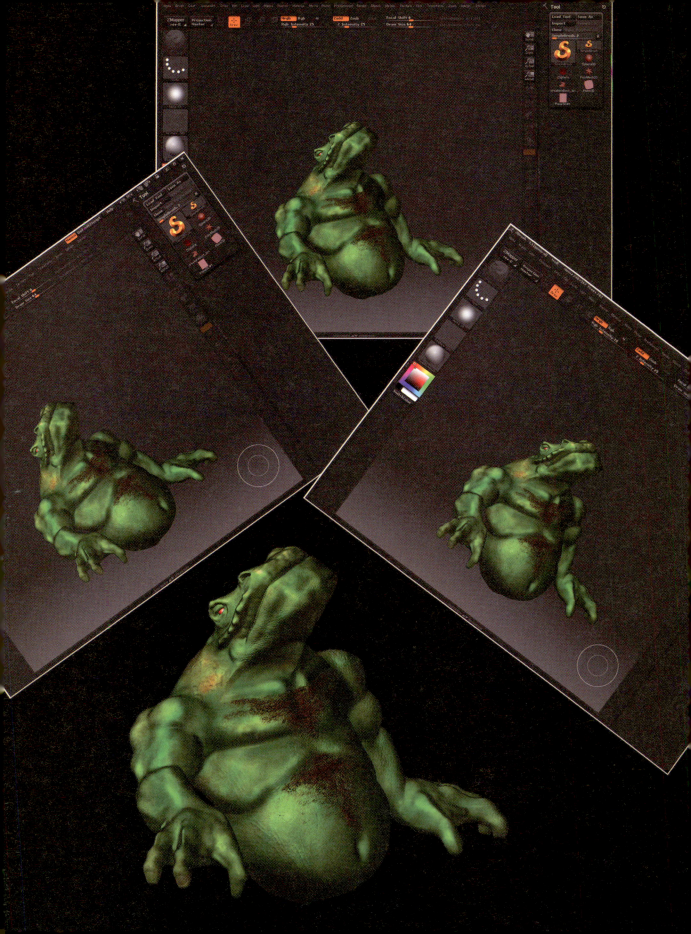

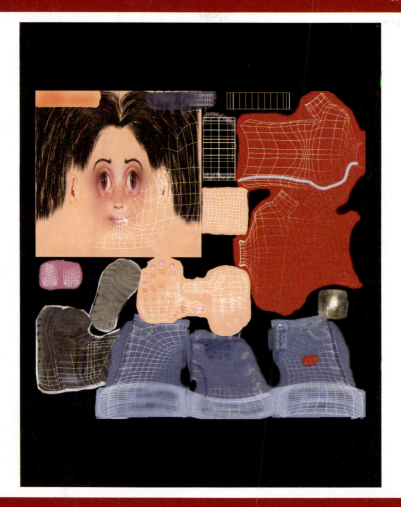

UVs and Texturing

With polygon models, texture placement is controlled by the UVs imbedded in the mesh. UVs are a two dimensional coordinate system which correspond to the X and Y direction of a 2D image respectively. Because UVs are flat, they can be used to assign a 2D image onto a 3D object.

Tutorial: UV Mapping Overview

With polygons' surfaces, you actually have to let Maya know where the UV coordinates lay. This is done using the Texture commands found in Edit Polygons>Textures.

1. Create a polygon sphere in a new scene.
2. With the sphere selected, go to Create UVs>Spherical Mapping. A mapping gizmo will appear indicating the polygons that have just been mapped. Keep in mind that you can UV map the entire object or, if desired, only selected faces.

339

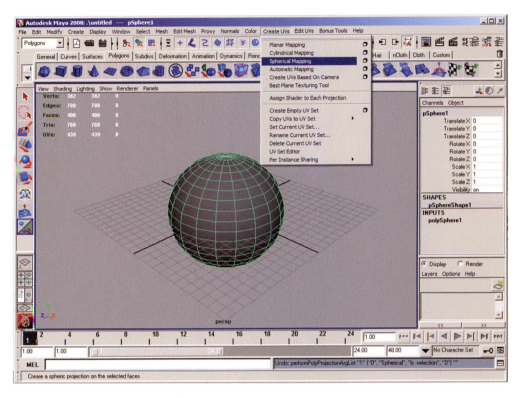

FIGURE 9-1 New sphere.

3. Select the red and green handles on the gizmo surrounding the sphere and adjust them around the object. This will extend the UVs completely around the object.

FIGURE 9-2 UV mapped sphere.

4. Open the Hypershade by going to Window>Rendering Editors>Hypershade.
5. Click on the Phong swatch to create a Phong material.
6. Double click on the newly created Phong material in the work area to open the Attribute Editor.
7. Click on the checkered box next to the Color setting to bring up the Create Render Node.
8. In the Create Render Node select the Textures tab and click on Checker. The Checker texture is a great way to check for any stretching or distortion caused by improperly laid-out UVs.
9. With the object selected, RMB click on the checkered Phong material and click on Assign Material to Selection in the marking menu.

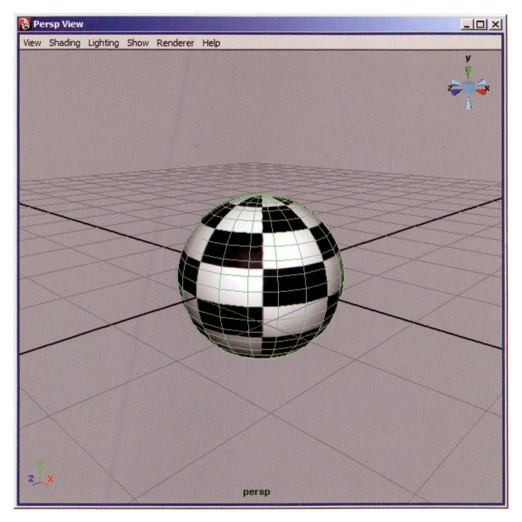

FIGURE 9-3 Checkered sphere.

1. Go to Window>UV Texture Editor to open the UV Texture Editor.

FIGURE 9-4 UV Texture Editor.

2. Select the sphere model you created.

3. You will see your sphere coordinates spread out over the checkerboard texture. Use the standard Maya commands to navigate in the texture editor window.

FIGURE 9-5 An object in the UV Texture Editor.

4. RMB click over the sphere outline and select UV from the marking menu.
5. Drag a marquee to select all of the UVs of that area. You will notice that when you select something in the UV Texture Editor, the selection also occurs in the main Maya viewports. The reverse is also true.

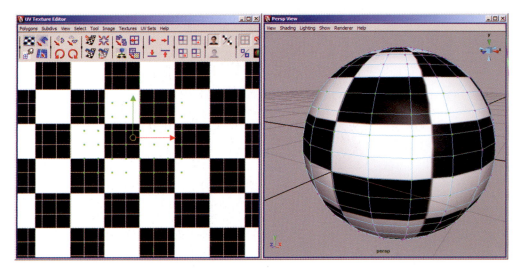

FIGURE 9-6 Selecting UVs.

6. Select all of the UVs of the sphere and scale them down. While working in the UV Texture Editor keep an eye on the object in the Maya viewports. As you scale the UVs, the texture on the sphere becomes larger. Try moving and rotating the UVs to see the effects.

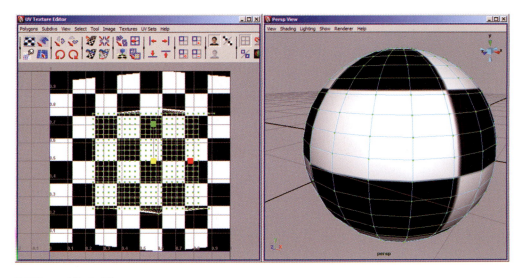

FIGURE 9-7 Adjusting UVs.

After mapping a polygonal model the UV Texture Editor is where you do all of the UV manipulation. In the editor, you can use the drop down options to snap UVs together, cut UVs, or even flip them.

While working on the UVs it is very important to keep an eye on the grid in the UV Texture Editor. Typically you want all of the UVs to remain within 0 to 1 coordinate space. Any UVs that fall outside of that area will begin repeating the texture.

Tutorial: Mapping a Character

As you begin laying out the UVs of your character, take some time to determine which mapping type will fit best for the different areas of the mesh. For the most part, I use cylindrical and planar projection maps. Cylindrical maps work great for sections like the head, arms, and legs. Planar maps, on the other hand, are great for the front of the torso, the back, and the tops and bottoms of the hands.

The goal is to get all of the UVs for your character to reside within this 0–1 coordinate space. This can take a considerable amount of time.

1. Open your character.
2. Select the faces of the torso of your character.

FIGURE 9-8 The front of the torso.

3. Go to Create>Sets>Quick Select Set to add the faces to a quick selection set named Belly. Creating selection sets for complex polygon face groups can save you from having to re-click the faces if they need to be selected at a later time.

4. With the faces of the belly selected go to Create UVs> Planar Mapping>□, Set the mapping direction to the Z-axis and leave the other options at their default settings. Click Project.

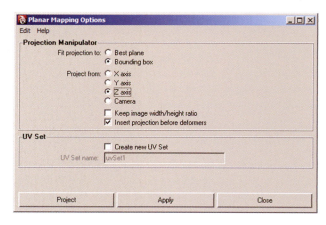

FIGURE 9-9 Planar UV options.

5. The selected faces of the chest now have separate UV coordinates known as a shell.

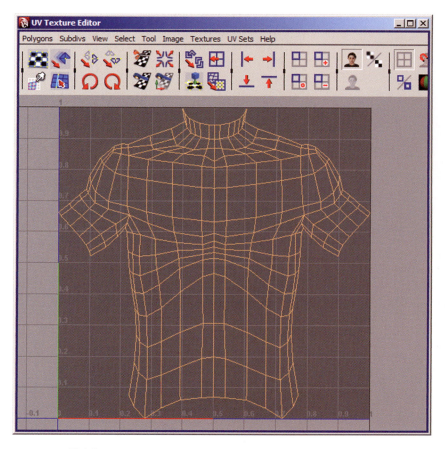

FIGURE 9-10 UV shell.

6. Select the faces that make up the head. Notice that I didn't select the faces at the bottom of the chin or on the top of the head. These polygons run perpendicular to the rest of the faces and will stretch if mapped at the same time as the rest of the head. Don't worry, they will be mapped later.

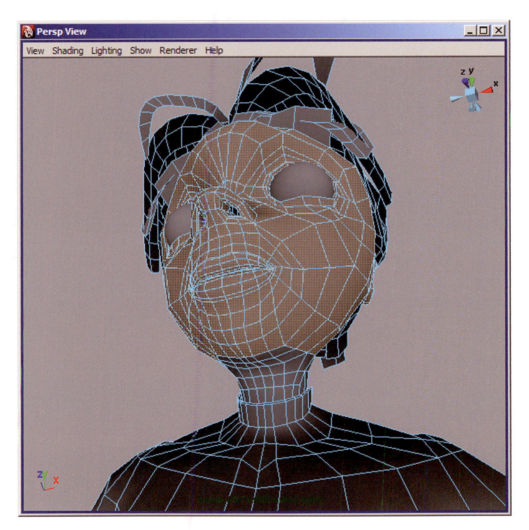

FIGURE 9-11 Polygons of the head.

7. Drag the red gizmo handle all the way to the back of the head. This will force the mapped UVs to fit within 0 to 1 space.

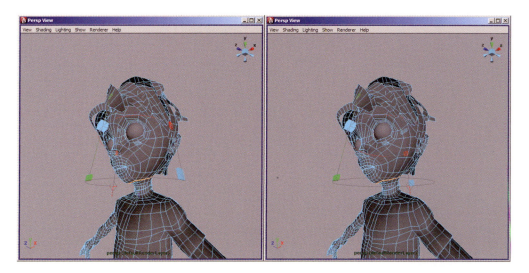

FIGURE 9-12 Mapping gizmo.

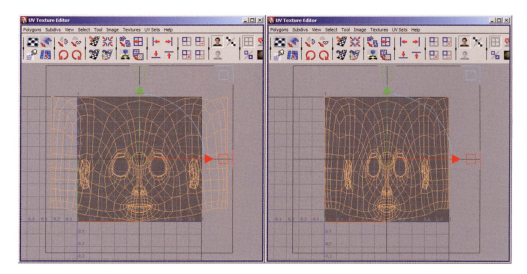

FIGURE 9-13 Head UVs before and after fitting into 0 to 1 space.

8. Select the polygons on the top of the head.

9. Click Create UVs>Planar Mapping>□. Set Project from to the Y axis and click project. At this point you will have a jumble of UV shells sitting on top of each other.

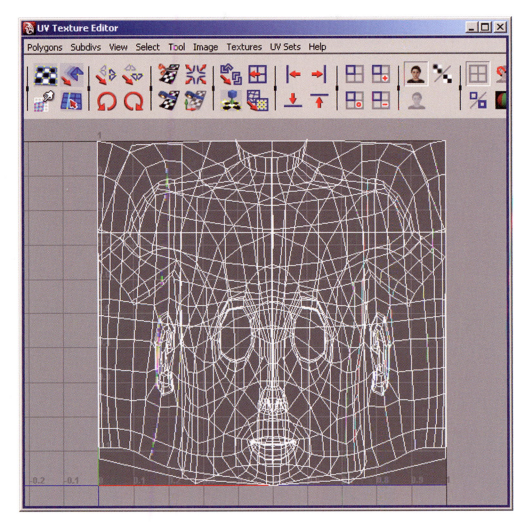

FIGURE 9-14 Jumbled UVs.

10. Finish mapping the rest of the character. At this point, don't worry about the mass of overlapping UVs, we'll look at fixing that later.

Tutorial: Cleaning Up the UV Layout

Now that the UVs have been created, it's time to clean up the layout. The cleanup portion is usually the most time-consuming part of UV creation. Take your time and plan everything out.

1. In order to display the textures correctly, we need to fix the overlapping UVs. Select a UV point on one of the shells and right mouse click to bring up the UV Editor Marking menu. Click Select>Select Shell to grab all of the UV points of a single shell.

2. Uniformly scale the shell down and position it on within 0 to 1 space. Every shell will need to fit within this space so take care in positioning them. Also, keep in mind that the larger the shell, the more texture space will be devoted to it. That means the key areas like the face should take up more space.

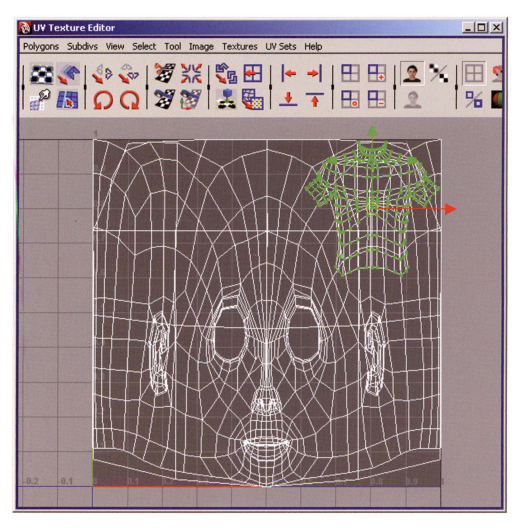

FIGURE 9-15 Fixing the overlapping UV shells.

3. Select the shells of the head and position them in coordinate space.

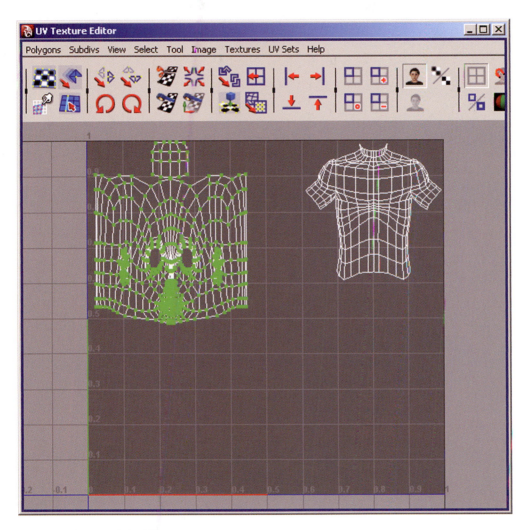

FIGURE 9-16 Positioning the head UVs.

4. At this time, the face and top of the head are still two separate shells. For UVs such as this, it's a good idea to connect them for easier editing. To Connect UVs, select the edges at the bottom of the planar mapped head shell. As you select an edge any edges connected to it that are part of a different shell will be highlighted as well.

FIGURE 9-17 Selecting edges.

5. In the UV Editor click Polygons>Move and Sew UV Edges. This will move and connect the small shell to the main head UVs.

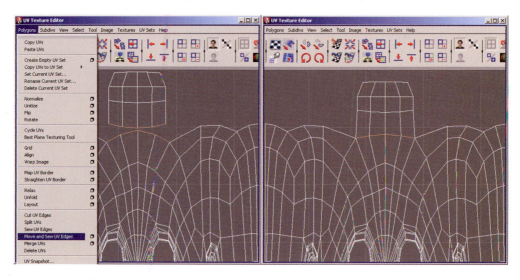

FIGURE 9-18 Sewn UV edges.

6. To conserve space, parts of the mesh that will have identical textures can have overlaying UVs. Select the shell to be flipped and in the UV Editor click Polygons>Flip □. Set the flip options to the desired direction and press Apply and Close. Just keep in mind that because the UVs overlap, the texturing will be the same. If the texturing for each area is to be different, then the UVs should not overlap. This method SHOULD NOT be used if the object is going to be taken into Zbrush as Zbrush requires that no UVs overlap. For ZBrush, lay out the UVs so there is no overlapping.

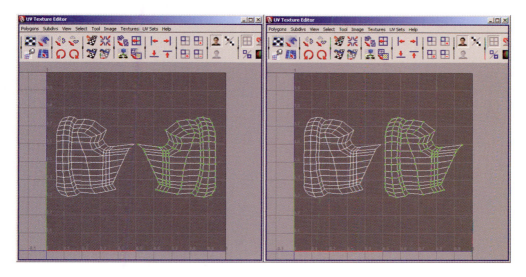

FIGURE 9-19 UVs before and after flipping.

7. Move the flipped shell so it sits over the first one.

FIGURE 9-20 Position the flipped shell.

8. Now you can marquee select both shells and position them together.

9. Using the above methods, create and lay out the remaining UVs.

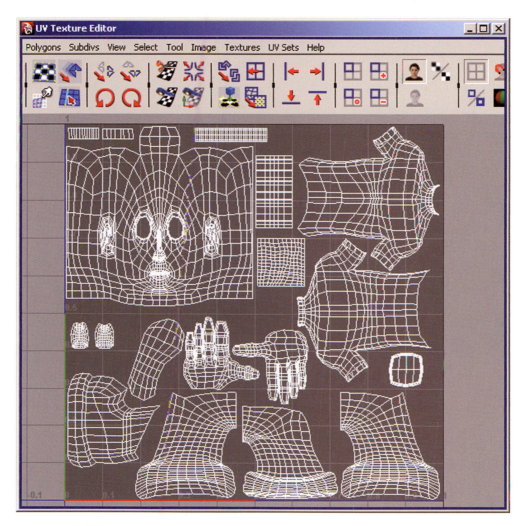

FIGURE 9-21 Final UV layout.

There are other texturing resources available. Check out some of the free scripts on www. highend3d.com for some of the different pelting scripts for Maya. Pelting is an automatic UV unwrapping function. Pelting takes very little time and if you plan on taking the model into ZBrush it makes a lot of sense. If you need to paint your texture using Photoshop you might want to stick with creating UVs in the normal way because they are easy to use as a template compared to pelted coordinates.

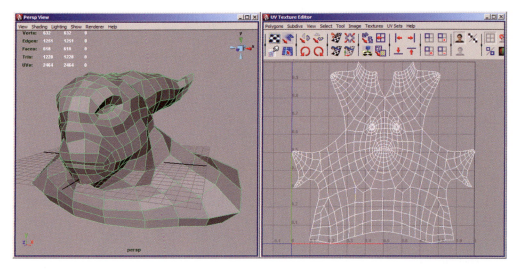

FIGURE 9-22 Pelting.

Tutorial: Texturing in Adobe Photoshop

When you are ready to begin texturing, first load Maya so you can create UV snapshots to help in painting the image. Snapshots can be loaded into Photoshop and used as a template to create the texture.

1. Open your character in Maya.
2. Select the mesh and open the UV Texture Editor.

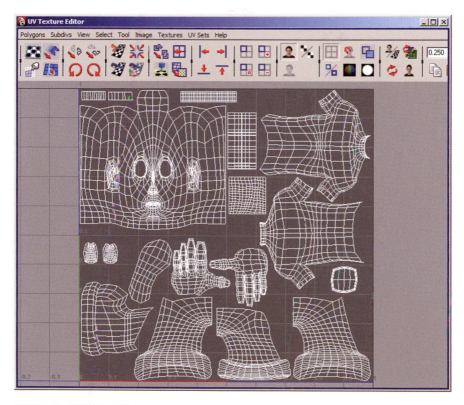

FIGURE 9-23 Well laid-out UVs.

3. In the editor, click Polygons>UV Snapshot.
4. Set the desired options for the snapshot image. All textures for video games should be Targa images in the power of two, meaning 1024×1024, 512×512, 512×256, etc.

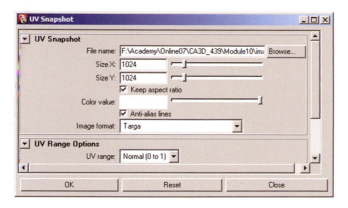

FIGURE 9-24 UV snapshot options.

5. Next open Photoshop and load the UV snapshot you created in Maya.

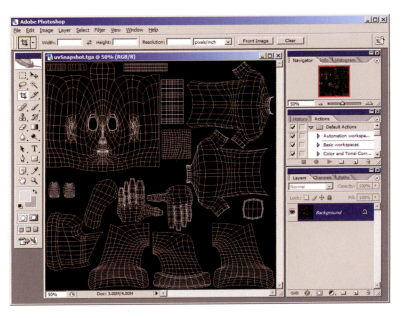

FIGURE 9-25 UV snapshot loaded in Photoshop.

6. Using the snapshot as a guide, paint the textures for the various parts of the model. Yes, it looks a bit strange now, but it actually renders just fine. Remember to turn off the UV layer before saving out the final texture.

7. I like to bring reference images together and blend them together using the clone stamp and healing brush tools.

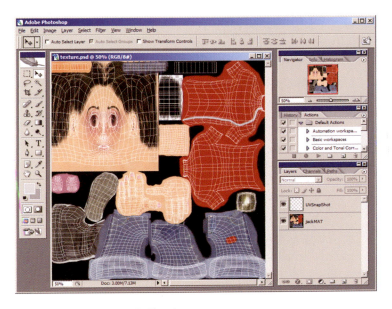

FIGURE 9-26 The texture created in Photoshop.

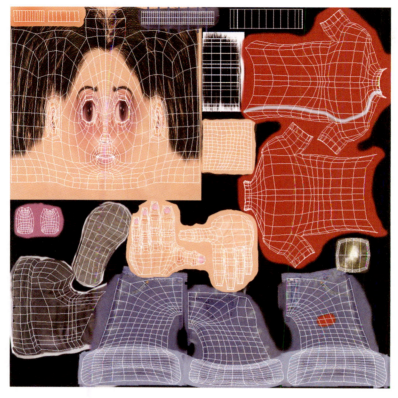

FIGURE 9-27 The final image.

After creating the geometry, the artist will need to let Maya know the surface properties of the object. In Maya this is known as a Shading Network. Each Shading Network holds such information as transparency, color, incandescence, and textures. All of the material work is done in a work area known as the Hypershade.

To open the Hypershade Go to Window>Rendering Editors>Hypershade. Clicking the Perspective/Hypershade button on the Toolbox will also open the Hypershade.

The Hypershade is separated into three main areas. To the left is the node creation area. This is where shading networks are initially created. The two other key areas of the Hypershade are the top and bottom work areas. The top space contains the main node information. The bottom space is the working area where the shading networks are actually constructed. Navigation through the Hypershade is done using the same mouse and keyboard command used in moving through Maya's main menus.

Notice that there are always three material nodes present. These are nodes that Maya uses as default shaders for new objects. Avoid changing these.

There are many different material types to choose from which to begin constructing your Shading Network. It's very important to choose the correct material type as they each render differently. For cutscenes, most of the material types should be okay to use. However, when texturing

in the game art, there will most likely be limitations as to which materials are safe to use. It's always recommended to read through any design documents for the game to see any specific requirements.

- *Anistropic*: For surfaces with small grooves, like brushed metal or a CD. As the view of an object with an anistropic material changes, the highlight will change depending on the direction of the grooves.
- *Blinn*: For surfaces that have soft specular highlights. Blinn materials are a good choice for soft metal surfaces.
- *Hair Tube Shader*: For very small tube-like surfaces. The object's normals are ignored when using the Hair Tube Shader, instead all of the shading comes from the camera view and direction of the object.
- *Lambert*: For matte surfaces. Use for object that will have no specular highlights.
- *Layered Shader*: For use when more than one material is needed for an object.
- *Phong*: For use on very glossy surfaces. Phong materials have a hard specular highlight.
- *Phong E*: Similar to Phong, but with a slightly softer specular highlight. Phong E also renders faster than a regular Phong.
- *Ramp Shader*: Uses gradients to control color changes of the material associated with changes of lights and angle.
- *Shading Map*: For creating non-photorealistic surfaces like cartoons.
- *Surface Shader*: Allows the artists to connect keyable attributes to the material. With a Surface Shader an object's color automatically change as it moves through the scene.
- *Use Background*: For use with blending real-life images with computer-generated objects. Objects using the Use Background material will not appear in your scene, but they are still affected by nodes in your scene. Thus shadows can still fall on them and they can still accept reflections.

Once the material type is chosen the surface attributes need to be created. Surface attributes are things like reflectivity, specularity, glow, etc.

1. Open your character in Maya.
2. In the Hypershade, create a new material by clicking Create>Materials>Lambert.

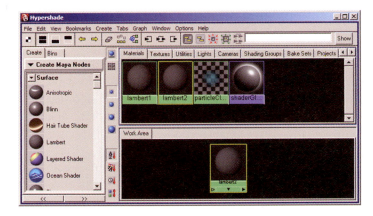

FIGURE 9-28 Hypershade.

3. Double click on the new material to open it in the Attribute Editor.

FIGURE 9-29 Attribute editor.

4. Click on the checker box next to Color.

5. In the Create Render Node window that pops up, press File.

6. This will bring you to the file tab of the lambert shader.

FIGURE 9-30 File tab.

7. Click the Folder Icon next to Image name and navigate to the targa texture you earlier saved from photoshop.

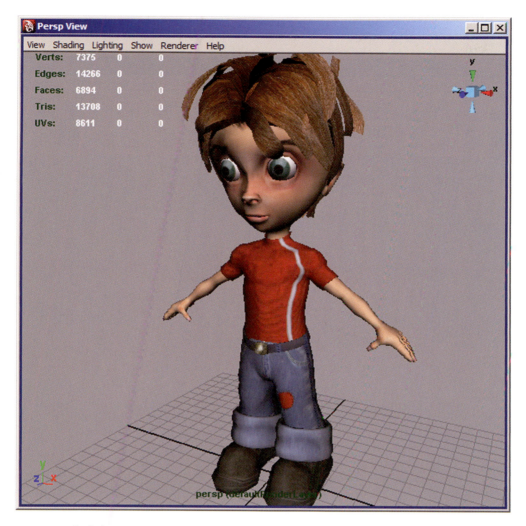

FIGURE 9-31 The final image.

Texturing is also possible with ZBrush. The ZProject brush was mentioned in Chapter 8. But there are other options available. Polypainting is a simple yet highly effective way to texture a model. Also available is the free plugin Zapplink from Pixologic. Zapplink allows you to use Photoshop (or any other 2D image program) for painting directly on the ZBrush mesh.

Tutorial: Polypainting

1. Load a model into ZBrush and place it on the canvas. Remember to press "t" to make it active.
2. Go to the highest division level. The more polygons in your model the smoother the polypaint will be.
3. Select a material.

FIGURE 9-32 Polypaint options.

4. Go to Tool>Texture and set the following options: disable UVs; turn on Colorize. You have to disable the UVs to give the maximum painting surface. Don't worry, if you keep your original .obj you can import the UVs later.
5. Turn off Zadd on the shelf.
6. Turn RGB on.
7. Select the desired color. This should be the base skin color.
8. Select a stroke type. Color Spray is a good starting point.
9. Choose an alpha if desired to change the shape of the brush stroke.
10. Start painting.

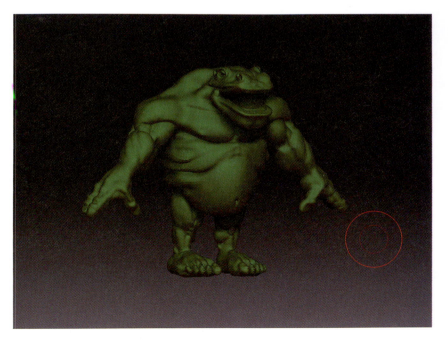

FIGURE 9-33 First pass.

11. While painting, try different RGB Intensity values. I like to use lower values and layer my painting.

12. The second pass should be to start defining sections of the mesh. For instance, the arms will have different colors when compared to the stomach. There will be subtle variations on the same main color.

13. Select different hues for various sections of the model.

14. Adjust the RGB Intensity in the shelf to a lower value and paint some splotches and imperfections along the model. These can be different colors as well.

15. For the last pass, darken the shadow sections and brighten the highlights. This can be done by adjusting the RGB Intensity.

Tutorial: Converting Polypaint to a Texture

1. To convert polypaint to a texture that will be useable in a 2D program, go to Texture and Set the width and height. 1024×1024 is a good learning size.

2. Hit new. This will bake out the polypaint info to the texture.

3. Press Tool>Texture>Col.

4. To retrieve the UVs from an earlier model, go back to the first division level of the mesh.

5. Import the original obj file into the current tool.

6. Because the UVs are the only thing that is different, they are all that will be imported. The mesh will not be changed.

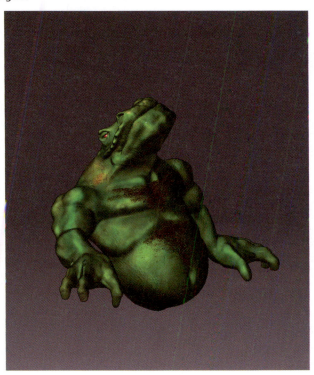

FIGURE 9-34 Final polypaint.

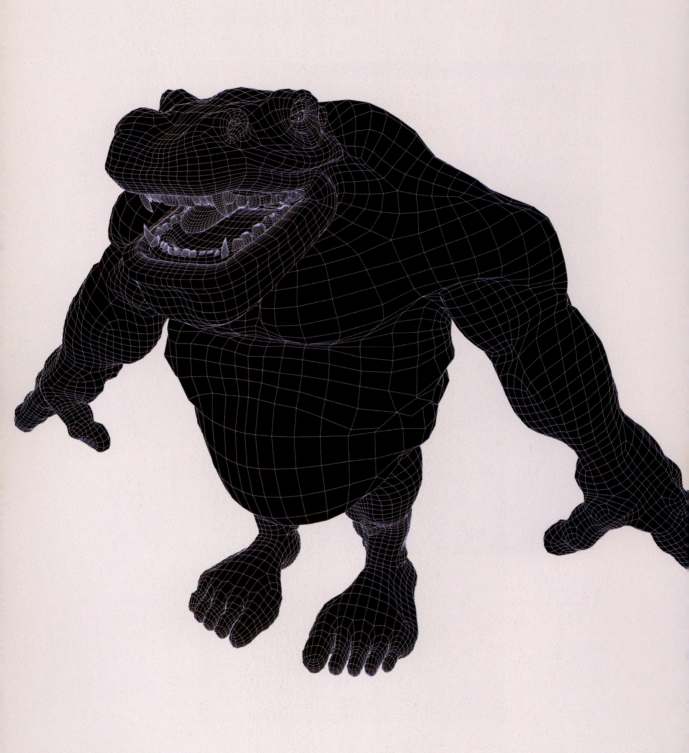

The Next Step

By now, you have a solid foundation for building both video game and film models. The next step is to start attending conferences for job networking. The two main conferences that you should attend are GDC and SIGGRAPH.

Now before you take your models to the conference and start showing them off, we need to look at a few more important topics that can really strengthen your demo reel presentation.

First we need to look at normal and displacement maps. These are images that when applied to a low-res model will change the appearance making it look high-resolution. They differ in that a normal map gives the illusion of changing the geometry of a model, whereas a displacement map actually does.

Let's look at normal maps first. As a modeler for video games, you will need to know how to create normal maps. A normal map takes the polygon normal information from a high-res model and applies it to a low-res one. This will cause the low-res model to appear to have much more detail than it actually does. When applied to a character in a video game, you get the look of a highly detailed character combined with the benefits actually having a lower polygon count. You can create a normal map from within either Maya or ZBrush. Both versions require that you create a high-res detailed version of your character.

Tutorial: Creating a Normal Map in Maya

1. Bring the original character and the sculpted high-res character together into one scene.

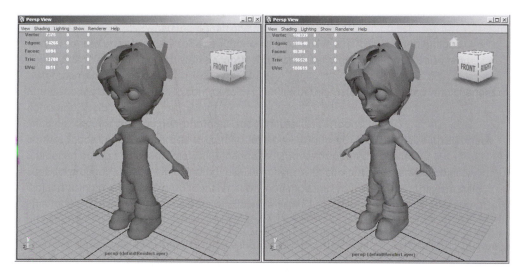

FIGURE 10-1 Original and high-res detailed models.

2. Both models should be at the origin.
3. Resize the high-res model so it is slightly larger than the original. This will help Maya transfer the normal information properly.
4. In the Rendering menu set, click Light/Shading>Transfer Maps.

FIGURE 10-2 Transfer Maps.

5. Select the original mesh and press Add Selected in the Target Meshes rollout.

6. Select the high-res mesh and press Add Selected in the Source Meshes rollout.

7. Press the Normal button under Output Maps. A new rollout will appear. Select a destination. Change the File format to Targa (tga). When working with games, targa files is a common format. Leave the Map space to Tangent.

FIGURE 10-3 Transfer Map window.

8. Under Maya Common Output change the Map width and height to 2048×2048. Leave Transfer in to World Space. Adjusting the Sampling quality to a higher number will give more accurate results but will take much longer to render.

9. Press Bake and Close.

FIGURE 10-4 The resulting normal map.

Tutorial: Creating a Normal Map in ZBrush

1. Load your model into ZBrush and place it on the canvas. Remember to press "t" to go into edit mode.
2. Lower the division down to 1. In order to generate the normal map, the model has to be set to a low division.
3. Press ZPlugin>ZMapper to start the ZMapper plugin. The model will turn blue and the controls will appear at the bottom of the screen.

FIGURE 10-5 *ZMapper.*

4. Click the Normal and Cavity map tabs along the bottom to expand the normal map options.
5. Adjust the Samples to a higher value. This will take longer to calculate, but will give a more accurate normal map.
6. Click Create Normal Map near the right of the ZMapper control pannel. A normal map will be rendered for the object. You can click on the different ZMapper display options to see a preview.

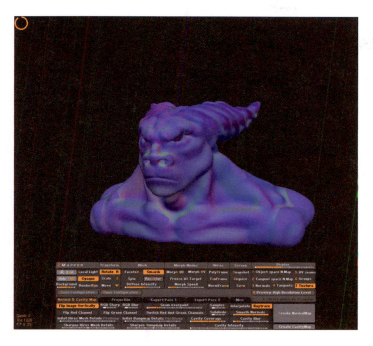

FIGURE 10-6 ZMapper.

7. Click Texture>Export to export the new normal map.

FIGURE 10-7 Export map.

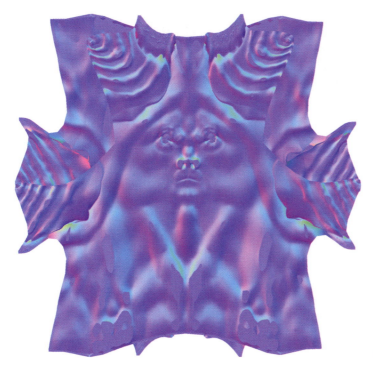

FIGURE 10-8 Final normal map.

The other important map that you need to know how to create is a displacement map. A displacement map applies deformation to a model based on an image file. For modeling, that means, you create a highly detailed character, save the displacement information to an image, then apply that image to a low-res model. Displacement maps are how all of the richly detailed characters are taken from ZBrush and rendered in Maya. It's also how most movie companies will add detail to their characters.

The two most common displacement map types are 16 bit and 32 bit. Thirty two bit, of course, has more information and will therefore give better displacement. However, 32-bit displacement maps are harder to work with so you will probably do most of your work using the 16-bit variety.

Tutorial: Creating a 16-bit Displacement Map

1. To create a 16-bit displacement, load your model into ZBrush and place it on the canvas. Remember to press "t" to go into edit mode.
2. Lower the division down to 1. In order to generate the displacement map, the model has to be set to a low division.
3. Open Tools>Displacement and set the following: check Adaptive; set a DPRres to the desired resolution of your displacement map; check Mode.

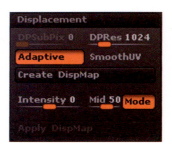

FIGURE 10-9 Displacement map settings.

4. Press Create DispMap. The newly created displacement map will appear in the Alpha menu.

5. Select your displacement map in the Alpha menu.

6. Click FlipV. The displacement will appear upside down in Maya. This corrects that problem.

7. Take note of the Alpha Depth Factor near the bottom. This is needed to tell Maya what is the mid-gray value of the displacement map.

8. Press Alpha>Export. Save as a tiff file. For 16-bit displacements I recommend using this method to export the image. Exporting through the Displacement Exporter will not give you the much needed value of the Alpha Depth Factor.

9. Load the tiff into Photoshop.

10. Click Image>Mode>RGB. The map needs to be RGB for Maya.

11. Save the file.

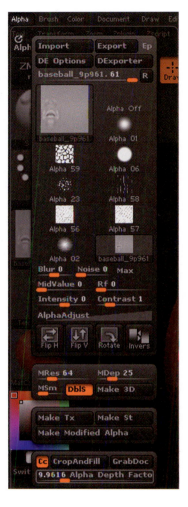

FIGURE 10-10 Exporting 16-bit displacement.

Tutorial: Creating a 32-bit Displacement Map

1. To render a 32-bit displacement, press ZPlugin>Multi Displacement 3 to expand the plugin options. Set the MaxMapSize. The higher this is the more detail you will get, but the longer it will take to generate. The map should also be in the power of two, meaning 1024×1024, 2048×2048, etc.

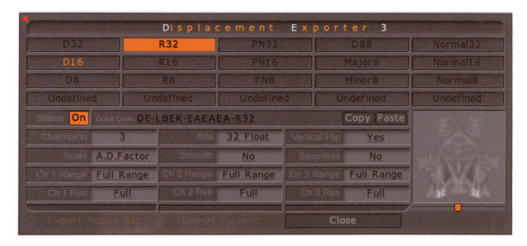

FIGURE 10-11 Displacement options.

2. Set the export options. If you have the quick code for the desired map type you can automatically set the proper export option for whichever program you are using. The quick code for Maya 32 bit is DE-LBEK-EAEAEA-R32. The R32 stands for 32 bit on the red channel. The displacement map needs to be RGB in order for Maya to recognize it. This export option automatically sets that.

3. Press Create All to generate the map. It will prompt you for a location to save.

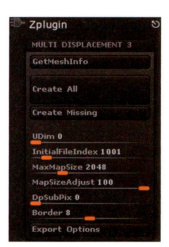

FIGURE 10-12 Export options.

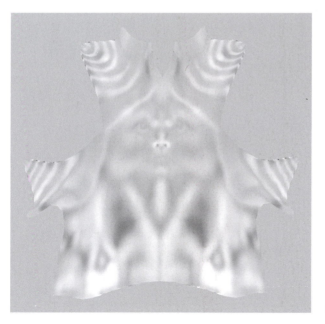

FIGURE 10-13 Displacement map.

4. For 32 bit you need to open a special Mental Ray tool called imf_disp.exe and use it to convert the displacement map to a readable format. Imf_disp.exe is located in the Maya's bin folder. Its default location is C:\Program Files\Autodesk\Maya8.5\bin.
5. With imf_disp.exe load your 32-bit image and click Save As.
6. Save under the .map format. This is a mental ray format that can read 32-bit displacements.

Tutorial: Rendering with Maya Software

Now you are ready to render. Go slow when setting up your displacements. If you try to up the settings to high, it can send your render times through the roof.

1. Open Maya.
2. Load your original base mesh.
3. Open the Hypershade by clicking Rendering>Render Editors>Hypershade.
4. Click on the Phong button to create a new material.
5. Below the materials is the Displacement section. Click on the button to add a displacement node.

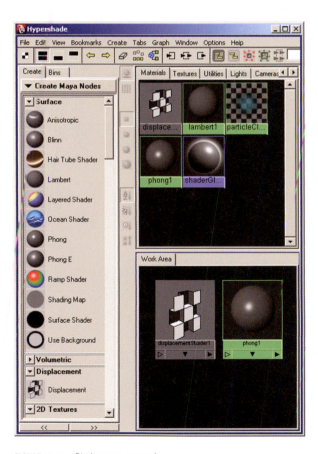

FIGURE 10-14 Displacement map node.

1. The displacement node needs to be connected to the Phong. Do this by MMB dragging from the solid triangle (outward connection) of the displacement node to the empty triangle (inward connection) on the Phong and releasing. Upon release it will ask you what you want to connect. Select displacement map.

2. Using the MMB, drag the File icon from the 2D textures section onto the input of the displacement map node. Choose the default connection.

3. Double click on the new file node to open it in the attribute editor.

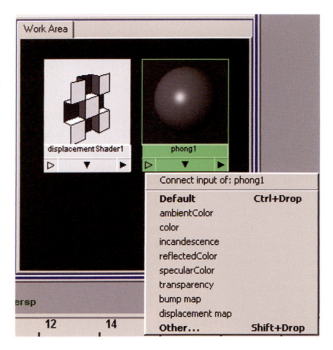

FIGURE 10-15 Connecting displacement map node.

FIGURE 10-16 The load section.

4. Under image name select your displacement texture.

5. Open the color balance section and if you are using 16-bit images type in the value of the Alpha Depth Factor that you got from ZBrush into the Alpha Gain section.

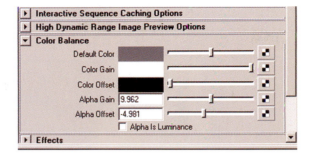

6. The Alpha Offset needs to be negative half of the Alpha Gain. For example, if your Alpha Gain is 2.8, then the Alpha Offset needs

FIGURE 10-17 Settings for Alpha.

to be −1.4. This is how Maya recognizes the mid-gray of your displacement map. If you don't do this, the resulting mesh will render incorrectly.

7. Apply the material to your mesh.

8. Select the mesh and click Modify>Convert>Polygons to Subdiv. Subdivision surfaces tend to work much better with displacement maps.

9. In the attribute editor in the Tessellation section, change the format to Adaptive and the Sample Count to 4. You can raise the sample count later if you need more subdivisions. The higher you raise this setting the more divisions, but the longer the render times.

10. In the Displacement Map section, uncheck Feature Displacement.

FIGURE 10-18 Displacement settings.

11. Render your scene and refine the settings as needed.

FIGURE 10-19 Final render.

Tutorial: Rendering with Mental Ray

As mentioned earlier, you should convert your 32-bit tiff image into .map file when you plan on rendering with Mental Ray.

1. Open Maya.
2. Load your original base mesh.
3. Click Window>Rendering Editors> Render Settings. Choose Mental Ray from the Render using dropdown.
4. Open the Hypershade by clicking Rendering>Render Editors> Hypershade.
5. Click on the Phong button to create a new material.
6. Below the materials is the Displacement section. Click on the button to add a displacement node.

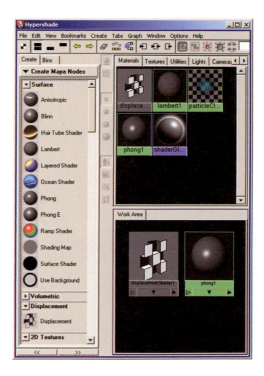

FIGURE 10-20 Displacement map node.

7. The displacement node needs to be connected to the Phong. Do this by MMB dragging from the solid triangle (outward connection) of the displacement node to the empty triangle (inward connection) on the Phong and releasing. Upon release it will ask you what you want to connect. Select displacement map.

8. Using the MMB, drag the File icon from the 2D textures section onto the input of the displacement map node. Choose the default connection.

9. Double click on the new file node to open it in the attribute editor.

FIGURE 10-21 Connecting displacement map node.

FIGURE 10-22 The load section.

10. Under image name select your displacement texture.

11. Open the color balance section and set the Alpha Gain to 2.2. With 32-bit displacements, the Alpha Gain will always be 2.2.

12. The Alpha Offset needs to be negative half of the Alpha Gain. With 32-bit displacements, this will always be −1.1.

FIGURE 10-23 Settings for Alpha.

13. Apply the material to your mesh.

14. Select the mesh and click Modify>Convert>Polygons to Subdiv. Subdivision surfaces tend to work much better with displacement maps.

15. In the Displacement Map section of the attribute editor, uncheck Feature Displacement.

FIGURE 10-24 The Approximation Editor.

16. Click Window>Rendering Editors> Mental Ray>Approximation Editor.

17. With the mesh selected click Create in the Displacement Tessellation section.

18. With the mesh selected click Create in the Subdivision section.

19. Click the Edit button in Displacement Tessellation to open the options in the Attribute editor.

20. In the Displace Tessellation Quality section, change Presets to Fine View High Quality. This will give you really good starting options. You may need to adjust the Max Subdivisions and Length in small increments when you start doing test render.

FIGURE 10-25 Displacement tessellation.

21. Go back to the Approximation Editor and click the Edit button in Subdivisions to open the options in the Attribute editor.

22. Change the Approx Method to Spatial. Set the Min Subdivisions to 3 and the Max Subdivisions to 5. Change the Length to 0.1. You may need to adjust the Min Subdivisions and Max Subdivisions in small increments when you start doing test render.

23. Render your scene and refine the settings as needed.

FIGURE 10-26 Subdivisions.

FIGURE 10-27 Rendered with Mental Ray.

The next step is to start putting your demo reel together. You know how to create normal maps and displacement maps. Below are some examples of which should be included in your demo reel.

Demo reel dos:

- Include resume and cover letter.
- Include your name and contact info at the beginning and ending of the reel.
- Include three to five models. Choose different types of models.
- Include only your best work. People really don't want to see what you created 7 years ago when you got your first computer.
- Put your best work in front.

- Include examples of displacement and normal maps.
- Show some wireframe renders. We want to see how the topology looks.
- Show some closeups.
- Only include final art.
- Only include work that pertains to the job you are applying for. No animation. No vfx.

Demo reel don'ts:

- No obnoxious music. The sounds will probably be turned off anyway.
- Don't go over 2 minutes. That should be plenty of time to show your work.
- No works in progress.
- No mediocre work. If you aren't happy with it, the interviewers won't be either.
- Don't send originals. You might not get it back.
- Don't include tutorials projects. Everyone else has done them too.

Tutorial: Creating a Turntable in Maya

A turntable is the de facto way of presenting your model in a demo reel. It's basically the model spinning slowly in front of a camera. This effect is very easy to set up in Maya. Don't make the mistake of trying to spin the camera by hand around the model. It will create a wobble effect.

1. Open Maya.
2. Position the perspective camera to the desired view. A new camera will be created based on this view.
3. Select a model.
4. In the Animation menu, select Animate>Turntable>□. Set the desired length for the turntable and click apply.
5. Your turntable is now ready.

Tutorial: Creating Wireframe Renders

Wireframe views of a model have always been tricky to create. There are a few different ways to get them from Maya, but my favorite method is to use the Vector Renderer.

1. Open Maya.
2. Select your model and click Normals> Harden Edge. The model will now have a faceted appearance.

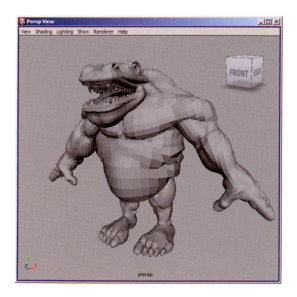

FIGURE 10-28 Hard edges.

3. Click Window>Rendering Editors>Render Settings. In the Render using dropdown, select Maya Vector. If it doesn't show, you need to load the plug-in by going to Window> Settings/Preferences>Plug-in Manager and checking load next to Vector Renderer.

FIGURE 10-29 Vector render.

In the Edge Options section check Include edges. Change the edge color to white. Leave the other options at the default.

7. Open the Hypershade by clicking Rendering>Render Editors> Hypershade.
8. Click on the Lambert button to create a new material.
9. Double click on the Lambert to open it in the Attribute Editor.
10. Change the color to black.
11. Assign the material to the object.
12. Render with the new wireframe render.

FIGURE 10-30 Vector render settings.

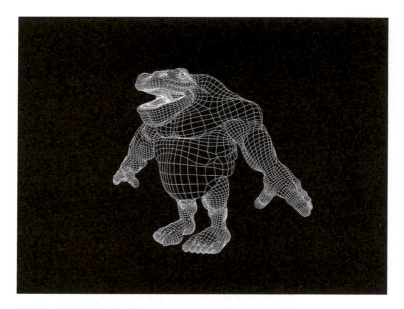

FIGURE 10-31 Wireframe render.

Now that you have your demo reel together you're ready to begin looking for a job. Of course, you'll be searching the websites. Check out the companies where you want to work. Make notes of their job requirements and demo reel submission info. Follow these guidelines or you run the risk of not having your reel being reviewed.

The best places to look for a job are at the conferences. The Game Developers Conference and SIGGRAPH are the two best conferences to attend.

The Game Developer's Conference, or GDC for short, is the best conference to go to for seeking a job within games. While not nearly as large as SIGGRAPH, GDC more than makes up for that in tutorials, tech demos, and interview availability. GDC started as a very small gathering over 15 years ago. It now hosts between 10,000 and 15,000 game developers annually. GDC was, for a long time held in San Jose, CA. Now, however, it seems to be alternating each year between San Jose and San Francisco. There is also a possibility that it will start being held in San Francisco every year. GDC really is a conference by game developers for game developers.

Demos of state of the art graphics boards, to upcoming physics engines can all be seen while wandering the floor at GDC. Also available are wide variety of tutorials and lectures available on all aspects of game development.

The other conference that every modeler should attend is SIGGRAPH. Where GDC focuses on games, SIGGRAPH is geared toward the film. Keep in mind that with the merging of technologies between video games and films, game companies are now frequently seen at the conference. Companies like EA, Sony Games, and LucasArts can all regularly be found at SIGGRAPH.

SIGGRAPH is a floating conference, meaning that it changes location year to year. It is commonly held in Los Angeles and San Diego, CA. But, it often times moves to other cities like Boston and San Antonio. SIGGRAPH, like GDC, is all about technology and networking, albeit on a larger scale. Companies will demo new technology and present tutorials on how certain effects were achieved.

The networking potential at SIGGRAPH is huge. It is a much larger conference than GDC with many more job booths to stop at. There is also a very large job fair.

This brings my book to a close. I hope it helps you understand the correct methods for modeling a character. Keep practicing with different types of characters.

Most important is to start creating and happy modeling.

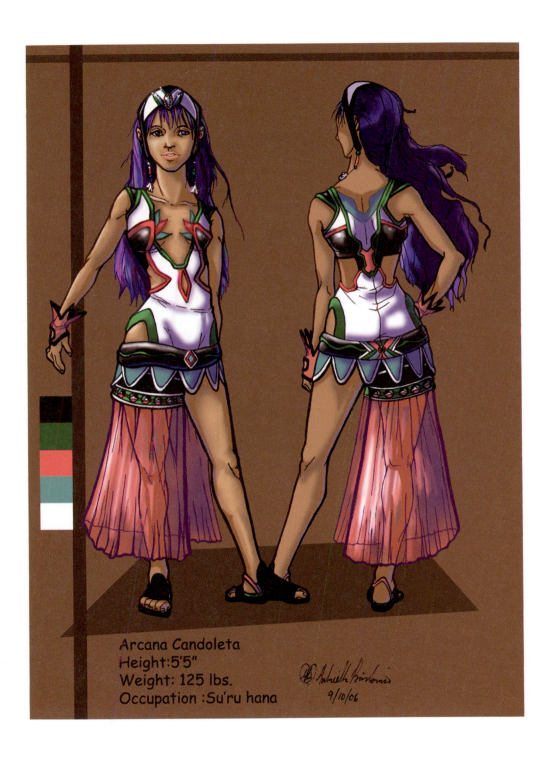

Arcana Candoleta
Height: 5'5"
Weight: 125 lbs.
Occupation : Su'ru hana

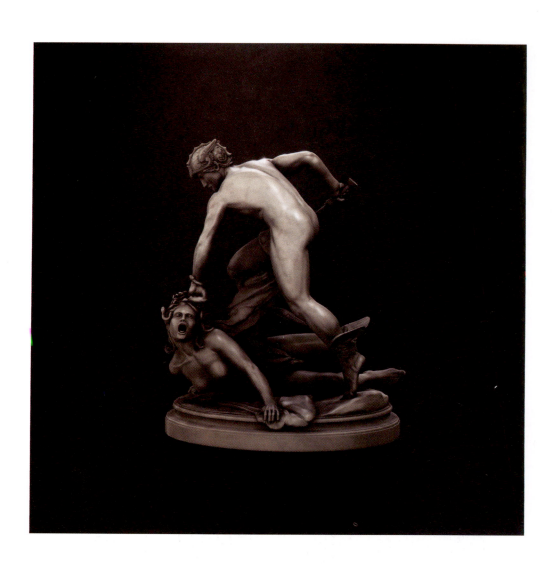

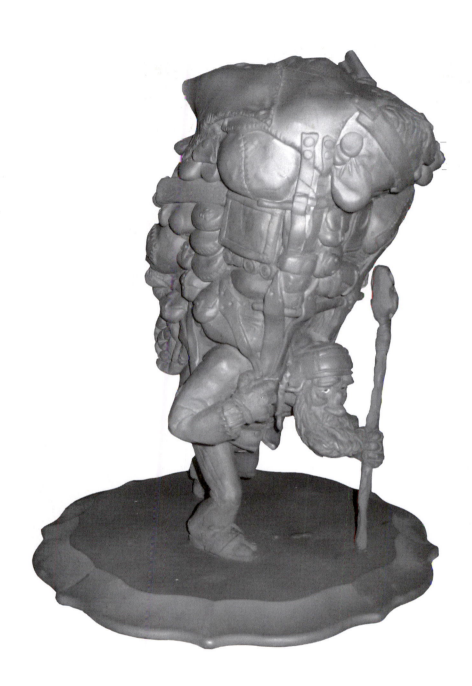

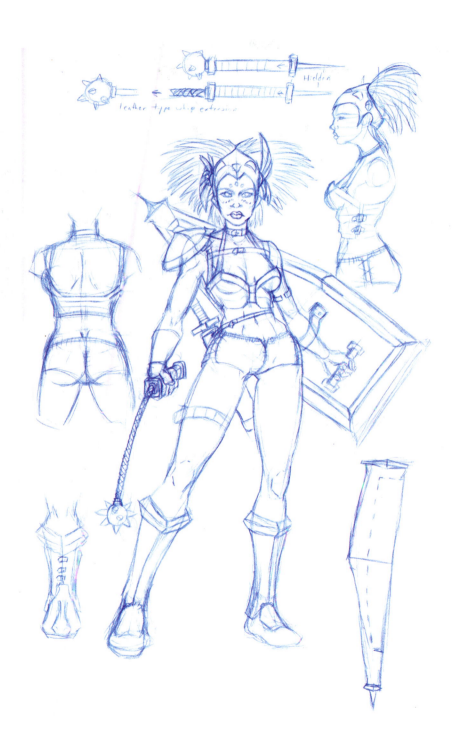

Hidden

leather type whip extension

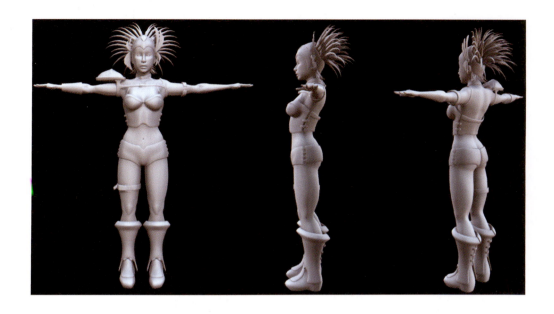

INDEX